ORAL HISTORY IN THE VISUAL ARTS

ORAL HISTORY IN THE VISUAL ARTS

edited by
linda sandino
and matthew partington

BLOOMSBURY

LONDON • NEW DELHI • NEW YORK • SYDNEY

Bloomsbury Academic

An imprint of Bloomsbury Publishing Plc

50 Bedford Square	175 Fifth Avenue
London	New York
WC1B 3DP	NY 10010
UK	USA

www.bloomsbury.com

First published 2013

British Library Cataloguing-in-Publication Data
A catalogue record for this book is available from the British Library.

ISBN:	HB:	978-0-8578-5197-0
	PB:	978-0-8578-5198-7
e-ISBN:	ePub:	978-0-8578-5200-7
	ePDF:	978-0-8578-5199-4

Library of Congress Cataloging-in-Publication Data
A catalog record for this book is available from the Library of Congress.

Typeset by Apex CoVantage, LLC, Madison, WI, USA.
Printed and bound in Great Britain

CONTENTS

ACKNOWLEDGMENTS

The majority of the essays in this book (excluding those by Richard Cándida Smith and Maria Tamoukou with Gali Weiss) began as papers presented at "Record Create: Oral History in Art, Craft and Design," the 2010 Oral History Society (OHS) conference held in association with the Victoria and Albert Museum (V&A), London. We would like to thank the OHS for agreeing to our suggestion of, and its subsequent support for, a conference focused on oral history in the visual arts. We would like to thank the V&A Learning department, especially Jo Banham, Stacy Gambrell, and Matilda Pye, for all their work in making that conference such a success. Our gratitude is also extended to Professor Christopher Breward, and Liz Miller of the V&A Research department.

Equally invaluable has been the support from our respective universities: the University of the Arts London and the University of the West of England Bristol. At the latter, Dr. Andrew Spicer and Dr. Iain Biggs at the PLaCE Research Centre are to be singled out; at the former, Professor Oriana Baddeley, the CCW Graduate School Staff Fund committee, and Matthew Whyte. At Bloomsbury, we would like to thank our editor Anna Wright, Emily Ardizzone, Sophie Hodgson, and especially Emily Roessler. Last but not least, Matthew is eternally grateful to Janine Partington, as Linda is to Richard Slee.

CCW
GRADUATE
SCHOOL

ual: university
of the arts
london
camberwell
chelsea
wimbledon

PLaCE

Place Location Context & Environment
UWE, Bristol, UK

LIST OF ILLUSTRATIONS

PLATES

ILLUSTRATIONS

INTRODUCTION
ORAL HISTORY *IN* AND *ABOUT* ART, CRAFT, AND DESIGN
linda sandino

Interviews, as one of the contributors to this book has commented elsewhere "have become a primary, perhaps obligatory resource on the visual and performing arts" (Cándida Smith, 2006:2). From celebrity profiles to specialist scholarly monographs, voices in the arts continue to intrigue, seeming to offer insights or stories unavailable by other means. In tandem with oral history, which also seeks to uncover hidden, marginalized aspects of the past, the interview appears to privilege firsthand narratives and experience. However, as this book seeks to show, the function of interviews in the visual arts and the knowledge they produce are complex and varied; sometimes transparent, sometimes opaque; and open to historical, critical, or creative interpretation. Contributors here show how interviews can be used as creative material *in* arts practice (Part I); as history *about* art, craft, dress, and architecture (Part II); and as a means to explore how identities in the art world are produced and at times contested (Part III). This book, therefore, engages with the heterogeneity of oral history practice among arts practitioners and historians. Our aim is not legislate how oral history should be conducted but to present a range of approaches that celebrate the diversity of the field.

Although oral history is now an established, global, reflexive methodology (Ritchie, 2005; Perks and Thomson, 2006; Abrams, 2010; Freund and Thomson, 2011) with its own professional societies, within the visual arts, oral history has been used extensively with several archives building collections, some of which are represented here. Writing about oral history in art and design has nevertheless been disparate and dispersed apart from a special issue of the *Journal of Design History* (Sandino, 2006). Crafts were the subject of an issue of *Oral History* (vol. 18/2, 1990), and a history

of *Crafts* magazine was also framed by oral history interviews (Sandino, 2009). One of the aims of this book is to expand the field by bringing together historians and archivists who have been working with oral history for some time: academics contributing to the debate about the function and meaning of oral history narratives and artists who use interviews as part of their creative practice. Apart from two essays (Cándida Smith, Chapter 6, and Tamboukou and Weiss, Chapter 17), the contributions in this book were originally presented at the 2010 "Record: Create—Oral History in Art, Craft and Design" conference we, my coeditor Matthew Partington and I, convened in association with the UK Oral History Society at the Victoria and Albert Museum in London. The international conference brought together arts practitioners, curators, historians, and social scientists who use interviews as a resource for their creative and/or academic output. "Oral history" was interpreted to include all its synonyms: in-depth interview, recorded memoir, life history, life narrative, taped memories, life review, self-report, personal narrative, life story, and oral biography (Yow, 2004:4) with a focus on art, craft, and design. Although there is ample advice on how to conduct qualitative research interviews (for instance, Kvale and Brinkmann, 2009; Silverman, 2011), this Introduction focuses on the historical, creative value and capacity of interviews and the documents that are produced as artworks, as history, and as identity narratives. The principal thesis here is that oral history, like the arts, is a multivalent, diverse, co-constructed practice that challenges conventional autonomous production and identities.

The great oral historian Alessandro Portelli (1991, 1997, 1998, 2006) has written eloquently on the responsibility of oral historians and their work in creating narratives of meaning co-constructed by its two interlocutors, the interviewer and the interviewee. He proposes that oral history documents operate on several levels, devising four categories that do justice to the complexity of its texts and how the method calls for a "stratified critical approach" (Portelli, 1998:23): performance-oriented *narrative*, content-oriented *document,* subject-oriented *life story*, and theme-oriented *testimony* (Portelli, 1998:27). These categories are useful in distinguishing the various ways in which either one or several narratives might be read differently (Sandino, 2009). Traditionally, content gathering is considered the primary objective of oral history, and as the Histories section of this book shows, several essays are historically focused studies (see Buckel, Chapter 14, and Flegg, Chapter 11). The biographical aspect is represented in the form of identity narratives that explore contexts and becomings of artistic practice and selfhoods (see Cvetkovich, Chapter 12, and Tamboukou and Weiss, Chapter 17). Although all the essays relate to art and design practice as their theme, "testimony" here refers to the representation of what has been lost or has vanished (see Handal, Chapter 4, and Furnée and Horton, Chapter 3), whereas "performance" might be taken here to signify the narrative competence of interviewees as they tell their stories (see Bruchet, Chapter 7, and McMillan, Chapter 2). However, despite the division of the book into sections on Arts Practices, Histories, and Identities, all the essays can be read across each other as each contributes to the polyphony of oral history in the arts.

Oral histories are situated dialogues and the contexts of their production need to be understood in order to explore their meanings: "*Who says what in which channel to whom with what effect?*" (Portelli, 1998:5). Communications theorist John Durham Peters traces the history of the term communication, demonstrating how ideal communication, a "registry of modern longings" embedded in technological inventions, is a yearning never fulfilled. Definitions of communication, denote transfer or transmission, exchange, and symbolic interaction, whereas its root from the Latin *communicare* translates as "sharing talk" (Peters, 2001:267). Oral history, an instance

of shared talk, draws on all of these definitions as interviewees impart and transfer their recollections, but always with an element of interference that resists complete communion. Solipsism and telepathy, Peters argues, are the two poles of communication: solitude and communication, or blockage and breakdown. Within these two poles, we must attempt to move beyond the Socratic dialogue that seeks sameness in order to attempt to communicate with and understand otherness. Interviews provide the circumstance and opportunity for retrospective reflection, and a means of closing the gap between the self-that-was, the current speaking self, and the projected self. Life stories sit between autobiography and biography, assisted narratives that are the product, or the co-production of interviewer and interviewee. To record life stories requires "an abandonment of the self in a quest to enter the world of another" (Andrews, 2007:15). The text that is created from this encounter becomes an account of encounters with the world (people, objects, artworks) that show identity created in narrative.

ARTS PRACTICES

A key example of interviews functioning as historical archive and arts practice is *Audio Arts* (1973–2006), a cassette publication launched by the artists William Furlong and Barry Baker (see Figure 1). Furlong has written about the origins of the work:

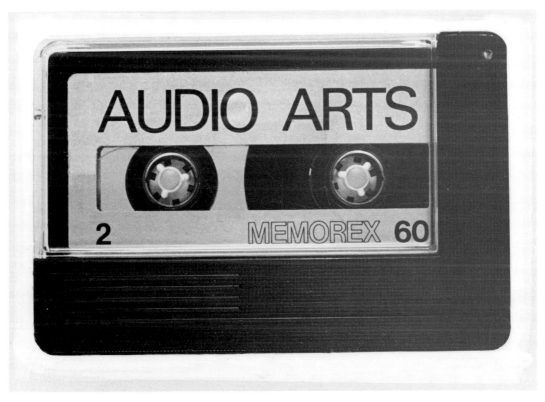

1. An *Audio Arts* cassette. c.1970s. (Presented to Tate Archive by Bill Furlong in 2004. Photo copyright Tate, London, 2012).

When the magazine was first published in the early 1970s I regarded it as part of the conceptual experimentation then taking place in international contemporary art. The recently introduced Philips cassette made possible for the first time the convenient recording and, more significantly, the wide dissemination, of the unmediated spoken voice of the artist. Audio Arts is more than a 'sound magazine'; it is a cumulative collaboration, which may be regarded as a unique work in its own right and whose material medium is sound. In this respect, as editor, I also considered myself as the artist as editor-curator, an orchestrator of diverse sound materials. From the outset Audio Arts featured in-depth recordings of many of the most important artists in Britain, Europe and the United States. (Furlong, n.d.)

Interviews with historically prominent figures such as Joseph Beuys (1974/1985), Lucy Lippard (1978), Noam Chomsky (1973), Laurie Anderson (1981), John Cage (1983), and Gerhard Richter (1988) have guaranteed the historical value of *Audio Arts,* deposited in 2004 with the Tate Archives. However, a more recent work titled "Anthem" (2009) represents the shift away from the focus on elites (in keeping with the ethos of oral history). Devised as a paean to the English seaside town of Bexhill, Furlong interviewed residents whose sound recordings were then orchestrated as a sound sculpture/installation (see Figure 2) at the De La Warr Pavilion in Bexhill-on-Sea.

Although *Audio Arts* arose as part of the conceptual experimentations taking place in the arts, especially sculpture in the 1970s, recorded interviews have continued to provide material for sound

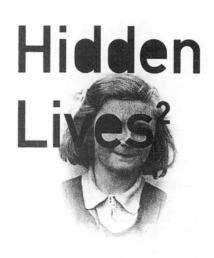

Hidden Lives²

The House of Memory
A sound installation by Cathy Lane
Part of the Stoke Newington Festival

Clissold Park, Stoke Newington, London N16.
Installation situated outside Clissold House.

Sunday June 10 (Street Festival Weekend)
Saturday June 16 (Children's Festival Weekend)
Sunday June 17 (Children's Festival Weekend)
From 12 noon to 7pm

Thanks to Hackney Museum, Hackney Archives, the pupils and staff
of Colvestone School, Stoke Newington Festival, Clissold Park.
Financially supported by the London Institute.

2. *Hidden Lives 2: The Sound of Memory* (2001) [poster]. (Image courtesy of the artist Cathy Lane, CRiSAP).

artworks. Sound Art is a category of arts practice that provides a fruitful partnership with oral history as, for example, the work of members of CRiSAP (Creative Research in Sound Arts Practice, http://crisap.org/index.php?home) demonstrates.

One of its members and a contributor here is David Toop (Chapter 1), who drew on his conversation and long-term friendship with the artist John Latham (1921–2006) for "The Body Event" (2005). The work was installed at The Flat Time House, Latham's former home and now the location of his archive, in 2006 where I first heard and experienced the work. The installation encompassed the range of emotional and intellectual registers that resonate in oral history recordings: voice, embodiment, presence, the desire to communicate and the inevitable gaps that such a desire presents, as Peters (2001) has suggested. Toop's essay reflects on the relationship between "The Body Event" and oral history and is emblematic of the poetic potential of aurality, embodiment, and the lost past.

Whereas sound performs an especially affective resonance in oral history, memory is also a key component of artists' use of recorded memories as Alexandra Handal, Ian Horton, and Bettina Furnée testify in their accounts of their use of interviews. Handal's work re-creates the destroyed homes of Palestinian refugees, drawing on their memories, photographs, and memory maps. Her work was carried out in the field, and she reflects on the practical rewards and emotional turmoil of undertaking such work. Through the discussion of two site-specific public artworks, Horton and Furnée explore how textual fragments function as signifiers of place, time, and the archive, drawing on Rosalind Krauss's concept of the indexical that "establish their meaning along the axis of a physical relationship to their referents" (see Chapter 3). Michael McMillan also draws on memory texts from his Caribbean background for his multidisciplinary arts practice (writer, playwright, mixed-media installation) but here focuses on how language, tradition, and emotion contribute to his creative practice and projects. All these artists share a concern with the representation of place and memory. However, furniture designer/maker David Gates (Chapter 5) takes up an interest in the "small stories" occurring in everyday conversation as the opportunity to challenge art and to design oral histories' focus on the past. Gates analyzes talk among the makers themselves to demonstrate the significance of talk-in-interaction in developing ideas and projects. Although there have been moves to human-centered design research by companies such as IDEO, the temporality that is essential in oral history work is absent. A more pertinent example is the regeneration of Barking Town Square by muf architects (see Figure 3), which included the recreation of "a fragment of the imaginary lost past of Barking" and involved the local community (muf architecture/arts, n.d.). However, David Gates's essay makes the important point that design practitioners are usually future oriented, and this may account for why a focus on the past is not a primary concern.

A distinctive development is the collaborative quality of using interviews/talk/dialogue in arts practice. This bears some of the elements of a "relational aesthetic" art production as propounded by Nicolas Bourriaud: "a set of artistic practices which take as their theoretical and practical point of departure the whole of human relations and their social context, rather than an independent and private space" (1998:113). Another distinctive element of these contributions is that they situate oral history work in a creative context that extends its interpretive capacity, as I discuss in more detail in the following sections. By concentrating on the imaginative, affective dimension of memory work as opposed to its truth value, they remind us of the ethical dimension of stories and memories. Along with other contributors in Histories (Part II) and Identities (Part III), they also show how interviews can function as a resource to be mined for "what insights they may bring to

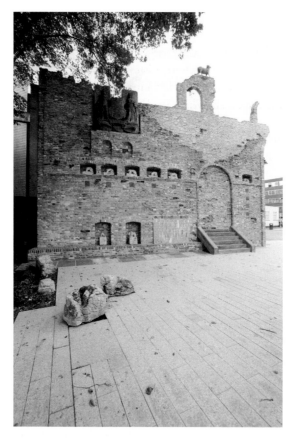

3. Folly Wall, Barking Town Square, London, muf architects, 2005–2010. (Photo: David Williams).

understanding social life" and as *topics* "of interest in themselves" (Plummer, 2001:34). As a resource, the focus is on content of the story told; as a topic, attention shifts rather to the construction, organization, and reception of the material.

HISTORIES

Memory plays a key role in becoming "the subject as well as the source of oral history" (Perks and Thomson, 2006:4). Recent research in memory has moved away from the individual storehouse/archive model to reveal the social, interactive formation of memory and its documents. The work of Maurice Halbwachs, *On Collective Memory,* translated into English in 1992, has become a popular benchmark for discussions about collective memory (Tonkin, 1992; Pascal and Wertsch, 2009). While the debates about memory as a defining category continue, historians have seen it as a strength, as a counternarrative to official histories, or as a weakness because memory is fallible and unreliable. It may account for why video has been embraced by some oral historians on the grounds of providing a "high-fidelity" record of the interview, the goal of the history of sound

recording and transmission (Sterne, 2003). Nevertheless, fidelity and subjectivity should be seen as complementary rather than as oppositional because subjectivity is the means by which "individuals express their own sense of themselves in history" (Portelli, 1991:ix).

As the contributors to this section reveal, history based on interviews provides a way into understanding and revealing values that have structured individual and collective experiences. Richard Cándida Smith (Chapter 6) explores the changing conceptions of quality among curators at the San Francisco Museum of Modern Art (see Figure 4). This essay is followed by that of Liz Bruchet, who reflects on how art historians' professional, performative skills shape their stories of the discipline as founding members of the Association of Art Historians. For smaller institutions such as the Cork Craftsman's Guild, oral history, as Eleanor Flegg (Chapter 11) describes, can recover the emotional impact of its rise and fall. Interviews also extend the history of objects and artworks, uncovering the processes and affective engagement involved in realizing creative projects as Liza Kirwin (Chapter 8) demonstrates in her essay on craft artists represented in the Nanette L. Laitman Documentation Project for Craft and Decorative Arts in America at the Archives of American Art at the Smithsonian Institution. Whereas craft interviews concentrate on individual creativity, Anne G. Ritchie's interviews (Chapter 9) with the engineers and

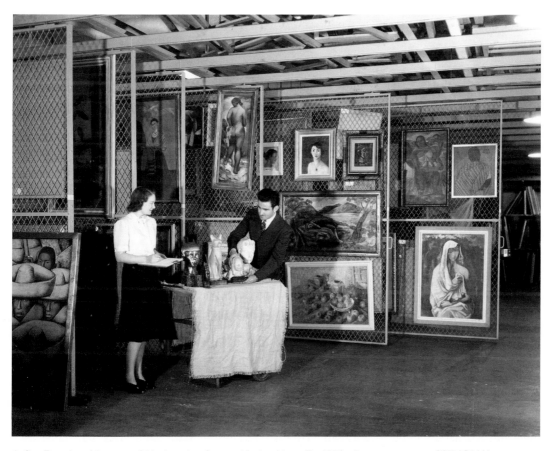

4. San Francisco Museum of Modern Art, Storage Vault with staff, c.1950s. (Image courtesy of SFMOMA).

builders, as well as the architects, working on the extension, designed by I. M. Pei, to the National Gallery of Art in Washington, D.C., draw out the collaborative negotiations involved in architectural projects. It is significant that all the contributors to this section (apart from Flegg) work as historians with or for archival collections (Regional Oral History Office at the Bancroft Library at the University of California at Berkeley, the Association of Art Historians, The Archives of American Art at the Smithsonian Institution, the National Gallery of Art Washington, the Victoria & Albert Museum). The British Library houses the National Life Stories collection of interviews that range across the visual and performing arts. An example of a dedicated archive is the Chicago Architects Oral History Project, which documents "the life experiences of architects who shaped the physical environment in Chicago and surrounding communities" (Art Institute of Chicago, n.d.).

Historians and archivists are sensitive to the temporal dimension of their research, and archives function as the repositories that store material for future interpretations. For artists, as well as for art and design history, the contingency of all evidence is possibly more easily accepted because processes of production and consumption and of history writing as a context-specific form of mediation have been integrated into its disciplinary identity (Lees-Maffei, 2011). Focusing less on events, the "truth problem" has been less of an issue. Most historians have finally come to accept that "evidence only signposts possible realities and possible interpretations because all contexts are inevitably textualised or narrativised or texts within texts" (Munslow, 1997:26). Although the question of history as a constructed narrative has concerned historians, the responsibility and power of the interpretation are more complex when the source of the evidence is a human subject, for whom the story is real. How does one reconcile a position of critical engagement with respect for the testimony? The narrative psychologist Ruthellen Josselson provides a way out of this dilemma. Drawing on the work of the philosopher Paul Ricoeur, she proposes two forms of interpretation: one that aims to *restore* meaning to a text and another that aims to *demystify* it. The former is

> characterized by a willingness to listen, to absorb as much as possible the message in its given form and [respect for] the symbol, understood as a cultural mechanism for our apprehension of reality, as a place of revelation. This type of hermeneutics is animated by faith. By contrast hermeneutics may be approached as *demystification* of meaning presented to the interpreter in the form of a disguise. This hermeneutics is animated by suspicion, by skepticism towards the given. (Josselson, 2004:3)

Nevertheless, both ask the fundamental question: Can we read in a text what is "not there"? The restoration of meaning is the ethical responsibility towards the participant, but even this involves interpretation since meanings may be implicit rather than explicit. Oral histories are "complex historical dialogues" that provide the opportunity to engage with subjectivity, a means by which complex theoretical abstractions can be realized in narratives that "[i]nform, challenge, complicate and shape our own categories and questions—especially if we are willing to share with interview subjects the authority of interpretation, to read narratives as offering an interpretive dialogue implicit in the relationships producing ethnographic or documentary evidence in the first place, and often explicit, if we stop to listen for it, in the texts generated in the process" (Frisch, 2007:13). Whether it is curators at the San Francisco Museum of Modern Art talking about quality, or art historians reflecting on their discipline, or a museum curator, such as John Clarke, interviewing Nepalese and

Tibetan craftsmen (Chapter 10), the effort toward meaning is played out in the interview and its subsequent iterations as written texts or other media including artworks as described previously.

IDENTITIES

The ubiquity of the interview format and the advent of the interview society as the means to revealing a true self has become a matter of inquiry itself (Atkinson and Silverman, 1997). It echoes the critique of privileging experience as the foundation for historical research; the interview society accords a parallel privilege to the speaking subject especially prevalent in art and design. Oral history, in fact, could be seen to collude with this view in that first-hand testimony is often treated transparently as an illustration of the past. Historian Joan W. Scott has famously problematized the "evidence of experience" that

> works as a foundation providing both a starting point and a conclusive kind of explanation, beyond which few questions can or need to be asked. And yet it is precisely the questions precluded—questions about discourse, difference, subjectivity, as well as what counts as experience and who gets to make that determination—that would enable us to historicize experience, and reflect critically on the history we write about it, rather than to premise our history on it. (Scott, 1991:790)

Scott argues that although documenting experience may demonstrate its existence, it does not reveal *how* it is constructed historically, how it produces and reproduces subjects: "[i]t is not individuals who have experience, but subjects who are constituted through experience" (Scott, 1991:779). This insight is particularly helpful in thinking about how artists, designers, curators, historians are constructed as subjects and how their narratives enable, produce and circulate the conditions of their subjectivity. Scott's essay does not propose that subject positions are singular, but that discourses are always contradictory and multiple. Subjects have agency even though it is "created through situations and statuses conferred on them" (Scott, 1991:793). The historian's project, she suggests, is therefore "[n]ot the reproduction and transmission of knowledge said to be arrived at through experience, but the *analysis of the production of that knowledge itself.* Such an analysis would constitute a genuinely nonfoundational history, one that does not stand on or reproduce naturalized categories" (Scott, 1991:797). Born from the challenge to dominant historical narratives, in the United Kingdom known as "history from below," oral history is ideally placed to carry out Scott's proposal however difficult it is to escape our own normative assumptions.

Several contributors to the Histories section of the book explore how identities are forged through dress. Natalya R. Buckel (Chapter 14) describes how feed-sack fashion provided the opportunity for resourceful stylishness of women in rural Appalachia in the mid-twentieth century. Dress and style as resistance across generations and cultures; "From Punk to the Hijab" via women protestors at Greenham Common women's peace camp is explored by Shehnaz Suterwalla (Chapter 16). Museum curator Claire Wilcox (Chapter 15) takes up the embodied experience of dress in her poignant rumination on an interview she commissioned for a project on maternity wear in postwar Britain. The interview between a mother and daughter confounded her curatorial expectations by providing an account of the experience of pregnancy in mid-century, suburban England that shaped the meaning of the mother's maternity wear. These

stories about fashion and dress provide a parallel to how gender and craft provide counternarratives to design and fine art, as examined in Jo Turney's work on amateur knitters (Chapter 13) and by Ann Cvetkovich (Chapter 12) on her conversations with lesbian artists Allyson Mitchell and Sheila Pepe, for whom their art as craft and the sociality it signifies can be documented through oral history. Like Cvetkovich's exploration of art and identity, the collaborative essay by Maria Tamboukou and Gali Weiss (Chapter 17) present a textual and visual dialogic encounter that unravels Weiss's narrative of becoming an artist. In her essay analyzing the small and big stories about the design of a crematorium, Arlene Oak argues for the value of both structures in understanding design processes and choices (Chapter 18).

These writers all share an interest in how narrative "is not merely an appropriate form for the expression of identity; it is an identity content [in which the self is] defined and transacted in the narrative process" (Eakin, 1999:100–101). Rather than the autonomous individualism, so prevalent in art and design history where producers are still celebrated as unique individuals, transactions echoes the shift noted above to a collaborative, socially embedded identity. Because language is one of "our principal means of referring. . .achieving joint reference is achieving a kind of solidarity with somebody" (Bruner, 1986:63), a form of collectivity that sustains particular worldviews, revealed in oral history narratives. Interviews with artists testify to the relational dimension with other artists and art objects (Sandino, 2010), indicating the shared world in which the "transactional self" is situated. Psychologists have been particularly attentive to identity formation, questioning the linear, developmental model in which identity is "immanent and indwelling" (Mishler, 1999:16). Citing the various ways in which relational models have been variously characterized as dialogical, discursive, or narrated, they all nevertheless, as Elliott Mishler concludes from his work on craftartists [sic], "[r]epresent a radical shift in the viewpoint, from the autonomous individual as the locus of identity and the source of stability and constancy over time and across situations, to the socially situated production of identity and to the ways individuals position themselves vis-à-vis others" (1999:111). This may explain why dress and gender have provided rich possibilities for oral history work (Taylor, 2002), partly I would suggest because clothing and dress provide the opportunity for displays of selfhood whereby common products are made individual. As well as documenting the history of alternative forms of practice and narratives of becoming, big stories, small stories, and even gossip as a "form of social activity which produces and maintains the filiations of artistic community" (Butt, 2005:1) contribute to the articulation of selfhood.

ORAL HISTORY AND ARTS PRACTICE: REAL AND POSSIBLE WORLDS

The term *oral history* covers both the history that is told, as well as the story subsequently presented—as history, as artwork—a double interpretive operation in which the narrator recapitulates the told in the telling. Narrative is at the core of oral history, and in order to grasp the meaning of its accounts as histories or artwork, how its narratives are created is significant. Interviewees may draw on a variety of already told versions and so a construction is always a re-construction, forever subject to re-tellings, or rather *re*configurations providing the opportunity to think again, or think differently about the past. As Paul Ricoeur wrote, the individual in interpreting his or her life "appears both as a reader and writer of [his or her] own life," and the "story of a life continues to be

refigured by all the truthful and fictive stories a subject tells about himself or herself. . . . This refiguration makes this life itself a cloth of woven stories told" (1988:246). So, rather than assuming the interview and the recording stand as a final authority, the accounts should be understood as situated within a particular context, achieved in and for a specific moment or function (art) that may change each time the story is told, so that

> the ways of telling and the ways of conceptualizing that go with them become so habitual that they finally become recipes for structuring experience itself, for laying down routes to memory, for not only guiding the life narrative up to the present but directing it into the future . . .a life as led is inseparable from a life as told-or more bluntly, a life is not "how it was" but how it is interpreted and reinterpreted, told and re-told. (Bruner, 1987:708)

Ricoeur's work on narrative (1984–8) offers a fruitful way of conceptualizing the production and reception of oral histories through three interrelated stages: prefiguration, configuration, and refiguration. Prefiguration is the competence we bring to narratives that enables us to understand them as stories with certain conventions and to know what the appropriate questions are: who, what, how, why? Refiguration describes the moment of understanding at the intersection of the world of the text and the world of the reader or hearer that makes the text meaningful. Between these two sits configuration, or emplotment, which synthesizes the heterogeneous elements into a totality either as history or as artwork.

Doing history is about making stories, creating interpretations, a creative, imaginative endeavour that draws on a culture's narrative resources. Historians have made a distinction between professional and amateur, but oral history as a practice collapses this distinction. Interviewees know more about their lives than does the interviewer, and through their use of descriptive passages, narrators *construct* stories in order to represent the past. They too become historians, not just in terms of their recollection of past events in order to feed the historian or the artist, but as creators of meaning about those events (Portelli, 1991; Brockmeier, 2009). "For understanding and appreciating the human condition it is far more important to investigate the ways human beings construct their real and possible worlds . . . than it is to establish the ontological status of the products of these constructions" (Brockmeier, 2009:214).

While not all visual arts practices are represented in this collection of essays, they nevertheless offer an insight into how oral history in the arts is the occasion for the creation of collaborative engagements that demonstrate how current practice is a social, relational, and ethical practice. Essays by historians, archivists, and curators also testify to the significance of alternative, hidden histories, and accounts of practice that explore how values and ideologies are constructed, challenged, or sustained in interview narratives and the documents they produce.

REFERENCES AND FURTHER READINGS

Abrams, L. (2010), *Oral History Theory*, London: Routledge.
Andrews, M. (2007), *Shaping History: Narratives of Political Change*, Cambridge: Cambridge University Press.
Art Institute of Chicago (n.d.), "Chicago Architects Oral History Project," <http://digital-libraries.saic.edu/cdm4/index_caohp.php?CISOROOT=/caohp>, accessed September 15, 2011.

Atkinson, P. and Silverman, D. (1997), "Kundera's *Immortality*: the Interview Society and the Invention of the Self," *Qualitative Inquiry* 3: 304–25.

Bourriaud, N. (1998), *Relational Aesthetics*, Dijon: Les Presse Du Reel.

Boyer, P. and Wertsch, J. V. (eds.) (2009), *Memory in Mind and Culture*, New York and Cambridge: Cambridge University Press.

Brockmeier, J. (2009), "Reaching for Meaning: Human Agency and the Narrative Imagination," *Theory and Psychology* 19: 213–33.

Bruner, J. (1986), *Actual Minds, Possible Worlds*, Cambridge MA: Harvard University Press.

Bruner, J. (1987), "Life as Narrative," *Social Research* 54: 11–32.

Butt, G. (2005), *Between You and Me: Queer Disclosures in the New York Art World, 1948–1963,* Durham, NC: Duke University Press.

Cándida Smith, R. (ed.) (2006), "Introduction: Performing the Archive," in *Text and Image: Art and the Performance of Memory,* New Brunswick and London: Transaction Publishers.

Eakin, P. J. (1999), *How Our Lives Become Stories*, Ithaca and London: Cornell University Press.

Freeman, M. (1993), *Finding the Muse: A Sociopsychological Inquiry into the Conditions of Artistic Creativity*, Cambridge and New York: Cambridge University Press.

Frisch, M. (2007), "Working-class Public History in the Context of Deindustrialization: Dilemmas of Authority and the Possibilities of Dialogue," *Labour/Le Travail* 51: 153–64.

Freund, A. and Thomson, A. (2011), *Oral History and Photography*, New York: Palgrave Macmillan.

Furlong, W. (n.d.), [website] <http://raw.wimbledon.ac.uk/?q=node/6>, accessed December 2011.

Halbwachs, M. (1992), *On Collective Memory*, ed. and tr. L. A. Coser, Chicago: The University of Chicago Press.

Josselson, R. (2004), "The Hermeneutics of Faith and the Hermeneutics of Suspicion," *Narrative Inquiry* 14/1: 1–28.

Kvale, S. and Brinkmann, S. (2009), *Interviews: Learning the Craft of Qualitative Research Interviewing,* Los Angeles and London: Sage.

Lees-Maffei, G. (ed.) (2011), *Writing Design: Words and Objects,* Oxford: Berg.

Mishler, E. G. (1999), *Storylines: Craftartists Narratives of Identity*, Cambridge, MA: Harvard University Press.

muf architecture/arts. (n.d.), "Barking Town Square," <http://www.muf.co.uk/archives/portfolio/barking-town-square-2>, accessed August 30, 2011.

Munslow, A. (1997), *Deconstructing History,* London and New York: Routledge.

Partington, M. (2004), "Ceramic Points of View: Video Interviews, the Internet and the Interpretation of Museum Objects," *Journal of Design History* 19/4: 333–44.

Perks, R. and Thomson, A. (eds.) (2006), *The Oral History Reader*, London and New York: Routledge.

Portelli, A. (1991), *The Death of Luigi Trastulli and Other Stories: Form and Meaning in Oral History,* Albany: State University of New York Press.

Portelli, A. (1997), "There's Always Gonna Be a Line: History-Telling as a Multivocal Art," in *The Battle of Valle Giulia: Oral History and the Art of Dialogue*, Madison: University of Wisconsin Press.

Portelli, A. (1998), "Oral History as Genre," in M. Chamberlain and P. Thompson (eds.), *Narrative and Genre,* London and New York: Routledge.

Portelli, A. (2006), "What Makes Oral History Different" [1979], in R. Perks and A. Thomson (eds.), *The Oral History Reader*, 2nd ed., London and New York: Routledge.

Ricoeur, P. (1984, 1986, 1988), *Time and Narrative*, 3 vols, tr. K. McLaughlin and D. Pellauer, Chicago: Chicago University Press.

Ricoeur, P. (1992), *Oneself as Another,* tr. K. Blamey. Chicago: University of Chicago Press.

Ritchie, D. A. (2005), *Doing Oral History: A Practical Guide,* 2nd ed., Oxford and New York: Oxford University Press.

Sandino, L. (ed.) (2006), "Oral Histories and Design," *Journal of Design History,* special issue, 19/4.

Sandino, L. (2007), "*Crafts* for Crafts' Sake, 1973–1988," in J. Aynsley and K. Forde (eds.), *Design and the Modern Magazine*, Manchester: Manchester University Press.

Sandino, L. (2009), "News from the Past: Oral History at the V&A," *V&A Online Journal*, Autumn, no. 2, <http://www.vam.ac.uk/content/journals/research-journal/issue02/news-from-the-past-oral-history-at-the-v-and-a/>, accessed August 30, 2011.

Sandino, L. (2010), "Artists in Progress: Narrative Identity of the Self as Another," in M. Hyvärinen et al. (eds.), *Beyond Narrative Coherence,* Amsterdam and Philadelphia: John Benjamins B.V.

Samuel, R. and Thompson, P. (eds.) (1990), *The Myths We Live By*, London: Routledge.

Scott, J. W. (1991), "The Evidence of Experience," *Critical Inquiry* 17: 773–97.

Silverman, D. (ed.) (2011), *Qualitative Research: Issues of Theory, Method and Practice,* 3rd ed., Los Angeles: Sage.

Smith, G. (n.d.), "The Making of Oral History," <http://www.history.ac.uk/makinghistory/resources/articles/oral_history_3.html#public>, accessed January 2012.

Sterne, J. (2003), *The Audible Past: Cultural Origins of Sound Reproduction*, Durham, NC: Duke University Press.

Taylor, L. (2002), *The Study of Dress History*, Manchester: Manchester University Press.

Tonkin, E. (1995), *Narrating Our Pasts: The Social Construction of Oral History,* Cambridge: Cambridge University Press.

Yow, V. R. (2005), *Recording Oral History: A Guide for the Humanities and Social Science,* 2nd ed., Walnut Creek: Rowman AltaMira Press.

Part 1
ARTS PRACTICES

THE BODY EVENT

VOICE AND RECORDED HISTORIES IN THE CREATION OF A SOUND INSTALLATION BASED ON THE IDEAS OF THE WORK OF ARTIST JOHN LATHAM

david toop

European philosophers of the eighteenth century thought of hearing as one of the dark senses. Even the analytical, creative mind of Leonardo da Vinci had come to similar conclusions centuries earlier; the prospect of losing sight was profoundly alarming to him, a prospect of entombment as if light and understanding share equivalence in the process of enlightenment, even in the essential meaning and vitality of engagement with the world. Sound has properties of instability, uncertainty, incoherence, the uncanny—an ambiguity in lived physical space, a fleeting presence in time. These are its limitations for a culture in which seeing is believing, but they are also a source of potentiality through which the pathos of haunting and loss may be transformed into more hopeful emotions through what I describe in my book, *Sinister Resonance* (2010), as the "mediumship of the listener."

This is the story of a single work in sound, a sound installation based on the voice, the practice, and the ideas of one person. The work is called *The Body Event*, a title I return to in the following text.

The person *evoked* by the work, and to some extent generating the work alongside my own contribution, is the artist John Latham.

Although this piece—*The Body Event*—was founded in a form of research practice, I had not thought to place it within the frame of oral history, only belatedly understanding this to be a context that opened up other potentialities. I have always been passionately curious about music and anthropology; about the dynamics of music, sound, noise, and listening in human relations; and about the relationship between humans and their environment. As I have already suggested, sound has an uncanny quality. Is it really there? What made the sound? Am I hearing things? This is particularly true of the voice. Much is invested in the link between speech and text, as if spoken words in their transcribed state can carry the complete meaning of any verbal communication. "Read my lips," George H. W. Bush said at the 1988 Republican Convention (speaking an untruth, as it later transpired), as if the silencing of sound in the visual formation of silent text was a guarantee of truthfulness and intent, because sound, the untrustworthy medium, was suppressed and overcome.

In the early 1970s, I learned a great deal from books such as *Purity and Danger* by Mary Douglas, and Ray Birdwhistell's *Kinesics and Context*. They helped me to understand the broader issues of communication, through which strong social codes were embedded in the etiquette of place setting at a dinner table or covert meaning could be revealed by paralinguistic elements of speech. Birdwhistell, for example, described his mother as being an "expert in untalk" (1973:52–3). He wrote, "She could emit a silence so loud as to drown out the scuffle of feet, the whish of corduroy trousers, and even the grind of my father's power machinery to which he retreated when, as he said, 'Your mother's getting uneasy.'" His mother was also a great sniffer. He paraphrases Mark Twain by saying that "her sniff had power; she could sniff a fly off a wall at 30 feet." Revealingly, he accuses her of being an irresponsible sniffer. She denied the evidence of her sniff and its power, yet used it as a weapon, a precisely targeted auditory signal that superseded all others, despite their greater specificity.

So, this is an indication of the wider background to my sound work, *The Body Event*. Now I should describe how it was made. First, I made a digital recording of a conversation with John Latham in his house in Peckham, South London. Then I extracted fragments of sound from the interview, particularly those elements of his voice and body movements that can be described as paralinguistic or kinesics. From these fragments, I then built and composed a number of sound files or distinct compositional units in my computer, inspired by John Latham's theories on time base and the primacy of event over object. Finally, I devised a sound installation. The files were played back on a multichannel sound system, exploiting the random playback function of cheap iPod Shuffles as an organizing principle, so that all of these individual passages of sound would combine unpredictably without any physical center or narrative. The piece was its individual parts overlapping, as sound does, in sequences without beginning, middle, or end. In some sense, they combined to become a version of John Latham, the sound of John Latham and the embodiment of his ideas as understood by me, the sound of the house in which he lived, and his continuing posthumous presence as a complex shifting event.

A few facts: John Latham was born in 1921; he died in 2006. He made works in many different media—sculptural reliefs, film, performance, constructions and discursive or theoretical essays—often returning to books as totemic objects, symbols of the containment, preservation, and propagation of all the world's knowledge, its beliefs, and its laws. As is often the case with artists, his reputation has risen since his death, though there were moments of controversy in his lifetime.

Most notorious of all was the work called *Still and Chew/Art and Culture, 1966–67*. Working as a part-time lecturer at St. Martin's College of Art in 1966, he borrowed Clement Greenberg's defining text of modern art, *Art and Culture*, from the library and then encouraged students to chew the book and spit out the pages. These chewed, spit-out pieces were processed over some months until reduced to liquid and injected into a glass vial. When he returned the transformed object to the library as an overdue book, he was dismissed from his job, but in the longer term, the work is now regarded as a key gesture of conceptual art and is kept in the collection of the Museum of Modern Art in New York.

As far as I can recall, my first exposure to John Latham's work would have been in one of the rooms of the Tate Gallery, where a magnificent book relief hung alongside works by Jackson Pollock and Franz Kline. This was in the mid-1960s, so it would be dubious to claim through hindsight that I can clearly recollect the impact on my adolescent self, but I am convinced that this dark, dusty work, like the upended floor of a bombed library, made a profound connection for me between the textural paintings and reliefs of Italian and Spanish artists—Alberto Burri, Lucio Fontana, and Antoni Tàpies—and a deeper world of ideas that I barely glimpsed at that time. Again, I can only speculate, but the sight of books—objects of desire and loathing, of liberation and repression—transformed into instant hits of visceral, burned-out information was wildly exciting. In the postwar period of reconstruction, destruction was a problematic concept, particularly when linked in this way to knowledge and, by inference, civilization. At the same time, destruction seemed inevitable and necessary. The Cold War haunted our dreams. Growing up in the inertia and conservatism of London's outer suburbs in the 1950s, I could only respond positively to that which was radically other, that which was reduced to fragments or rubble, the outer edges of emotion, or to celebrations of noise and chaos.

In 1968, I was in the audience for a performance evening called *Float*, held at Middle Earth, a psychedelic club located in Covent Garden. The poster for *Float* advertised performances by seventeen artists, but I was most impressed by Latham's contribution. He was cutting up books with the kind of floor-mounted electric saw used by timber merchants. As if the noise from this activity wasn't brutal enough, the body of the saw was amplified through a contact microphone. I enjoyed the noise attack so much that I picked up one of the book fragments from the floor and took it home. Reading through this sundered volume in a conventional manner generated fantastic imagery automatically. The book was a romantic novel, written in florid style, and so nonsensical lines of overheated, exotic poetry flowed from its pages. These broken texts became songs, in some cases, and I read long passages from them into a cassette tape recorder, using a flat voice that gave no acknowledgement to the consistent ruptures of syntax and meaning.

This was the beginning of something for me. By that time, I had read *Nova Express* (1966) by William Burroughs, and I was getting to know something about cut-ups and concrete poetry. A few years later, I would be working in a trio with sound poet Bob Cobbing and drummer Paul Burwell, an experience through which I would be introduced to the world of sound poetry. There was an emergent context, then, but I had discovered a way to write, as well as a way to speak and sing (and new subjects to speak and sing about). Difficult as they were, Latham's ideas began to intrigue me: musicians find the notion of a world based on time-base and event, rather than object relations, relatively easy to assimilate, because time and immateriality form the foundation of their practice. I would describe Latham and Cobbing as unwitting mentors to my early career, and there were connections between the two artists. Cobbing was an organizer of events in which

Latham took part, and Cobbing's tape sound poetry had been incorporated into at least one of Latham's performance installations of the 1960s. From both artists, there was the attraction for me of destroyed syntax and scattered nouns, even though their intentions and methods were radically different.

My art school education was not a great success, at least in the accepted terms. I was accepted at Watford School of Art to study graphic design, then left after a year to try painting, returning again to Hornsey College of Art, where I had spent my foundation year during the turbulent, stimulating student sit-in of 1968. The course and most remaining tutors seemed useless to me. Before the second term was over, I decided to give up visual arts for music. One good thing that came out of this brief time back at Hornsey was a connection with other students—through them, I visited the Lathams one Saturday night at their house in West London. From that point, I began a conversation with John and Barbara Latham (now better known as Barbara Steveni) that slowly developed into an ongoing association with the Artist Placement Group (APG). The APG was formed as a charitable trust in 1966 by the Lathams, along with a few other artists including Barry Flanagan and Stuart Brisley. The idea was to create a formal mechanism through which artists could have a more central and active role in social, political, and commercial institutions—they would be paid, like any other worker, to practice as artists (or incidental persons, as John Latham put it) within such institutions, and their responses to whatever they encountered would, in theory, generate new ways of thinking about some aspect of the functioning of the company, the community, the government department, or whatever it was. In many ways this is an approach that has been assimilated into current strategies such as creative partnerships and knowledge transfer—for example, *Transplant* (2008) by sound artist John Wynne and photographer Tim Wainwright within the transplant unit of the Royal Brompton and Harefield Hospital—but in the 1960s and 1970s, APG was seen as impractical, hare-brained, politically reactionary or politically subversive (depending on your politics), and downright lunatic.

Eventually, Barbara Steveni secured me a half-placement (i.e., funded very minimally from sources other than the London Zoo but willingly hosted within its education facility, the Centre for Life Studies) at London Zoo. This was a very productive environment in which to explore issues of interspecies communication and the anthropology of un–self-conscious humans in close proximity to the dazzling, albeit caged, otherness of nature.

My first small, privately printed book, *Decomposition as Music Process*, published in 1972 by Paul Burwell's Mirliton Publications and Bob Cobbing's Writers Forum Press, was typed on John Latham's typewriter, so it is strange to see its visual similarity to those letters that I have kept from our small correspondence. My doubtless naïve questioning of a language I was ill-equipped to understand was answered by Latham's patient tutoring. In a personal letter from 1974, he noted, for example, that "the Spectrum notion has not come through yet . . ." and so elucidated with a diagram. I have used this spectrum model ever since—a horizontal line of thirty-six bands representing the shortest possible bases to the potential life of stellar systems—and find it particularly useful when people are stuck on what they would like to define as absolute differences between noise, sound, music, speech, and silence.

Occasionally, we discussed sound, which seemed to fascinate him. For example, he imagined Big Breather—his ambitious bellows construction from 1972—rather poetically as a huge reed instrument that would sound out like a bagpipe: "However, if we could persuade enough Scots to have it made at sea, properly, I am sure it would be possible to have the sound heard from

Bell Rock over some fifty miles of coastline that is about twelve miles away" (Latham, 1975:21). "I'd like to have an instrument made," he wrote in the same letter, "that's little more than an amp which gives you the (touch) structure of a piece, like the membrane of a loudspeaker. It does of course give great precedence to the percussive event, and this is of some interest in so far as on time-base theory each instant is percussive right down to space and extendedness as either space, or time (itself)."

By 1989, APG had transmuted into a new organization, O+I, led by Barbara Steveni (now known by her family name). The Tate acquired the APG archives, and from younger artists there was growing interest in APG history, perhaps because it seemed as if the group's methodology might be useful in contemporary conditions in which art struggled between the pressures, seductions and illusions of the marketplace and the institutional weight of museums. Meeting John Latham again, at an O+I meeting in the summer of 2004, I felt the compulsion to record an interview exploring his theories. Maybe I just wanted to preserve his voice, because when I hear a person's voice I feel I can enter into a part of them that I know deeply, that I remember without having to remember. I recorded our conversation in what he called the Mind section of Flat-Time House, the place where he lived and worked until his death. This house is now the location of the John Latham archive. He imagined the house as a living sculpture, a kind of living organism, so gave the rooms names like Face, Mind, Brain, Hand, and Body Event, the latter being the site of all human necessities, eating, sleeping and what he called plumbing. At the time of this interview, he was preparing a new exhibition for the Lisson Gallery, and he showed me new sculptural works made from thick glass and books. We discussed the condition of transparency and evanescence common to both glass and sound. Later, after listening to my MiniDisc recording of our conversation in the Mind section of Flat-Time House, I suggested creating a collaborative installation derived entirely from his speech, vocal sounds, pauses, breathing, moments when he banged the table for emphasis, room sound, and ambient sounds from the street. The resulting piece, *The Body Event*, was exhibited as a part of *God Is Great and Belief Systems as Such*, at Lisson New Space from January to March 2005 and subsequently at Flat-Time House in 2009.

After recording the conversation with Latham in October 2004, I had been struck by the prominence of unintentional vocal sounds in his speech. Visibly frail at that point, he had been suffering from throat problems. During a discussion in which he elaborated his theory of event structure, he talked about the place on a time base spectrum of what he described as "the body event," the human being in its various manifestations within the unimaginable time base of the universe, its physical presence in the moment as a seemingly coherent body bounded by skin, its history in DNA and the actions of many other beings over evolutionary time, and its future as a carrier of code and the traces of its archive. As he spoke, his words were interrupted, augmented perhaps, by long pauses and tiny clicks. Age interceded. The act of speaking required great effort even though the desire to do so was very strong, and these tiny clicks seemed to act as a symbol of human capacity to function simultaneously at varying, yet closely connected, points on this spectrum. They also served as a reminder that the body is the primary improvising instrument (Plate 1).

The Body Event, as I named the piece, was created by exporting the Latham interview into two computers, a PC and a Mac, then editing the spoken "text" into workable and relevant sections. These were then processed using a variety of software programs: Logic Pro, DSP-Quattro, Max/MSP granular patch, Ableton Live, and one or two other applications. By this method, it was possible to reduce the voice down to a "least event," a minimal sample of audibility, or to expand a

similarly brief least event through multiple repetitions to a continuous (by implication infinite) sound. The hierarchy of meaning could be reconfigured by giving equal prominence to paralinguistic sounds, environmental sounds, individual words, or particles of words, and Latham's verbal articulation of complete ideas, memes perhaps, such as spray gun, least event, or the body event. He had spoken about least event as a prerequisite for understanding key statements of extreme minimalism in twentieth-century art, such as John Cage's *4' 33"* (1952), Robert Rauschenberg's white canvases (1951), or Latham's own expositions of least event, his spray paintings, or Noit, one-second drawings, that dated from the mid-1950s. There seemed to me to be some connection between the spray gun and its instant mark, and the new possibilities for precise editing, granulation, and microsounds available through computer audio software.

Because the piece was originally designed for a three-point loudspeaker setup, in which the sources of sound would be made as difficult as possible to see or locate, I divided the piece into many cells, then split these into three main groups, so that the voice and its traces would appear to be extruded through the entirety of the gallery, in the same way that John extruded books through glass. In 2009 *The Body Event* was installed for a period in Flat-Time House. In effect, a palimpsest emerged, as sounds from a specific place were introduced back into that environment as a memory or revenant. After John Latham's death, his family converted the house into an exhibition space and research center devoted to his archive. It was as if the architecture was inhabited by his memory, like sound itself, almost a ghost. I modified and reworked the piece so that it could move through the organs and extensions of "the body" as a percussive event, without recourse to the circumscribed form typical of musical performance and composition, and in this formless form it felt as though a body was flexing, haunting, extending and interjecting within a space which it once knew.

Another way to think about *The Body Event* is to consider it as a portrait in which the lines and marks that shape the subject constantly shift and fade. As sound, it can only be a tangential example of the genre, of course, but still a reasonably comfortable fit within portraiture after Cezanne, Seurat, Italian Futurists such as Giacomo Balla, Marcel Duchamp's early painting, and particularly Picasso. These artists were searching for ways in which to break up the dominance of the single viewpoint, a single space, the solidity of objects, or the static moment. The commonsense idea that the world was made up of solid, stable objects all moving forward within temporal unity was challenged by simultaneity, atomization, multiple viewpoints, and a drive toward abstraction. What I find surprising about Picasso's oeuvre is the frequency with which he returned to stringed instruments as subjects, so many guitars, mandolins, and violins, even just in the beautifully compact spaces of the Picasso Museum in Paris. Picasso is said to have disliked most music, so why so many instruments? Perhaps it was a question of space. One of the most economical ways of representing a contained space is to paint a guitar, itself like a small hidden room with entry points that allow sound to escape and project from the space within which the sound circulates and grows resonant and rich in overtones. The guitar or violin becomes, in a sense, a machine through which this interior space can be turned inside out and can exist in many simultaneous versions of itself. This is indeed what happens when music takes place. The spectators watch an instrument and its activation, as if the instrument itself were the music, and yet the music is moving through and out of the instrument—an irruption, a cutting and filling, a dispersal, and an absence—joining itself to each individual listener and fusing them, along with all of the musicians, into the conglomerate that we term an audience.

Picasso was profoundly engaged with the representation of space, yet these works more closely correspond to our experience of lived time. How can the spatial illusion of a painting convey a contemporary experience of an event in space? The essential difference comes from listening to the works rather than simply looking at them. What we hear is evidence from a fragmentary, incomplete and fugitive history of listening; to use contemporary parlance, these paintings are exemplary incidents in the evolution of sound art, though they have never been acknowledged as such and perhaps never will be.

In 2004, when I recorded the interview with Latham, I had been struggling with music's limitation as a medium that can only communicate by articulating time. The eternal stillness and silence of a jar, evoked by T. S. Eliot in *The Four Quartets* and by Virginia Woolf in *Between the Acts*, seems only possible in music through devices such as static form, drones, and repetition. Again, Latham provided me with food for thought. As John Walker wrote in his monograph, *John Latham: The Incidental Person—His Art and Ideas*:

> A key characteristic of spray-gun painting was the fact that it was a direct result of the process of production employed . . . A painting or sculpture was the consequence of a temporal making process but it was also, in Latham's view, *atemporal* in that its whole display was available to be apprehended by the viewer and remained omnipresent while the image was being examined. Hence, Latham reasoned, a defacto atemporality could be expressed via visual but non-figurative paintings because they "deactivate passing time and motion", whereas this was not possible in language because speaking or reading a linear sequence of words "necessarily activates passing time". He concluded that the newly defined, double character of visual art—exemplifying temporal/atemporal—gave it a unique advantage over language and literature when describing "the whole as an indivisible event", an event that is both spirit and matter, mind and body. (Walker, 1995:24)

John Latham's theories and artworks focus on problems in the ways we think and speak and in the ways we understand and articulate our relation to the world through which we pass. Certainly, a sense of wholeness for the body event is not possible if we think solely in terms of object relations, because so much of the polyphonic body event, including the voice, is evanescent, immaterial, transient, and frankly mysterious. This has returned me again and again to my 1970s fascination with representations of the extra-human, in which specialist technologies and techniques were invented in order to sound out a model of the body (and world) that encompasses all these intangible qualities, properties, and intimations. As a post-Freudian, drawn to the sacred without being in any way religious or mystical, I made that interpretation. John Latham's ideas have remained a constant referent for me. Although I would not claim to understand everything he said or wrote, my initial, instinctive response to his artwork has been a silently resonating pitch of lifetime duration that maintains my will to continue with what I do. As for this sound piece, *The Body Event*, it exists, when it exists, as a sound event that cannot be reduced to written history but through which a history can be sensed and divined in aurality. I think of it as the bones, traces, and lingering thoughts of a man oscillating within an extended space as if expanding and contracting in all dimensions. In this sense, it aspires to be both oral and aural history of an artist, his ideas, their context and my relationship to all these elements, susceptible to analysis through verbal exegesis but at the same time an event through which listening affords an intimate connection to the sensations of a voice heard in time.

REFERENCES

Birdwhistell, R. L. (1973), *Kinesics and Context: Essays on Body-Motion Communication*, Middlesex: Penguin University Books.

Burroughs, W. (1966), *Nova Express*, London: Jonathan Cape.

Douglas, M. (1966), *Purity and Danger*, London: Routledge & Kegan Paul.

Latham, J. (1975), "A Personal Letter," *Musics*, no. 5, December 1975/January 1976: 21.

Walker, J. A. (1995), *John Latham: The Incidental Person—His Art and Ideas*, London: Middlesex University Press.

2.

DE MUDDER TONGUE
ORAL HISTORY WORK AS
AN ARTS PRACTICE
michael mcmillan

language is a point of reference
its what I use when I write
like my forebears wisdom
like my skin the night
that covers my overstanding
and help me not miss
the how/ why / the wherefore
of speaking like this. . . . (French, 1983)

What the late poet Lynford French alludes to in the opening extract, from his poem "Over Understanding" (1983), is that he cannot escape the cultural politics of language in his practice as a writer. Born in Britain of Caribbean migrant heritage like myself, his point of reference was not simply writing Caribbean creole, sometimes referred to as patois, but the struggle between creole and English in a postcolonial migrant context. That struggle for many second-generation migrant descendants born, growing up, or educated in Britain was about the suppression, oppression, and resistance to our linguistic backgrounds and oral cultures, which had an impact on the shaping and negotiating of our identities. Caribbean creoles, as syncretic fusion of the English lexicon with an African grammar, have been seen as bastardized forms of pidgin and uncivilized languages of the Other. Speaking it ran the risk of either being rebuked at home for using bad English, misunderstood, and therefore ignored or, in school, being seen as an act of resistance. Although the

Bajan (Barbados) poet and historian Edward Braithwaite (1984) has reaffirmed Caribbean creoles as "Nation Languages," its psychic inferiorization, as Frantz Fanon (1993:37) argues, provides a political understanding of racial hegemonies at the level of black subjectivity. This reflects my own oral history and is therefore relevant in considering how oral history work has become, or generated, my arts practice.

In my early plays, writing creole-based dialogue was an act of political resistance that echoed the Trinidadian playwright Mustapha Matura (McMillan, 2000) and meant listening to its sounds, idioms, and cadence, much less trying to speak it authentically. In my early oral history work with first generation Caribbean migrants, they did not share my romantic notion of keeping alive the creole they spoke and sometimes opted to use the Queen's English in a "speaky-spokey" style. The linguistic tension between creole and English outlined here throws up wider questions about what the oral history interview means for the interviewer and the interviewee as a performative event and about how language is ascribed and used. It also raises questions from an ethical perspective about the role of the interviewer, who, like myself, has gone on to edit oral history material as transcribed text or audio pieces. Therefore, in sharing some extracts from my oral history work in the development of interdisciplinary practice as a writer, a playwright, and a mixed-media installation artist, I provide a discursive context to illuminate how that material was used in my creative process.

Both my parents came from Saint Vincent and the Grenadines (SVG) in the Caribbean and grew up hearing folktales about the spirits (called "Jumbies" in the Eastern Caribbean and "duppies" in Jamaica) of the deceased, who refused to pass over into the next world, were invoked by those will evil intentions or acted as guardians for the living. One such story was about when my dad (see Figure 5) once walked home at night from Kingstown, the capital of SVG. He was buoyed by the prospect of leaving the island and so had no fear of the dark, until a white dog appeared to be following him. When he reached home, his mother saw the animal, and believing it to be my paternal grandfather, she thanked it for guarding her son. These folktales, as part of an oral tradition, are rarely written down, which is one of the reasons I became a writer, so that I could document stories that form part of my oral culture.

I have used transcribed texts throughout my practice: *Brother to Brother* (McMillan, 1996) and *The Black Boy Pub & Other Stories* (McMillan, 1997), which used recordings of oral history interviews with first-generation Caribbean migrants. This publication was the culmination of a year-long writers' residency in High Wycombe, where I was born and where many Caribbean migrants, particularly from SVG had settled. The following extracts were based on interviews with my parents and were transcribed with attention paid to their way of speaking English in a creolized style. It should be noted that my dad often referred to Guyana as BG (British Guyana), even though it was made independent in 1966:

> I went to BG in 1953. First, I was cutting cane, which I never do home an' it was hard work. I den went into de interior an' I met ah fella from St.Vincent an' he introduced me to diving. I took it up fe six years. There was de prospect of getting rich from diving for diamonds and it was de quickest money. If yuh had ah diamond shout, it was big money. We didn't meet ah big diamond shout though.
>
> De first time I dived, three of us went to ah place called Apicca—there were three diving pumps in de pool, ah Brazilian, ah Guyanese an our pump. I saw dey pulled up ah man from de Brazilian pump—he was dead. His suit was leaking. I went down on one

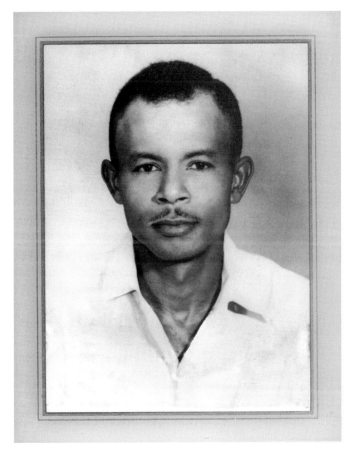

5. Dad—Godrick "Edd" McMillan. (Image courtesy of Michael McMillan.)

rope, in complete darkness an' I kept going down—I couldn't reach de bottom so I gave dem four signals which meant danger, so dey pulled me up immediately. Dey asked me what's wrong, I said dat I couldn't reach de bottom—they laughed. Dey said I had to go down again sixty feet. I went down again an' met de gravel an' started to work. Yuh could do half ah day down there sometimes, wid air coming from above. I was very fit doing it. (McMillan, 1997)

My mum (see Figure 6) would argue that if Dad had found diamonds of any worth, then she and the family would be well off by now. In the following extract, my mum talks about travelling to England and about how she met my dad, followed by his version of their courtship:

Mum

I went to Curacao fe work . . . I did servant work an spent five years dey an' went back to St. Vincent in 1959. After ah few months I came to England . . . de ship went to Genoa in Italy an' we took ah train across Europe an' took ah ferry to England. We came to Victoria Station, where my brother met me. I then started looking for work and my first job was

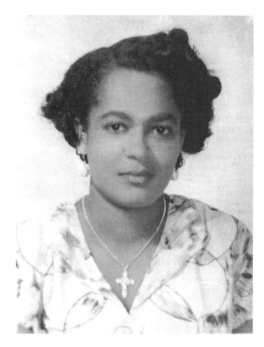

6. Mum—Escalita "Letha" McMillan. (Image courtesy of Michael McMillan.)

cleaning and tidying up in a shirt factory. My brother took me to High Wycombe on Sunday to ah cousin of mine Alston Nedd, who owned de first pub in Wycombe—"The Bird in the Hand." Wen I went to de train station—yuh father was following his cousin an' we met—after de next week Saturday he came down to London looking for me at St. Anne's Rd. . . (McMillan, 1997)

Dad

I wanted to find out more bout her—she was living at ah Polish or ah Jewish lady an' sharing ah room wid ah cousin—when I went an' knocked de door—dey said she wasn't in—she'd gone to do shopping—ah half hour later I went back an' dey said she hadn't been back yet—I went back an' hour later an' dey said de same ting—when she reach home de landlady gave her notice to leave wid in ah week cause she didn't like her tenants having male visitors . . . (McMillan, 1997)

Gregory Ulmer argues that "memory stores information in 'emotional sets', gathering ideas into categories classified not in terms of logical properties but common feelings, feelings that are based in eccentric, subjective, idiosyncratic physiognomic perceptions" (1994:142). From this understanding of memory processes, it is evident that reminiscence with first-generation Caribbean migrants can provide a therapeutic means of catharsis in remembering events such as the moment of arrival. Yet, these interviewees sometimes censor their stories, because those narratives can still trigger painful memories. Although these migrant narratives have been documented in several celebratory reminiscence and heritage-orientated projects such as Moving Here developed by the National Archives (2005–7), they tend not to feature as core narratives in British social and cultural history. These representations also tend to oversentimentalize this generation's negotiating how knowledge

production, in an intergenerational context, has been intrinsic to the shaping of emergent black British identities (McMillan, 2009a).

Kwesi Owusu uses the term *orature* to describe the practice of narration in the oral tradition: messages or testimony that are verbally transmitted in speech and song, such as folktales, sayings, songs, ballads or chants, forms of literature and other knowledge that are transmitted across generations (1986:127–50). In self-reflexive terms, what Karin Knorr Cetina calls an "unfolding ontology" (2001:182), resonates with my realization that my familial orature is inscribed within the maturing of my arts practice (McMillan, 2010). That maturity has enabled me to embrace Hal Foster's phrase of "the artist as ethnographer" (1996:302), where ethnographic research has drawn me to the material culture of the everyday (de Certeau, 1988) and sacred practices of the domestic interior and public domain within the African diaspora such as *Van HuisUit* (McMillan, 2007). The approach is illuminated in an interview with the anthropologist and writer James Clifford, who uses a phrase coined by the writer William Carlos Williams—"the universal [approached] through the particular"—in which the particular, as Clifford sees it, should involve "look[ing] at common sense, everyday practices—with extended, critical and self-critical attention, with a curiosity about particularity and a willingness to be decentred in acts of translation" (quoted in Coles, 2000:55–56).

The emergence of mixed-media installation in my practice came after a paradigmatic shift from playwriting, writing for performance, and live art toward an interdisciplinary mode that included all of these and more. The multimedia exhibition that contextualized *The West Indian Front Room* installation at the Geffrye Museum (McMillan, 2005–6), included several large archival photographic prints, vintage 700 series telephones playing edited oral history excerpts, and two short films, *Recollections* and *Commentaries* (Karamath, as cited in McMillan, 2005–6). What seemed to resonate with interviewees was that the topic of the questions took place in their front room/living rooms, the site of their aesthetic styles and domestic practices. This seemed to appeal to members from a local Methodist Women's Group and the resulting audio material was replayed as part of a public art installation in Buena Vista, Curaçao, *A Living Room Surrounded by Salt* (McMillan, 2008a) (Plate 2). By contrast, in creating text for the publication *The Front Room: Migrant Aesthetics in the Home* (McMillan, 2009b), I transcribed interviews from the BBC4 documentary version titled *Tales from the Front Room* (Percival, 2007), again being faithful to individual styles of speech:

Stuart Hall

> From the moment I arrived in England during the early 1950s I was aware of how important the source of heat in your domestic space really was. When I went to college I lived in two rooms: a small room where I studied and my bedroom. My bedroom had no heating at all and I remember waking up in bed, seeing my breath and frost on the inside of the window. I thought this is impossible and went into the next room and tried and get as near to this tiny two bar electric heater without burning up.

Angie Le Mar

> If you moved the blow glassfish you'd get into trouble and sometimes it would knock as you passed it and you'd freeze because you knew that if it ever fell down and broke onto the glass coffee table that we would have to leave home or we would be put into care. It was simple as that and we would accept it. My mum would be very disappointed if you

messed up her front room. She had hundreds of ornaments if you moved one she would notice which one it was. Very deep!

Norma Walker

My front room was something to hold onto and I spent so much time making sure it was clean and looking nice, but I let that go because my life has now changed. I don't take much interest in my front room anymore and I would rather go into my bedroom because the children have grown up and the family have gone away. Why should I want to sit in there and be lonely?

THE BEAUTY SHOP

Thematically, another exploration of intersubjectivitity of the black body was featured in my installation *The Beauty Shop* (McMillan, 2008b) (Plate 3), in which I shared how experiences of my hair, skin, complexion, and body image changed as I grew up, in interviews with black men and women. Objects and related material along with the interviews (with a black barber, hairdressers, and a group of black women) were placed within six white plinths. Visitors could listen to extracts while looking at themselves in a full-length mirror. These audio excerpts contextualized the beauty shop installation with shelves of branded cosmetics for skin and hair as well as accessories for the beautification, maintenance, transformation, and adornment of the black body. At the end was a confessional booth where visitors could record their responses to and reflections on the exhibition:

I was aware of lighter and darker skinned girls because my mum said that I was going to marry the girl next door who had long Indian hair and clear skin. (Anonymous, male)

If you were a light skinned black guy you were more accepted and everybody wanted to go out with you and if you were mixed-race then you hit the jackpot. (Anonymous, male)

My father was black and I grew up in Cheltenham with my white mother and she would cut my hair with wallpaper scissors and it was only when I came to London that I began to learn how to take care of my hair and skin. (Anonymous, female)

As you in England and you go back home people say how you so black and you abroad. So people try to change their complexion. But the cream I use to lighten my skin does burn me sometimes. (Anonymous, female)

My experience of my hair was so painful growing up that when I shaved my head it was the most liberating thing I did in my life. (Anonymous, female)

I was forced to wear a girdle at primary school because my parents felt that my bottom was too big and I was too sexualised because of that. It was only in my thirties that I was able to get over those negative feelings that affected me and be the woman I wanted to be. (Anonymous, female)

In an ontological sense, the duality revealed in this project echoed Erving Goffman's *The Presentation of Self in Everyday Life* (1959), which for people of African descent can be translated as good grooming. The performance of good grooming does not reveal all there is to know about black subjectivity, but it does reveal the mythic nature of black popular culture, as a theater of popular desires (McMillan, 2009b).

THE WAITING ROOM

As an arts practitioner, I have worked in different institutions using an ethical approach developed through my oral history work (McMillan and Lowe, 1992). As an outsider, for me this often means negotiating institutional practices, procedures, and ideologies of, for instance, a hospital. As part of an Arts in Health and Wellbeing residency in North Wales (McMillan, 2010–11), I met patients, carers, and staff on the Alaw Ward (Cancer and Palliative Care Unit) in YsbytyGwynedd (YG) and the Rheumatology Clinics at YG and YsbytyLlandudno. Initially, I knew that I wanted to use an oral history approach, though I was not sure how it would be done until it became apparent that cancer patients often spent hours receiving treatment on the Alaw Ward Day Unit and that, without a carer with them to talk to, they welcomed any form of conversation. As Susan Sontag argued in her seminal book *Illness as Metaphor* (1978), the fear of cancer can sometimes be worse than the disease itself. Therefore, in talking with patients, I did not want to focus on their illness, unless they wanted to, but rather on their personal background and experiences. While listening to stories about growing up, family life, courtships, marriage, and working lives as diverse as aluminum smelters, welders, printers, teachers, nurses, shipwrights, diplomats, scientists, merchant sailors, roofers, farmers, and musicians, among many others, I was always conscious that I did not speak Welsh. I could, therefore, understand the cultural and political dynamics between Welsh and English because it was similar to my experience of Creole.

I wanted to audio record these rich personal stories, not in the hospital environment but in the interviewees' homes where they would be in control and their individual identities and personalities could be honored. Travelling via public transport across North Wales to carry out the subsequently arranged home visit interviews, with the Snowdonia mountain range usually in the background, was challenging but rewarding. As part of my questioning, I asked interviewees to share a story about a cherished object in their living room. The following quotes provide captions to photographs of these objects in a photo album and correspond with a series of anonymous, edited interviews that can be listened via a CD player contained within a mobile antique wooden sewing box. *The Waiting Room* (McMillan, 2010–11) has been installed within the actual waiting rooms of the different wards in which I had undertaken my residency:

> This is my first granddaughter at a certain age. It was a traumatic time for her and her mother, my daughter, because the father was a drug addict. My granddaughter is much older now and her father wasted all those years when she was growing up. And what makes me angry now, because I haven't got much time left myself, is people wasting their time, because there is so much they could contribute for themselves and to the world. (Anonymous, female)

My father was awarded the clock courageous services and it has a plaque on it. He was a second engineer on a ferry, The Hibernia, which used to travel the Irish Sea. There was a massive fire in the engine room and though I don't know exactly what he did it must have been heroic, they called him "Red a' Dare" after that. (Anonymous, female)

I painted this picture of a seagull to represent my nana who passed away two years ago. She used to always say that she wanted to be a seagull when she passed away and that I would know it was her, because she would poo on my head. (Anonymous, female)

I spotted this painting on the street in Moscow when my husband was teaching there. I love the composition and the red colour used in it. But I also like it because it is of a group of four women wearing Russian peasant costumes sitting and gossiping. And you can almost guess that they're mocking the men outside, which means for me that this scene could be anywhere in the world. In Russia, I found that women were so strong, many being single parents and often doing jobs that men would do. It's a very uplifting picture for me, because it's about women sticking together. (Anonymous, female)

LAST WORDS

During the residency, my dad, followed by my mum, died from heart related diseases within the space of nine months. At one point, I was spending much of my time professionally and personally in hospital environments, and I felt it was either a mistake to take on the residency or it was an opportunity to explore my bereavement creatively. During my travels in North Wales, I was able to meditate on my relationships with my mum and dad. My dad's stories gave me the gift of writing and telling, and my mum, the ability to listen.

In my work, my aim has been not so much how to achieve objectivity according to orthodox oral history practices, but rather to contest this notion. As with quantum theory, the observer affects and is affected by the object of study. It is this paradigmatic sense of oral history interviews as variably contingent that resonates with the disorderly, fragmented, nonlinear, multi-registered nature of the creative process that I have used to produce the various theater and performance pieces, installations, and publications. My other objective has been to empower the individual as a subject to identify, value, and celebrate his or her own everyday cultural practices and material. Achieving this required gaining trust, being sensitive to unexpected circumstances, being democratic by offering choice, and being transparent about my intentions. It has been my role in this process, as I see it, to generate the creation of artwork that communicates the subjects' story in their own words and style.

REFERENCES AND FURTHER READINGS

Braithwaite, K. E. (1994), *The History of the Voice*, London: New Beacon.
Clifford, J. (1997), *Routes: Travel and Translation in the Late Twentieth Century*, Cambridge, MA: Harvard University Press.
Coles, A. (2000), "An Ethnographer in the Field: James Clifford Interview," in A. Coles (ed.), *Site-Specificity: The Ethnographic Turn*, London: Black Dog Publishing.

de Certeau, M. (1988), *The Practice of Everyday Life*, tr. Steven Randall, Berkeley: University of California Press.

Fanon, F. (1993), "On National Culture," in P. Williams and L. Williams (eds.), *Colonial Discourse and Post-Colonial Theory: A Reader,* London: Harvester Wheatsheaf.

Foster, H. (1996), *The Return of the Real*, Cambridge, MA: MIT Press.

French, L. (1983), "Over Understanding," in *Her/Story So Far,* London: Black Ink.

Goffman, E. (1959), *The Presentation of Self in Everyday Life*, New York: Anchor Books.

Karamath, J. (2005–6), "Recollections & Commentaries," in M. McMillan, *The West Indian Front Room: Memories and Impressions of Black British Homes*, London: Geffrye Museum.

Knorr Cetina, K. (2001), "Objectual Practice," in K. Knorr Cetina, T. R. Schatzki, and E. von Savigny (eds.), *The Practice Turn in Contemporary Theory*, London and New York: Routledge.

McMillan, M. (1996), *Brother to Brother* (play), London: YaaAsantewaa Arts Centre & UK Tour, published in C. Robson (ed.), *Black and Asian Plays Anthology*, London: Aurora Metro Press, 2000.

McMillan, M. (1997), *The Black Boy Pub & Other Stories: The Black Experience in High Wycombe*, High Wycombe: Wycombe District Council.

McMillan, M. (2000), "Ter speak in yermudder tongue: An interview with playwright Mustapha Matura," in K. Owusu (ed.), *Black British Culture & Society: A Text Reader*, London: Routledge.

McMillan, M. (2005–6), *The West Indian Front Room: Memories and Impressions of Black British Homes*, London: Geffrye Museum.

McMillan, M. (2007), *Van HuisUit: The Living Room of Migration The Netherlands*, Amsterdam: Imagine IC.

McMillan, M. (2008a), *A Living Room Surrounded by Salt*, Curaçao: Instituto Buena Bista IBB/ The Center for Contemporary Curacao Art.

McMillan, M. (2008b), *The Beauty Shop*, London: 198 Contemporary Arts & Learning.

McMillan, M. (2009a), "The West Indian Front Room: Reflections on a Diasporic Phenomenon," *Small Axe: A Caribbean Journal of Criticism* 13/1: 133–56.

McMillan, M. (2009b), *The Front Room: Migrant Aesthetics in the Home*, London: Black Dog Publishing.

McMillan, M. (2010), "Expert-Intuitive Operations in the Creative Decision-Making of 'The Front Room' Installations/Exhibitions: A Portfolio," Arts Doctorate Dissertation, Middlesex University, London.

McMillan, M. (2010–11), *The Waiting Room* (art installation), North Wales: Arts in Health & Wellbeing Artist in Residence, BetsiCadwaladr University Health Board.

McMillan, M. and Lowe, N. (1992), *Living Proof: Views of a World Living with HIV and AIDS*, Sunderland: Artists Agency.

MovingHere (2005–7), "Moving Here: 200 Years of Migration in England," London: National Archives, <www.movinghere.org.uk>, accessed January 23, 2006.

Owusu, K. (1986), *The Struggle for Black Arts in Britain*, London: Comedia.

Percival, Z. (director/producer) (2007), *Tales from the Front Room*, London: BBC4.

Sontag, S. (1978), *Illness as Metaphor*, New York: Farrar, Straus & Giroux.

Ulmer, G. (1994), *Heuretics: The Logic of Invention*, New York: Routledge.

3.

PRIVATE VOICES AND PUBLIC PLACES
USING ORAL HISTORIES IN SITE-SPECIFIC TEXT-BASED ART
bettina furnée and ian horton

INTRODUCTION

This chapter examines the use of oral history in text-based site-specific public art practice. It highlights some of the features these two practices share and examines the tensions that arise when visual or material artworks use oral history records, not merely as a research tool but also as a key component in the final outcome. By giving visual form and context to oral history, visual art practice can aim to (re)position the personal experience of history as central to the reading of received history. The way in which such works may be produced is critically examined in this chapter with direct reference to two projects, *Witness* and *Prisoner of War*, by the artist Bettina Furnée. By analyzing these works, it is in the first instance argued that, in making the oral histories concrete, the artwork can reconnect these accounts firmly to their place of origin. In the second instance, it is proposed that, in grouping fragments of oral histories, an artwork may establish a vital link to a discourse. In addition, although the focus of this chapter is on text-based visual art, it is suggested that the themes and concepts explored may be relevant in the analysis of other kinds of practice, such as sound-based and socially engaged forms of art, that use oral histories in their creation.

Oral histories, in aiming to record and archive people's accounts of past events, must reference time and place. They are a record in the present time and place of events that move fluidly across

both time and place through the act of recounting. Both issues of the *Oral History* journal published in 1998 examined this relationship in detail. The editorial from the issue titled "Landscapes of Memory" noted that

> Memories of place are deeply rooted in human imagination and identity . . . The articles (in this issue) focus on the relationships between memory and place, the ways in which physical and social landscapes are remembered and told, and the significance of place memories in individual lives and for collective identity. ("Editorial," 1998:2)

In this chapter, it is argued that the features outlined above are also evident in site-specific art practices that similarly reference the history of place while being firmly located in the present moment of creation and/or reception. This relationship is examined in reference to Miwon Kwon's ideas concerning shifts in site-specific art practice from the 1960s to the present (Kwon, 1997, 2002).

Oral histories can most directly be presented in an art context aurally. If they are to take physical or material form then the issue of editing becomes central to the practice unless a printed transcript is presented in full. The (re)mediation of oral histories in the artwork is examined in relation to Rosalind Krauss's notion of the indexical and linked to the idea that the textual fragment substitutes for the archive itself (Krauss, 1976a,b).

WITNESS

The first of the two works discussed in this chapter is *Witness*, a permanent text-based artwork by Bettina Furnée, installed in 1998 in Bilston, West Midlands (Plate 4). The way in which Furnée used existing oral history recordings to give content to the work will then be analysed in reference to Miwon Kwon's ideas concerning site-specific art.

The artist initially trained as a letter cutter and art historian and has been involved in many text-based public art commissions across the United Kingdom. The commission for *Witness* came relatively early in her career and is seen by the artist herself as a pivotal project. The work was commissioned by Wolverhampton Metropolitan Borough Council via the Public Art Commissions Agency (PACA), based in Birmingham, and funding was provided through European inner-city regeneration schemes and a "Percent for Art" policy. The brief was to provide a decorative cladding for the north parapet of the bridge on Church Street, crossing over a new light railway track.

Furnée was shown the mid-nineteenth-century cast-iron memorial slabs in the churchyard adjacent to the site—a legacy of the local metal working industry. She was also given access to a collection of audiotapes with recorded interviews, conducted by Helen Sykes in 1994 for Bilston Art Gallery. The interviewees were elderly inhabitants of Bilston who were invited to share their memories of the recent history of the town. The steel mills and factories came to a halt in the 1980s, with the general decline of the manufacturing industry. It signalled the end of an era for Bilston, as

> Bilston Steelworks was
> The heart of the area
> The furnaces there
> Made anything

From anything.
When the steelworks closed
Probably two and a half thousand jobs went
Open the doors!
The blast furnace blow out
The melting shop.

These words are represented on one of a sequence of fourteen text panels that together constitute *Witness*. The texts were composed by Furnée from verbatim extracts of the spoken memories of Arthur Bullock (steelworker), Josephine Beecher (midwife), Lila Langford (worked at Sankeys and in pubs), Jim Speakman (chemical worker), Eileen Morgan (shop worker), and Irene Everitt (worked in shops and lock factory). Each panel combines several voices around a subject. The sequence of the panels takes the reader from recollections of women's conditions of work in Bilston such as these:

Lots of children in the street
Lots of women working
Carried the fruit
In great boxes
Made armatures
For the war
You got a rise on your birthday
We had no teabreaks at all

via social life represented on the central panels

You could have mild
And you could have bitter
Even if it was
Pitchblack with fog
Town used to be packed
Full every night
There were so many
On either side of the road

to the final panels with recollections of work at the steelworks predominantly done by men, such as the description of one particularly grueling work-related accident:

I saw it
Come out of the box
I was folded backwards
Shiny black
And crushed
From the ribs down
My eyes had come out
Like two big organ stops
The furnace
That crippled me.

The work is executed in cast iron, in reference to the area's industry, and the contribution of local participants is acknowledged on a plaque. On some panels, the letters are executed in bold san-serif capitals to act as slogans, but on others, the letters are shaped as dense patterns requiring some deciphering. The oral history excerpts have been taken from their original spoken context and repositioned with the aim of strengthening the content by combining the voices on one subject. However, the work is firmly embedded in its locality through the choice of material and the local ownership of the narratives.

Miwon Kwon in "One Place after Another: Notes on Site Specificity" sums up the artistic movements which helped shaped a cultural climate in the late twentieth century, which could foster (publicly funded) site-specific projects like these.

> The (neo-avant-garde) aspiration to exceed the limitations of the traditional media, like painting and sculpture, as well as their institutional setting; the epistemological challenge to relocate meaning from within the art object to the contingencies of its context; the radical restructuring of the subject from an old Cartesian model to a phenomenological one of lived bodily experience; all these imperatives came together in art's new attachment to the actuality of the site. (Kwon, 1997:86)

In other words, antimodernist artists' desire to take art out of the gallery and into the world in their belief that the artwork can no longer be considered as autonomous, combined with the emancipation of all sorts of subjects and a reliance on new academic disciplines (such as sociology and psychology) and research methods (such as ethnography and oral history), tied art in the second half of the twentieth century firmly to its locality. So much so, that Richard Serra famously contended in 1984 that the removal of his controversial *Tilted Arc*, a large barrier of metal slicing through a public square, was to destroy the work, arguing that the work did not exist without its context (Kwon, 1997:86).

Witness, albeit in a more subtle way, also asserts a close connection to its site, through a heavy materiality and permanence and the site-specific content. The work is an index of the voices of its people and cannot exist elsewhere as it needs the bodily experience of the viewer to complete the work. This fits closely with Nick Kaye's (2000) alternative perspective on site-specific art, which is concerned with the performative aspects of such practices and the idea of an active viewer. In *Witness*, the performative dimension is evident in the presentation of the text on street level, making repeated reference to so-called shifter words, such as *I*, *you*, and *we*. The viewer actively constructs the narrative when reading the fragmented oral histories across the different panels.

PRISONER OF WAR

Prisoner of War is another site-specific and text-based work by Furnée, created as a temporary installation seven years after *Witness*. Although the same methodology is evident with respect to the use of oral history, *Prisoner of War* has a different relationship to its site in more than one way. When commenting on more contemporary notions of site specificity, Kwon stated that

> The distinguishing characteristic of today's site-specific art is the way in which the artwork's relationship to the actuality of a location (is) . . . subordinate to a discursively

determined site that is delineated as a field of knowledge, intellectual exchange or cultural debate. Furthermore, unlike previous models, the site is not defined as a precondition. Rather, it is generated by the work, often as "content" and then verified by its convergence with an existing discursive formation. (Kwon, 1997:90)

Prisoner of War was conceived as part of Furnée's self-initiated project *If Ever You're in the Area* (Furnée, 2005) The project consisted of a series of interventions in the coastal landscape of East Anglia, which related to contemporary fears of invasion, such as immigration and the legacy of war. Quite apart from *Prisoner of War* being a temporary installation, its site is indeed no longer a strictly physical one, but rather is a set of conditions, and requires the critical, not only physical, presence of the viewer. Coinciding with the sixtieth anniversary of the end of the Second World War, the work converges with an existing discursive formation and the relationship to its site is altogether more fluid than previous notions of site-specificity discussed in this chapter.

The aforementioned project, *If Ever You're in the Area,* was funded through Grants for the Arts by the Arts Council and was held at two art venues and coastal locations during 2005–6. The complex project included a webcast, temporary interventions, performance, and time-based works. For instance, the project included a work titled *Lines of Defence* that followed the progress of an art installation of thirty-eight flags positioned on fast-eroding cliffs on the Suffolk coast. A camera positioned in a Martello tower sent an updated image every fifteen minutes to the website for the duration of the project. During the course of 2005, the complete art installation and seventeen meters of land disappeared, extending the notion of fear of invasion into the realm of climate change. The project website brought together the different elements of the project, linking individual works that operate according to different artistic discourses, and it now constitutes the final archive, and site, of the works.

Prisoner of War, then, was one of five interventions by Furnée in Bawdsey, near Felixstowe on the Suffolk coast (Figure 7). It is the site of First and Second World War military installations, a series of Napoleonic Martello towers, and Bawdsey Manor, where radar was developed. A coastal footpath leads two miles north to Shingle Street, which was rumored to be the site of a failed German invasion attempt of 1940. Further north is Orford Ness, another site of radar experimentation, and to the south is Landguard Fort, built to protect the busy sea route to Felixstowe and Harwich. This historically heavily defended coast is now subject to coastal erosion.

Prisoner of War was installed in the old wartime Battery Observation Post at East Lane in Bawdsey (Plate 5). The texts were strung in letter beads across the window spaces on all three levels of this partially derelict building. Three texts were stenciled directly onto the concrete walls using iron oxide, thereby temporarily embedding the words into their place of origin. Two of these stenciled texts referenced the history of the area rather than specific memories, and acted to place the individual voices within wider discourses.

The texts were based on the recorded memories of older inhabitants of Bawdsey, recalling the big events they had witnessed: the Second World War, the very severe winter of 1947, and the floods of 1953. The majority of participants were interviewed by Furnée as small groups of friends in Bawdsey Village Hall, with plenty of tea and biscuits on hand, to allow the conversation to flow with minimal intervention from the interviewer. Some interviews were conducted individually, both in the Village Hall and in people's homes, to take account of the mobility and hearing difficulties experienced by some participants. At the time of the interviews, the oldest contributor was

7. *Prisoner of War.* Bettina Furnée with Simon Frazer, Battery Observation Post, East Lane, Bawdsey, Suffolk, 2005. (Image courtesy of Douglas Atfield.)

in their early nineties and the youngest in their late forties, passing down family stories of the war rather than their own experiences. The participants were brought together by Liz Marks, who acted as Furnée's intermediary, and the names of participants were credited on a small pink plaque at the site: Norman Simper, Elizabeth Maskell, Eric Dunn, Mike Weavers, George Mark, Vic Clouting, Hazel Crane, Margaret King, Wendy Tolliday, Roy and Jean Ford, Pam Backhouse, John Garnham, and Jack Baker.

The majority of the texts were strung in the window openings to frame the landscape that was the cradle of these histories, thereby constructing an important visual and material link (Figure 8). The choice of materials served to emphasize this conjunction of text and image. The square white ceramic beads were threaded on wires and painted with black letters, giving the work an intimate and somewhat nostalgic feel. The sans-serif typeface was reminiscent of the utilitarian typefaces used during the Second World War.

The interviews were edited and thematically constructed in collaboration with Suffolk writer Simon Frazer. The smaller and stenciled texts were written by Frazer in response to the audio recordings but the larger letter-bead compositions were a collage of excerpts of recorded conversations, brought together to create a full impression of events and the location. Some of the interviewees had served during the war in the Battery Observation Post, which was, incidentally, for sale as a second home at the time of the project. This text was displayed in a window with a view over the marshes in the direction of Bawdsey:

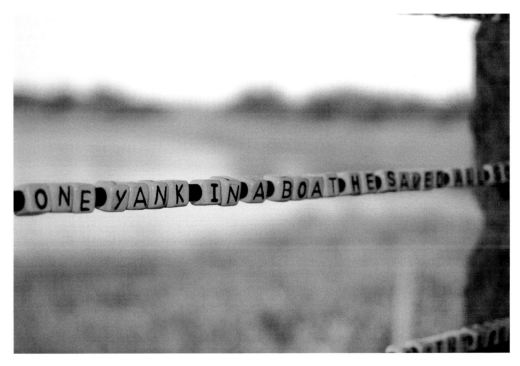

8. *Prisoner of War,* detail of installation of texts. Bettina Furnée with Simon Frazer, Battery Observation Post, East Lane, Bawdsey, Suffolk, 2005. (Image courtesy of Douglas Atfield).

> A PLANE CAME DOWN AT A CORNER OF WHAT'S CALLED WOODCOCK
> WOOD THAT BURST INTO FLAMES THE PILOT WAS A NEW ZEALANDER
> THEY SHOVED US BACK BECAUSE
> THE BULLETS WERE ALL FLYING OUT OF THE PLANE A GERMAN BOMBER
> CRASHED ON
> THE MARSHES THERE WAS A TERRIBLE SMELL OF BURNT BODIES FOR
> A LONG WHILE AFTER THAT THEY BURIED THEM UP AT THE CHURCH
> YARD IN THE FAR CORNER

and the following text was located in a window looking out to Bawdsey Manor and the North Sea beyond:

> DRONE A CONSTANT DRONE THEY USED TO HAVE A SIREN DOWN AT
> THE MANOR
> THAT USED TO GO WE HAD AN ANTI-AIRCRAFT BATTERY ALMOST IN
> OUR BACK
> GARDEN THEY'D SHAKE YOU OUT OF BED AT NIGHT I CAN REMEMBER IN
> THE
> COTTAGE STANDING IN THE KITCHEN AND THE SHRAPNEL BANGING ON
> THE ROOF
> THE PUT-PUT OF THE DOODLEBUGS KEEP GOING YOU'D THINK KEEP
> GOING

The reader here is placed in a similar position as were the wartime inhabitants of Bawdsey, looking out to sea or in the direction of Bawdsey Manor to discern any threat. Therefore, the site-specific and material aspects of the work add layers of meaning and make the viewer or reader aware of alternative histories not present in the oral histories themselves.

TRANSCRIPTION AND THE INDEXICAL

In contrast to the analysis above it could be argued that the texts presented in *Witness* and *Prisoner of War* create fragmented, incomplete or even potentially false histories of place because the full transcriptions of the interviews are notably absent. The process used to generate the final texts for *Witness* and *Prisoner of War* was intuitive and not strictly analytical. In this respect, these works have something in common with Al Johnson's *Land of Laundries*, which used oral history interviews to generate works combining visual texts with sound installations. Johnson described her position thus:

> As I am an artist and not a sociologist or anthropologist I make no claims to being fair or even-handed about the ways in which I found the interviewees, or made the selections from the resulting recordings. I edited together what I liked the most and what seemed the most interesting. I aimed for a variety of voice sounds, and accents, and mixed the larger group recordings with that of individuals, and pairs talking together. I included lots of laughter, and some of my own responses, and divided the recordings into "chapters," each preceded with the recorded sounds of running water, soaping and scrubbing. (Johnson, 1998:84)

Witness and *Prisoner of War* share a similar intention to create an evocative, even poetic, presentation of place using oral histories as a starting point. Krista Woodley (2004) in her essay "Let the Data Sing: Representing Discourse in Poetic Form" notes that she used poetic form as an analytical tool for exploring oral history recordings. Although she does not consider her own work as an artistic practice, her overview of some debates surrounding transcription is relevant to the issues raised in this chapter.

In "Perils of the Transcript," Raphael Samuel argued for a transcription that would not distort the words of a recording, with a focus on "the collecting and safe preservation of . . . [an oral historian's] material, rather than in the use he can immediately find for it" (1998:392). In *A Shared Authority*, Michael Frisch acknowledges how important it is "to preserve and accurately transcribe the actual full interview," but when creating a documentary for a public audience, "the integrity of the transcript is best protected, in documentary use, by an aggressive editorial approach that does not shrink from substantial manipulation of the text . . . one must also be able to abandon the pretence of literal reproduction, in order to craft the document into a form that will answer to the needs of successful presentation and communication" (2004:51).

In contrasting Samuel's and Frisch's approaches to transcription, Woodley highlights the importance of editing and communication for all kinds of art practices that use oral history as a generative device. Although this chapter has focused exclusively on texts presented as visual art, the issue of editing could equally apply to the work of audio or sound artists such as Cathy Lane, Alison Marchant, Nye Parry, and David Toop, all of whom have featured oral histories in their installations. So far, it has been suggested that the site-specific and material aspects of the artworks examined allow them to overcome the limitations evident in using textual fragments from the original oral histories. It is interesting to consider how these ideas might also relate to artworks using sound fragments

taken from oral histories and presented in the context of site-specific installation. The relationship between these different kinds of art practice can be explored by introducing Rosalind Krauss's notion of the indexical, which she used to explain emerging artistic trends of the early 1970s:

> As distinct from symbols, indexes establish their meaning along the axis of a physical relationship to their referents. They are the marks or traces of a particular cause, and that cause is the thing to which they refer, the object they signify. Into the category of the index, we would place physical traces (like footprints), medical symptoms, or the actual referents of the shifters. Cast shadows could also serve as the indexical signs of objects. (Krauss, 1976a:198).

Oral history texts concerning place, when presented in a site-specific context, can be considered as indexical signs in Krauss's terms. Whether presented visually or aurally, the text is not the cause itself, in this case the original utterance about place, but only a trace. Even when the trace is experienced in its place of origin, the memories, or the histories to which it refers are remote and absent to the present viewer. To overcome this distance these textual fragments often use the so-called shifters of *I, you, we,* and *they* (words used in everyday speech) as referents to engage the audience, which then is invited to become actively involved in the interpretation of place and its history. However, as much as these site-specific and text-based works might engage the audience, visual or aural fragments, by their very nature, signal both their own incompleteness and the stories of place left untold.

REFERENCES

"Editorial" (1998), *Oral History* 28/2: 2.
Frisch, M. (1990), *A Shared Authority*, Albany: SUNY Press.
Furnée, B. (2005), If Ever You're in the Area, <www.ifever.org.uk>, accessed November 10, 2012.
Johnson, A. (1998), "Land of Laundries: An Oral History Installation," *Oral History* 26/2: 82–85.
Kaye, N. (2000), *Site-specific Art: Performance, Place, and Documentation*, London: Routledge.
Krauss, R. (1976a), "Notes on the Index, Part 1," in R. Krauss (1986), *The Originality of the Avant-Garde and Other Modernist Myths*, Cambridge, MA: MIT Press.
Krauss, R. (1976b), "Notes on the Index, Part 2," in R. Krauss (1986), *The Originality of the Avant-Garde and Other Modernist Myths*, Cambridge, MA: MIT Press.
Kwon, M. (1997), "One Place after Another: Notes on Site Specificity," *October*, no. 80: 85–96.
Kwon, M. (2002), *One Place after Another: Site-specific Art and Locational Identity*, Cambridge, MA: MIT Press.
Samuel, R. (1998), "Perils of the Transcript," in R. Perks and A. Thomson (eds.), *The Oral History Reader*, London: Routledge.
Woodley, K. (2004), "Let the Data Sing: Representing Discourse in Poetic Form," *Oral History* 32/1: 49–58.

4.

CHRONICLE FROM THE FIELD
alexandra handal

The first oral history fieldwork that I undertook left me with a number of conceptual, formal, methodological, and ethical questions to consider. It led to the inception of a dramatic shift in my art practice. Engaging with lived history opened for me an entirely new creative and intellectual space. In this chapter, I reflect on the ways in which the participatory and interactive aspects of this fieldwork have paved the way for me to explore new narrative possibilities at the intersection of fine art, cinema, new media, design, and experimental literature. I discuss the making of *Dream Homes property consultants* (2007–2010)[1] (Plate 6), a new media documentary, or web-based artwork, that draws on oral tradition and oral history as the impetus for exploring silenced voices of conflict, while pursuing ways of expanding the documentary genre. I began my fieldwork by documenting the interviews as audio recordings and through note taking. However at a later stage, I incorporated filming and participatory drawing. This method of conducting oral history research prompted an intricate transmission of knowledge spread across a variety of media. It generated the sort of material that I would eventually use in my art practice to renarrate the stories that were passed on to me. My multifaceted approach to fieldwork created the premises for developing this hybrid form of storytelling, which is evident in *Dream Homes*, a work that consists of mental maps, private archive pictures, documentary photos, short films, animations, illustrations, sound, and mixed-genre text.

Dream Homes (Handal, 2010) does not function as a real-life estate agency. However, it is not fictitious either, requiring the ambiguous space of being neither to define itself. Its purpose is to investigate the architecture of lived experience by focusing on the memories and firsthand accounts of Palestinian exiles forced from their homes in areas that became known as West Jerusalem since 1948. The personal spaces where memories dwell are the basis of this real but imagined estate agency. It is the most extensive piece to have emerged from my ongoing fieldwork, which began in 2006 and to date has involved twenty-four Palestinians. Twenty-two participants are first-generation refugees from West Jerusalem who reside today in East Jerusalem and Bethlehem, with the exception of one in Arkansas. Two participants are the children of West Jerusalem exiles; one currently lives in London and the other in East Jerusalem.

I met most of the participants through people we knew in common. Some contacted me after they heard about my research, and the rest emerged from chance encounters. The refugees from West Jerusalem were predominately middle-class Palestinians, although some were from the upper-class and therefore did not end up in camps. Yet regardless of class, each one had to completely rebuild their life anew. The list of participants included in *Dream Homes* so far indicates not only whom I was able to meet but also who accepted or was capable of participating. Old age, illness, and the desire to remain anonymous because of fear are some of the reasons that individuals could not participate. On two occasions, though, I was able to work with people who wanted to remain anonymous as I found a way to include their stories without revealing their identity.

Some meetings happened in public venues like coffeehouses or restaurants, however in the main, they took place at people's present-day homes over coffee, dessert, lunch, or dinner. I met every participant on a number of occasions, and most often, our conversations lasted several hours. For instance, my meetings with Abla Dajani, who is a refugee from the western neighborhood of Lower Ba'qa, took place at her current residence in East Jerusalem, each occasion lasting between seven and eight hours. Sometimes we would be engaged in lengthy conversations while she was knitting. The television sound would be turned on low as the evening news, music videos, or a Turkish soap opera dubbed in Arabic provided ambient light to the softly lit living room. She always made sure to pause in our conversation to bring me a plate of homemade food.

There was no standard interview setup, but rather by our spending time engaged in unstructured conversations, small recollections that the participants thought a researcher would not care to know were brought to the surface. By identifying these moments in the midst of conversations, I was able to give the participant an example of the kinds of details that I wished to know and that would set the tone for future meetings. Rather than drafting a fixed set of questions, I found that through chance-based interviewing, I too was discovering what it was I could find out. For instance, Marie Jannineh, a refugee from 'Ayn Kerem, on our third meeting told me about her beloved dog Bobby, who had been lost in exile. Personal memories such as these enabled me to depict this vanishing world in a more intimate, personalized way.

Although I relied on chance, I had nevertheless carefully delineated the parameters of the conversations to the house each interviewee had lived in before their exile. As it became clear to me how I was going to use the material in my art practice, the conversations became even more specific. This approach uncovered other kinds of unanticipated components that then shaped the making of *Dream Homes*. One of these happened during my first meeting with Issa Giacaman, who was exiled from Jerusalem in 1948. In 1911, his father, Saleh Giacaman, like other affluent Bethlehemites, had two houses built in Jerusalem, one for his son Issa and the other for his son Ya'coub (Giacaman, 2007). However, in 1948, Israel confiscated both of these West Musrara properties. (I refer to the part of the divided neighborhood that was emptied of its indigenous Palestinian population as West Musrara.) Today, Issa Giacaman can no longer access the nearby city of Jerusalem without a permit required by the Israeli government. Unable to accompany me to West Musrara, Issa Giacaman drew a mental map of the neighborhood as he remembered it. This document conveyed a more complex story about these properties, for it served as a visual testament not only of the Giacamans' dispossession, but also brought to light the other four families who had been renting their properties and had become refugees in 1948.

The mental map served as a guide to locate the houses so I could photograph them. The drawing indicated that the Giacamans' expropriated properties are located next to the Salesian School,

which is a religious landmark in the neighborhood, making it easier to find. How these mental maps would complement the story of another participant was informative. Issa Soudah, a refugee from the same neighborhood who resides today in the Old City of Jerusalem, took me on a walking tour of West Musrara. When we passed by the Giacamans' properties, he had fond memories about both houses, for he remembered going to play there as a boy. He later showed me some surviving photographs that were taken during Palm Sunday in the garden of one of the houses (Soudah, 2008, 2009). I was slowly building the material that I would use to tell each interviewee's story of displacement, even if at that stage I was not aware of how I was going to use it.

As a result, mental maps (see Figure 9) became an instrumental feature of my research with a multifaceted purpose. I found that drawing these maps helped trigger the memory of most participants. In the act of drawing, some of them would tell stories as the tip of their pencil moved, linking personal memories to certain places they were in the process of recollecting. In addition, memory maps had a functional purpose. They assisted me in identifying seven houses featured in *Dream Homes*, as well as where certain businesses were once situated, like the Jasmine Hotel in Talbiya (Theodorie and Theodorie, 2007). Sometimes, the map was not sufficient to help me identify

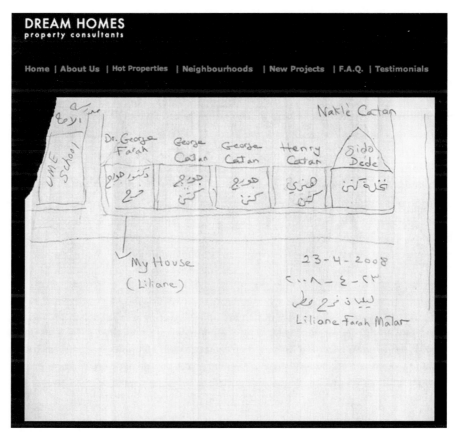

9. Alexandra Handal, *Dream Homes property consultants*, "Arab-style house, real old-world charm," Directional Map, new media. (Image by Alexandra Handal).

a house as in the case of the home of another interviewee, Omar Qunnais (2007), a refugee from 'Ayn Kerem. Although close to the existing landmark of St John the Baptist Church, the fact that it was tucked away on a dead-end street made it difficult to find. It took combining where it was in relation to the church, with looking for a small carving of two lions, unique to the house, to know that I had reached Dar Qunnais (which literally means "home of the Qunnais family").

The element of virtual encounters also added a whole new dynamic to the research. I was introduced to Raouf Halaby via e-mail through a Palestinian friend of mine, who happens to be his cousin. He is a refugee from Upper Ba'qa who currently resides in Arkaphelia, Arkansas, where he teaches English and Art at Ouachita Baptist University. Being a virtual participant involved a different type of engagement, for it required corresponding through technological means. Most of my participants are elderly people, and the only way of communicating with them was in person. Younger participants like Raouf, who have memory of life before 1948, are rare. Raouf answered my e-mails attentively, surprising me with surviving photos that he had scanned of family members, as well as sending me the original mental maps he drew of his neighborhood and house as he remembers it. By the time I began corresponding with Raouf, I was already aware that my fieldwork was going to take the form of a property consultancy, which was helpful in directing questions through email correspondence. Raouf e-mailed me the instructions of how to get to his house, and because he had visited Jerusalem after 1967, he had the new Israeli street names (Halaby, 2007). However, I discovered that this area of Upper Ba'qa was undergoing renovation for its Jewish settlers, and as a result, the Palestinian Arab city of Jerusalem was (and is) disappearing. What I witnessed in the neighborhood, including my discovery that Raouf's family's home had been demolished, led me to choose a film letter as the form to recount the story of his house and his exile.

Simultaneous to my fieldwork, I was investigating how expropriated Palestinian houses were being imagined in Israeli real estate agents' websites. In 1950, the State of Israel passed the Absentee Property Law, which ensured through legal construct the confiscation of Palestinian property (Cattan, 1988:72–74). That same year, Israel passed the Law of Return (1950), which grants a Jew from anywhere in the world who desires to settle in Israel the right to do so (Khanin, 2005:183); this is also known as doing *aliyah*. Today the growing clientele base of "Arab-style"[2] houses in West Jerusalem are Jews from the United States, England, and France who are looking to purchase a second home to spend Jewish religious holidays in Jerusalem, or as a part of doing *aliyah* (ascent). Israeli real estate agencies depict these expropriated Palestinian properties in such a way that the word *Arab* in "Arab-style" has no agency, but is reduced to scenery. As Dr. Meir Margalit (2006), founder of the Israeli Committee Against House Demolitions, states,

> Immediately after the '48 war, when the remaining Arab neighborhoods in the West city were emptied of their original inhabitants, the municipality populated them with new [Jewish] immigrants and tried to erase their memory with Hebrew names. Thus Musrara became "Morashah," Katamon became "Gonen," Baka became Guelim," Talbiya became "Komemiut," and so on . . .
>
> Today, very few [Jewish] Jerusalemites know what is concealed behind these names and most believe these neighborhoods have been Jewish since the days of King David. It is true that the buildings there are known as "Arab houses" but the brainwashing has reached the point where an "Arab house" is identified with an architectural style and not with a concrete place and its Arab past.

Features created by the indigenous Palestinian population such as the "mature trees," "original tiled floors," and "high ceilings" are appropriated by Israeli real estate agencies in order to provide their Jewish clientele with an "old," "authentic" scenery in which to imagine their "return" to Jerusalem. I wanted to disrupt this Zionist spectacle of power (Debord, 1994) by creating *Dream Homes property consultants*, an "agency" that discloses the stories of displacement, dispossession, and cultural cleansing of Palestinians that are camouflaged by the post-1948 Zionist architectural terminology: "Arab-style." Each section of the website menu makes way for a different entry into its scenarios, which are divided into the following eight parts: About Us, Hot Properties, Neighbourhoods, New Projects, F.A.Q., Testimonials, Terms & Conditions, and Contact Us. Resorting to black humor, *Dream Homes* describes itself as

> [a] leading agency in "Arab-style" houses, specialising in properties that were built from the late Ottoman period to the British Mandate of Palestine . . . Our agents, natives of Jerusalem and surrounding cities like Bethlehem are dispersed throughout the world since 1948, providing over six decades of experience in dealing with questions of home and property from various destinations. (Handal, 2010)

The About Us section plays with the irony of the word "Arab-style." The term, which belongs to the Israeli Jewish lexicon, contextualizes the Palestinian refugee stories in their absurd political reality.

The Hot Properties (see Figure 10) section consists of current listings of seventeen homes. The story of each house unfolds in four parts. First, there is a text that briefly explains when the house was built, the description drawing on an interviewee's memory. Each house is referred to by a title that reflects the house in some way. In the case of Ya'coub Rock's family home, it is "A Lock-up-and-go Arab-style house, spectacular view." The following is an excerpt:

> The house is known in the village for the extraordinary story that happened to Maria, known as Umm Manawel. She was pregnant with her last child Pascal when she was hanging the laundry on the wooden balcony of the house. The balcony was not very solid, as a result it gave way under her feet and collapsed. She was hanging in mid-air for short while, yet she succeeded in holding tightly to the iron hand rail. Umm Manawel could not hold her heavy weight and she fell to the ground. Clinging to the iron rail eased her landing on a pile of stones, which were supposed to be used to build the tomb of Sido Emmanuel, but finally were left abandoned for years in the garden. (Handal, 2010)

I punctuate the official narrative tone of a historical real estate agency with small stories that reflect the house in question, bringing to the light the Palestinian refugee memory of the place. This is followed with instructions on how to reach the property using a Palestinian sense of direction, which is visual and makes use of landmarks and the social fabric of a neighborhood. This is how to reach Dar Theodorie:

> Head to Talbiya. Opposite the Capuchin Monastery is Dar Theodorie. It is the two-storey house located in the corner. At the entrance of the house, to your right is an impressive apricot tree and to the left is a beautiful garden with a great variety of flowers—this should help you to understand if you have reached the correct address. You cannot miss the climbing roses, which form a huge bush. The rose petals are unforgettable . . . To the right of Dar Theodorie is Dr. Kalebian's house. Behind Dar Theodorie is As'ad Khadder's house. Across the street to the left of Khadder's house is the Hallak's house. Opposite of

10. Alexandra Handal, *Dream Homes property consultants*, Hot Properties, new media. (Image courtesy of Alexandra Handal).

Khadder's house and across the street is the Jasmine [Hotel], which got its name from the owner's daughter, Yasmeen Canaan . . . You can always go ask at the hostel for directions should you get lost, it is reputed for its hospitality. (Handal, 2010)

By giving directions using the present tense, I map the world that has been eradicated for all the Theodories, the Kalebians, the Khadders, and the Hallaks who were made refugees in 1948; none of what I describe remains, except the actual structure of the house.

How these places are remembered is evoked in the line drawings made by Palestinian refugees. However, the viewer of *Dream Homes* is not yet aware that all they have seen or read thus far has been destroyed. This is only revealed at a later moment in an amalgamation of forms from short films to animated photographs and other audio-visual combinations. These either are placed as a continuation of the featured house or can be seen in the Neighbourhood section, where a link takes the viewer to the particular house where the story continues in another medium. In the case of Abla Dajani, it is the short film of her surviving album and love of taking photographs that is at the heart of the story of her exile.

The Testimonial section features firsthand accounts of Palestinian refugees who went to see their home for the first time after the 1967 Six Day War, merging collaged images taken from Israeli real estate agencies with excerpts of oral testimonies as both text and audio. One such testimony in the

Open House section is by Liliane Farah Catan, a refugee from Upper Ba'qa who recollects, "He took us of course to house in '68, I remember very well, January '68 . . . we went to the house and they didn't allow us in. A girl was eating an apple, and he told her: 'I want to show my daughter our house.' She did not accept to let us in . . ." (Handal, 2010). Other Open House "events" sometimes do not contain oral history testimony, but instead contain a notice such as postponed, cancelled, or delayed. The F.A.Q. section opens the property consultancy to others experts on West Jerusalem, aside from refugees. The viewing chronology, however, is subjective as one can enter and navigate the site at different points, creating one's own experience of *Dream Homes*.

As the principal agent and narrator of *Dream Homes*, I needed to enter into the roles of detective, archaeologist, traveler, historian, cartographer, and urban drifter, as a way to engender and collect bits and pieces of material that would otherwise be eradicated or forgotten. For instance, when I could not feature a home with images because it had been demolished, I turned to the language of cyberspace, using (http) response status codes, such as "no longer available," in order to tell the story. Phrases such as "moved permanently," "not found," "temporary redirect," and "forbidden," which all evoke the experience of navigating online, became a means to describe my search on the ground. My persistent challenge was how to deal in an aesthetic way with the various forms of destruction. In the case of commercial spaces, like hotels, barbershops, grocers, and shoemakers, I created imaginary banners (see Figure 11) throughout the website. These animated advertisements are informed by the way in which these places were conveyed to me through oral testimony. The fact that they no longer exist only becomes evident after clicking to inquire more about the service offered. It is at that point a notice appears, stating "We regret to inform you that we have been closed since 1948. Please visit us at a later date, as possibility of re-opening is pending" (Handal, 2010). The repetition of such notifications depicts the monumentality of loss.

My experimental, chance-based approach to fieldwork could not have been possible without the necessary mutual respect that this type of interaction demands. Some participants came to see me as a member of their family. I provided every interviewee with a detailed description of my fieldwork in Arabic and English, stating how I was going to use the material. Furthermore, I went to great lengths to inform each participant about what would happen to his or her stories not only in written form, but also by showing them the web documentary in progress. Every participant signed a written consent form with the exception of two people who wished to remain anonymous. In those instances, I obtained an oral consent. In almost all cases, a member of the participant's family, like a son or a daughter, was aware of his or her parent's involvement in my project as family members had come to know me in the initial phase of the research. Given the tight-knit family culture of Palestinians, this proved to weigh more, in terms of addressing ethical concerns, than the written consent form. Participants seemed to have felt that I overextended myself drafting an information sheet that outlined my fieldwork. However, after I explained the reason for the forms, they appreciated its implications. Working between the United Kingdom and Palestine, I opted to formulate an ethical code that considered the transcultural context in which I was working.

In her book *Women, Native, Other*, a poetic reflection on storytelling and its relationship to history, Trinh T. Minh-ha states, "The story depends upon every one of us to come into being. It needs us all, needs our remembering, understanding, and creating what we have heard together to keep coming into being" (1989:119); the collective spirit of storytelling is one that informed my thinking. To create *Dream Homes*, I fused facets of both oral tradition and oral history, focusing on the creative storytelling aspect of the former and the desire to address suppressed histories through

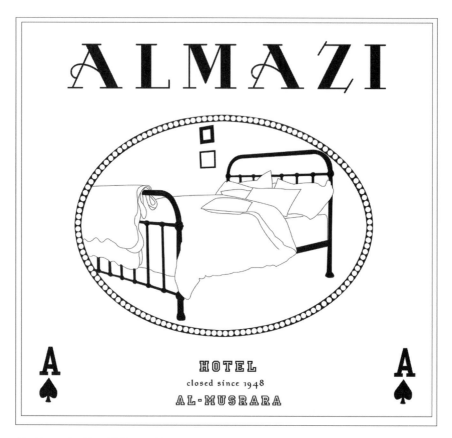

11. Alexandra Handal, *Dream Homes property consultants*, Almazi Hotel banner, new media. (Image courtesy of Alexandra Handal).

meticulous research of the latter. As my role shifted from listener to storyteller, my greatest challenge as an artist/filmmaker became how to translate the stories that were told to me into other narrative forms (image, sound, and text) that would reflect the dynamic, intersubjectivity of fieldwork. I view that moment when listening becomes storytelling as a creative act that possesses social agency on an individual as well as a collective level. After determining ways of retrieving through oral history what remains of this vanishing world, I consulted my own memory and imagination in order to retell the stories transmitted to me. As an artist and filmmaker, I was able to explore the role of the listener as instigator, interpreter, and transmitter of historical knowledge. *Dream Homes property consultants,* however, transmits another kind of knowledge about home, one that takes oral history as material to retrace the footsteps of displacement so as to recover through art what has been destroyed and lost.

NOTES

1. Since completing my PhD, I have continued to undertake the remaining fieldwork for *Dream Homes.* That aspect is urgent as the participants are elderly and the political situation is unpredictable. Therefore, *Dream Homes* will be published in Spring 2013 at http://www.dreamhomespropertyconsultants.com.

2. See Handal (2010), Chapter 2, "The Zionist Spectacle in Cyberspace" (pp. 95–130), which examines the misleading term "Arab-style."

REFERENCES

Cattan, H. (1988), *The Palestine Question*, London: Croom Helm.

Debord, G. (1994), *The Society of the Spectacle,* tr. D. Nicholson-Smith, New York: Zone.

Handal, A. (2010), "Uncovering the Hidden Palestinian City of Jerusalem: Disrupting Power through Art Intervention," PhD dissertation (unpublished), University of the Arts London.

Khanin, Z. (2005), "The Vision of Return: reflections on mass immigration to Israel from the former Soviet Union," in A. M. Lesch and I. S. Lustick (eds.), *Exile & Return: Predicaments of Palestinians & Jews*, Philadelphia: University of Pennsylvania Press.

Margalit, M. (2006), "On Urban Policy for East Jerusalem: If the Signpost Could Talk," *Alternative Information Center* 22/11, <http://www.alternativenews.org/content/view/750/70/>, accessed March 2009.

Minh-ha, T. T. (1989), *Woman, Native, Other*, Bloomington: Indiana University Press.

Interviews

Giacaman, I. (2007), conversation with the author, Bethlehem, August 18 and September 19.

Halaby, R. (2007), e-mail correspondence with the author, September 28.

Qunnais, O. (2007), conversations with the author, Bethlehem, September 19, 21, 30.

Soudah, I. (2008), conversation with the author, East and West Jerusalem, April 15.

Soudah, I. (2009), conversation with the author, Old City, March 6.

Theodorie, T. and Theodorie, N. (2007), conversation with the author, Bethlehem, September 17, 28.

5.

HISTORY IN THE MAKING
THE USE OF TALK IN
INTERDISCIPLINARY COLLABORATIVE
CRAFT PRACTICE
david gates

INTRODUCTION

My research is about what craftspeople say, what they use language for, and what it does in their practice. I come to this as a furniture maker, and therefore, some of what I do in this research is fed by what I do, what I know, learn or observe as a maker and by being *in* the constituency I am studying. This research uses an ethnomethodological perspective to achieve an understanding of crafts practice based on what craftspeople say in professional settings. Craft is usually encountered or mediated through objects; in the craft literature works are accorded status or relevance as markers of material culture or as relevant within art history. Craft is less often presented as a process. When process is discussed in the literature, I argue that what actually is in the foreground are matters of technique and skill. Conventional accounts of the working lives of craftspeople are presented as (auto) biography, relying for their telling on recall and testament of past events, usually to an interviewer. This research seeks to break with these paradigms and present a case for the *lived-experience, the being* and *doing of making.* In doing so, this chapter challenges oral history accounts of past actions in order to reveal the role and significance of talk *in the now* in sites of contemporary crafts practice.

The data used for this study come from extended sessions of talk-in-interaction among a small group of contemporary crafts practitioners from different disciplines who have been working on a project together and are discussing the experience so far.

SILENCE AND TACIT KNOWLEDGE

The default working condition for many contemporary craft practitioners is of working alone with materials and tools, hours spent in relative isolation. Not a condition that is unique to the crafts as a type of work by any means, but nonetheless, I would argue, formative in the construction of craft and its discourses.

The notion of solitary working would appear to sit ideologically very well with the accepted position in the craft literature that its knowledge, that is how people know how to make things, is tacit. This view, found its strongest advocate in Peter Dormer who argued that craft knowledge is silent and unsayable. Tacit knowledge, he proposed, is gained locally through experience and through doing, and although it cannot be explained with words, it can be demonstrated. In his 1997 essay "The Language and Practical Philosophy of Craft" Dormer argued that

> [w]hat can only be shown cannot be written about, and to those who think there can be a theory and critical language of craft that is a warning worth heeding. If they do not then they will distort the integrity of the very subject they profess to respect. (1997:230)

More recently, the idea of tacit knowledge in the crafts has been revisited by Richard Sennett who, in making his case, reminds us that Denis Diderot made similar observations when compiling his *Encyclopaedia* in the mid-eighteenth century, remarking, "Among a thousand one will be lucky to find a dozen who are capable of explaining the tools or machinery they use, and the things they produce with any clarity" (2008:94).

WHEN MIGHT LANGUAGE BE NEEDED?

Anyone who has either taught or learned a craft knows how difficult it can be to explain actions with words. We know that to show is often the easiest way to illuminate the process. We might agree then that knowing can be divided into the binary opposition of those things that can be said, propositional knowledge, and those that cannot, or knowing *that* and knowing *how.* The crafts and craftspeople have in various ways and at different times tolerated, sometimes questioned, but more often celebrated this apparent tradition of silence. Maybe there is something avowed in a notion of silence, and we can hold the view that the work should speak for itself. Working in a silent tradition also provides the condition of not having to engage with theory. Nevertheless, no great play is made of silence when we think of other learned skills like riding a bicycle, driving, or cooking. So instead of characterizing the crafts as silent, what if we instead think of them as mute, or language-less?

Sometimes conditions exist when a need for words is not to the fore: being absorbed in the work—deep in the flow of doing. Some makers might speak quite reverentially of being in a dialogue or conversation with their materials when reflecting on their working practices. So the idea of a linguistic exchange, even as a metaphor, is not unfamiliar. For example, to refer to an "exchange" with clay or metal suggests a distinctive or arcane language known only to initiates, which privileges the idea of the individual as a conduit or mediator in any account of the experience. However, just because some skill knowledge cannot be turned into words, or the fact that someone usually works alone, does not preclude language and communicative practices from having a significant role in the doing of craft.

IS TECHNIQUE EVERYTHING?

The assumption that craft knowledge is tacit and that language has a limited role in the crafts has traction because an assumption is made that matters of technique, skill, and materials are at its core. Craftsmanship is, by most definitions predicated upon a response to, or awareness of, materials and making. As Janet Koplos states, "works never lose sight of what they're made of . . . the medium never becomes invisible. It's not just a means to make some particular point, but is always part of the point" (2002:82). Discussions of technique, skill, and materials therefore have formed, and continue to form, large parts of the crafts literature. Tanya Harrod observed, "by the 1970s . . . each craft had its own technical language and its own fast growing body of technical literature, but the common language that made sense of this multiplicity of activities was almost non-existent" (1999:409). However, as Harrod points out, language can also be a sense-making tool. Language helps us to understand, formalize, and construct the world and our selves. As educational theorist and researcher Etienne Wenger writes, "An adequate vocabulary is important because the concepts we use to make sense of the world direct both our perception and our action" (1999:8). A point elaborated by the anthropologist Allesandro Duranti is that

> [t]o have a language then means to be part of a community of people who engage in joint, common activities through the use of a largely, but never completely, shared range of communicative resources. In this sense, having a language also means being part of a tradition, sharing a history, and hence having access to a collective memory, full of stories, innuendoes, opinions, recipes, and other things that make us human. Not having a language or having only a very limited set of its resources means to be denied such access. (1997:34)

I am not about to suggest that an expert knowledge of materials and a sensibility founded on working with them is anything other than central to a craftsperson's understanding. Nevertheless, I do argue that to foreground skill and knowledge of materials does not reflect the everyday professional communicative practices, or experiences of craftspeople.

To illustrate my point about skills, if we think of a recent journey, perhaps a trip to the local grocer's shop, and make an account of it, we would probably not start with a description of the techniques of walking . . . heel down . . . straighten leg . . . shift weight forward. Instead, we would talk of the caught glimpses, overheard words, the striking juxtapositions, or the chance meetings. It's the new things that we come across that happen while doing that stick in our mind and take us forward. Accomplished, curious craftspeople operate in a similar way. It is not that material knowledge is necessarily taken for granted; being able to do something well takes many hours of work and practice. In the moment of doing, that knowledge is a way of getting somewhere else: it enables progression and is future oriented. As a parallel to our tale of going to the grocer's, I propose that this is where one might also look for accounts of crafts practice. We need to take account of the situated discourses of what practitioners say to each other when doing and/or discussing their work, articulating their conceptual, "practical" thinking. This approach challenges the dominant view of explaining craft by attending to matters of technique and skill as outlined previously. We should listen to what is happening on the inside rather than trying to explain from the outside. Makers' interactions, the small details of chance and occasion, of juxtapositions: the often unreported, situated talk of practice might reveal the ways in which talk gives shape and does

things, beyond, for instance, talking about kiln temperatures, demonstrating how language is co-constitutive in the making process.

TALKING AND MAKING-IN-INTERACTION

In holding to the idea of technique and materiality as being central to defining the crafts, we can observe a certain paradox. The finished object is usually how craft is presented and mediated, on the printed page of the literature, via the direct experience of the gallery plinth (Plate 7). The life of its making is evacuated; the object abstracted from its origins. As the anthropologist Tim Ingold writes, "we are inclined to look for the meaning of the object in the idea it expresses rather than in the current of activity to which it properly and originally belongs" (2000:347). To encounter the finished object is only one way to engage with or consider the materiality of craft practice. Given the centrality of materials, it therefore follows that processes of their transformation are equally central: craftspeople work by changing the state or form of materials. These various processes are temporally situated, partly improvisatory; they have fluidity (see Figure 12), even evanescence. Thus, considerations of contingency and ephemerality should become closer to the center of any inquiry of making and craft practices.

In making an account of the contingent and improvisatory nature of the doing of craft, we must turn to communicative practices and their uses among practitioners. To reveal Ingold's "proper current of activity" (2000:347), we should look in places other than conventional representations of doing craft. In interpreting craft as material led, matters of technique and skill have played a

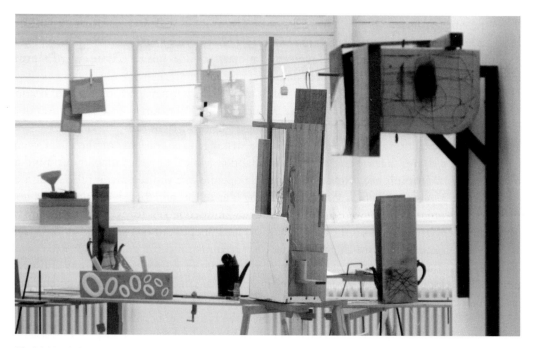

12. Making in Interaction. The work of Intelligent Trouble, 2011. (Photo: David Gates).

large part in the discourse of craft, but these are the published discourses *about* craft. The interactions of practitioners as everyday discourses *of* craft are non-canonical representations that show the communicative uses of talk in social settings. As such, they resemble Michael Bamberg's (2007) and Alexandra Georgakopoulou's (2007a,b) concept of small stories: "locat(ing) a level and even an aesthetic for the identification and analysis of narrative: the smallness of talk, where fleeting moments of narrative orientation to the world (Hymes, 1996) can easily be missed out on by an analytical lens which only looks out for fully-fledged stories" (Georgakopoulou, 2007b:146). The ways in which the crafts have been, and are, written about operate as a set of centrally located explaining devices (for an overview, see Greenhalgh, 2002:4). I suggest that the writings on craft have generated in Lyotard's (1984) terms a core of Grand Narratives, lenses through which craft is viewed and projected. Small stories break with the idea of the Grand Narrative and render more visible "a gamut of under-represented narrative activities, such as tellings of ongoing events, future or hypothetical events, shared events . . ." (Georgakopoulou, 2007b:146). This research finds natural space for Freeman's (2007:155–63) critique of small stories in that the data used often refers to the "recently happened" parts of ongoing events, allowing for reflective distance in telling. However, this reflection occurs in the likeness of small stories as underrepresented, socially enacted and as both retrospective and prospective. Here the *lived processes* of making and *talk-in-practice* bear great similarity in their fluidity and their lack of immediate concretion. Stitching, tacking, repairing, improvising: action and idea back and forward across time.

A Note on the Data and Transcriptions

The excerpts used in this chapter have been transcribed from short passages of talk. In conversation analysis, quite complex systems of notation are adopted to represent as closely as possibly how talk happens in time, including notation of pauses, breaths, and interruptions. My argument relies on the substantive content of the sampled talk rather than the micro-detail of interaction. Therefore, a much simpler system has been adopted, much like a script. Each anonymous participant is accorded a new line start; only brief interruptions from others appear as insertions these lines.

The conversations, or talk-in-interaction, as conversation analysts refer to them, come from organized occasions of talk among four craft practitioners, their peers, and their associates, talking about a recent collaboration. The project was initiated by the practitioners to explore ideas around collaborative making (see Figure 13). The most usual working practice in contemporary craft is that of a solo practitioner making discrete or bounded objects. The aim was to question this notion of authorship, trust, the idea of "finished" work and risk. The conversations took place at the gallery where the works from the project were on display. The practitioners recounted the events and aims of the project, followed by questions from the audience and a general group conversation. Although the model of a "gallery conversation" or presentation is quite normal in the working life of artists, these occasions extended to two hours and more with the aim of invoking naturalized or situated interaction. Although the session began with a presentation by the craftspeople whose work was on show, the overall setting was informal. The subsequent questions and peer conversation was unstructured with no one person chairing or directing the topics; the general direction of the session was allowed to evolve. The practitioners and others at the event are therefore jointly constructing an account, or an understanding of the project. Through their interaction, and by orienting to

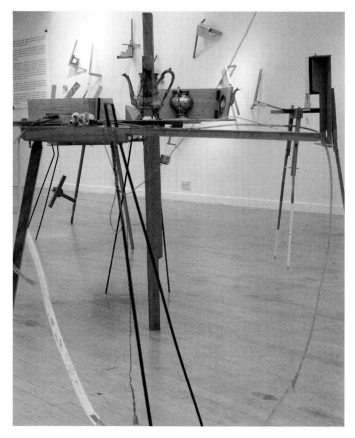

13. Making in Interaction. The work of Intelligent Trouble, 2011. (Photo: David Gates).

each other's utterances (sometimes below the level of a sentence), a representation of a socially constructed reality (the project) is in turn socially constructed. This representation explains and creates meaning that is communicable without the structure of an interview or external explanation.

Excerpt 1

John: It was really quite complex trying to understand what happened where at what kind of loop and feedback back into the process was. It was quite heartening really that although we were trying to put a kind of framework around it that it was very difficult to pin down and capture.

Eve: As is a conversation, to think back over a conversation its quite difficult to . . .

Dan: And you twist it, add your own interpretation.

In excerpt 1, John is explaining the installation phase of the exhibition, trying to think back to the sequence of the works so that this might inform how they are displayed. That this might be remembered or charted in any kind of sequential or temporally structured way is clearly problematic,

but this is thought of as "heartening," that what has been done cannot be "pinned down." Eve and Dan compare it to remembering conversations, and that when this is done, recall is subject to contemporary inflections.

The topic of how the project was managed is revisited in excerpt 2. The idea of work being required to fit into a linear structure is used by Hazel as a way of introducing her view of how "creative" people work. In "making" an essay, Hazel has been working from the "centre outwards," challenging the accepted sequential approach of how something is made and any linear way in which written accounts might be made. We might view this as having an ever-expanding horizon of growing possibilities as opposed to a goal-oriented approach with a finishing point.

Excerpt 2

Hazel: The thinking behind it you've got that diagram the other side a kind of sequential, consequential kind of route through but it doesn't always work like that but . . .

John: it didn't work like that at all, we set that up as a kind of an opening gambit but . . .

Hazel: . . . that it seems we expect this arboreal kind of logical tree-like logical way of thinking, whereas I think lots of creative people think more rhyzomically, so it's sort of centre-outwards and I know in writing that I've been doing recently, the kind of essays I've been writing them from the middle outwards struggling with how that contradicts the seeming order of how you write an essay. And I was thinking that in terms of practice, because it helped with my writing and I decided that I was making essays once I was making essays it was far more understandable to me as a process.

My argument that craftspeople use what they know to move forward echoes how conversation analysts view the role of talk-in-interaction in social settings. Its ethnomethodological basis stresses the role of interaction in the ongoing reformulation of social reality at a local level. As Deborah Schiffrin writes, "[p]articipants continually engage in interpretive activity—and thus reach understandings—as a way of seeking order and normalcy during the course of their everyday conduct . . . Social action thus not only displays knowledge, it is also critical to the creation of knowledge" (1994:223). John Heritage makes the claim that "communicative action is doubly-contextual in being both *context-shaped* and *context-renewing*" (quoted in Schiffrin, 1994:235). We build on and refer to what is available, implying subject positions of being simultaneously retrospective and prospective.

Excerpt 3

Haley: As makers or as a maker it is making that enables you to think and so it's obvious that that that's the thing that gives me the (**Dan** yeah) freedom to flow so you have to do it to be able to think, it's that basic, (**Dan** yeah) and sometimes you forget that when you're doing other stuff especially when lots of us are caught up in other things like writing or (**Eve** teaching) teaching and talking so it's quite interesting how . . .

Eve: other types of thinking though . . .

Haley: . . . yeah, other types of . . .

Dan:	yeah
Eve:	. . . other types of thinking and other types of doing
Dan:	doing, yeah
Haley:	yeah, and they are yes . . .
Eve:	I do think of writing actually as a practice as well
Haley:	. . . well, yeah, and I see my, the way (**Dan** yeah) yeah . . . I mean when I see, when I write I mean, I see, I use I apply the same methods that I use in making
Liz:	I do too, yeah yeah
Dan:	and I do with cooking.

Excerpt 3 shows the participants orienting to each other, and through turn taking, utterances below the level of the sentence jointly construct group agreement. Each utterance is part of a locally produced sense of meaning that is situated within this interaction, understood in the instant and taken further. A sense of group identity is formed by seeing "making" as central to thinking, alongside the insistence that it is the *doing* of making. It is interesting that the notions of writing and teaching are cast as something "other," that the participants might be "caught up" in them. The group is further reinforced by what is outside normal activity. Making is returned to as an epistemological core in the agreement that writing can be done by applying the same methods used in making. It is notable that when taken in conjunction with some of the content of excerpt 2, there is a joint construction and acceptance of a folk knowledge of what the writer's world is like. None of them cast him- or herself as a writer, but there is considerable implied foreknowledge within the group of how *doing* writing is imagined to be done, and used to maintain *difference.*

CONCLUSION

In considering how objects are fixed and interpreted, I think a parallel can be drawn with history as recall and testimony, where past events are edited, ordered and (re)interpreted. A dominant model of life-story telling in the crafts is retrospective (for example, Jeffri, 1992; Mishler, 1999; Halper and Douglas, 2009). As Bamberg (2007:171–73) discusses, this calls into question the role of reflection in portraying identities performed in the telling. It induces a "big story" (see Bamberg, 2007; Freeman, 2007; Georgakopoulou, 2007b) that through its postsequencing of past events becomes decoupled from immediate temporality, or, as I argue in relation to craft, the contemporaneity of performing, or doing, meaning making through interaction. The story becomes reified as a thing, rather than as the moment. (Interestingly, in premodern times, the word *thing* referred to an action or event set in passing time, a temporally based experience.)

In this final excerpt, references are made to the processes of making, Haley is reflecting on having been given a part-made piece of work as part of the project. In thinking about how something is made it is thought of as a process happening in time based on "unpicking" and "thinking backwards" so things can "continue."

Excerpt 4

Haley:	We talked about this quite a lot actually how you might have to unpick a process or literally think backwards about what they've done in order to take it apart and continue with something.

This research presents the case that the talk "in and of" practice might offer a more lucid, flexible description of contemporary craft. The fluidity of talk-in-interaction mirrors and captures the ongoing, contingent processes of making-in-interaction. Unfinished passages of talk, making and repairing "in the now," making sense of enough to get to the next *now,* a parallel to making as a continuously unfinished process, doing enough to get to the next step. Talk*ing* and mak*ing* are active, present verbs, indicating the ongoing character of the now—of becoming. In addition to the reflected-upon accounts of a life examined, of tellings to an interviewer, listening to the present use of talk outside of the interview, of what I call an "ethnography of the now" has much to contribute to contemporary renderings of our histories.

REFERENCES

Bamberg, M. (2007), "Stories: Big or Small. Why Do We Care?" in M. Bamberg (ed.), *Narrative—State of the Art,* Amsterdam and Philadelphia: John Benjamins.

Dormer, P. (1997), "The Language and Practical Philosophy of Craft," in P. Dormer (ed.), *The Culture of Craft,* Manchester: Manchester University Press.

Duranti, A. (1997), *Linguistic Anthropology,* New York: Cambridge University Press.

Freeman, M. (2007), "Life 'on Holiday'? In Defense of Big Stories," in M. Bamberg (ed.), *Narrative—State of the Art,* Amsterdam and Philadelphia: John Benjamins.

Georgakopoulou, A. (2007a), *Small Stories, Interaction and Identities*, Amsterdam and Philadelphia: John Benjamins.

Georgakopoulou, A. (2007b), "Thinking Big with Small Stories in Narrative Identity Analysis," in M. Bamberg (ed.), *Narrative—State of the Art,* Amsterdam and Philadelphia: John Benjamins.

Greenhalgh, P. (ed.) (2002), *The Persistence of Craft,* London: A&C Black.

Halper, V. and Douglas, D. (eds.) (2009), *Choosing Craft, the Artist's Viewpoint,* Chapel Hill: University of North Carolina.

Harrod, T. (1999), *The Crafts in Britain in The Twentieth Century,* New Haven, CT: Yale University Press.

Ingold, T. (2000), *The Perception of the Environment,* London: Routledge.

Jeffri, J. (ed.) (1992), *The Craftsperson Speaks. Artists in Varied Media Discuss their Crafts,* New York: Greenwood Press.

Koplos, J. (2002), "What's Crafts Criticism Anyway?" in J. Johnson (ed.), *Exploring Contemporary Craft; History, Theory and Critical Writing,* Toronto: Coach House Books.

Lyotard. J.-F. (1984), *The Post Modern Condition, A Report on Knowledge,* Manchester: Manchester University Press.

Mishler, E. G. (1999), *Storylines; Craftartists' Stories of Identity,* Cambridge, MA: Harvard University Press.

Schiffrin, D. (1994), *Approaches to Discourse,* Malden, MA: Blackwell.

Sennett, R. (2008), *The Craftsman,* London: Allen Lane.

Wenger, E. (1999), *Communities of Practice,* Cambridge: Cambridge University Press.

Part 2
HISTORIES

ON QUALITY
CURATORS AT THE SAN FRANCISCO MUSEUM OF MODERN ART (1935–2010)
richard cándida smith

In 2006, the San Francisco Museum of Modern Art (SFMOMA) asked the Regional Oral History Office (ROHO) at the University of California, Berkeley, to collaborate on a project commemorating the seventy-fifth anniversary of the institution in 2010. Founded in 1935, SFMOMA was the first museum on the West Coast devoted to exhibiting and collecting work by both modern masters and younger, less-established artists. ROHO had interviewed the founding director of the museum, Grace McCann Morley, in 1960, two years after she had resigned. ROHO had also previously interviewed board members as well as artists close to the museum during her tenure. These interviews provided material on the museum from its founding in 1935 to about 1965. For the new project, we interviewed fifty-seven individuals, including all the museum's directors except the second (who had died), curators, trustees, education programmers and other staff, artists, and gallery owners who have been close to the museum at different periods, ranging from the late 1940s to the present. This chapter examines how curators interviewed for the project discussed the concept of quality in their interviews.

As professionals who were working closely with objects, the criteria for establishing why certain works are worthy of attention but others are not is an important marker of professional subjectivity. With a myriad of tasks to undertake, most professionals have time only to skim the surface of an extensive theoretical literature that all agree is relevant to their work. The working concepts that

museum professionals use daily need to be distinguished from parallel theoretical debates found in publications and conference presentations. Oral history interviews provide a window into how curators have synthesized their understandings of theoretical arguments into a set of practical values useful for thinking about ongoing tasks. In discussing how they defined quality and how they understood what objects offer both scholars and the public, interviewees returned to the unresolved problems that arose with every effort to translate principles into practice. During the 1990s, I collaborated with the Getty Research Institute on a project using oral history interviews to examine the development of art history and related fields across the twentieth century (Getty, 1991–2002). One method we developed for tracking how disciplinary culture had changed during the twentieth century was to encourage discussion of working concepts such as style, quality, iconography, connoisseurship, patronage, and meaning in order to see the degree to which the perspectives expressed reflected a generation-specific vocabulary. Quality proved to be a particularly useful discussion topic as responses revealed unambiguous shifts in how the term has been used and regarded across the generations. The lessons drawn from this experience informed our approach to the SFMOMA interviews.

Oral history interviews do not capture the complexity of ideas intellectuals debate in print, even when the interviews have been done with individuals who themselves wrote at length on a subject. The conversational nature of an interview undercuts any tendency an interviewee might have to lapse into lecture mode—though of course on occasion that does happen. Oral history privileges tentative, practical conclusions typical of conversational exchange rather than well-argued principles prepared for publication and/or conference presentations. In the course of daily professional activity, summary statements allow concepts to be put to work in a variety of practical situations. Concepts that are complex and theorized in literature appear in records of everyday discourse as ready-to-hand precepts that can guide whether or not to buy a work of art, what to include in an exhibit, which slides to include in a lecture, how to write about an object in a book or article, who to invite to participate in a symposium or to contribute to an anthology or a to an exhibition catalogue. Oral history provides an excellent vantage point for seeing what potentially dense concepts like quality came to signify in practical terms for interviewees.

The museum had a contentious history with the leading staff divided over giving priority to collecting recognized masterworks as its priority or to showing a broad range of new work, as well as the closely related issue how best to balance showing work produced by local arts communities with making the local community knowledgeable of what major international artists have done. The divisions were not unusual for a regional institution, with limited resources. For all sides, the most important disputes centered on the standards of quality that the museum followed, and there was little consensus as to what constituted the "best," the most important bodies of work that should be the focus of the museum's activities. Additionally, a continuous increase in the costs of collecting work and mounting exhibits guaranteed that questions of quality were entangled with the role of money more generally in the art world. Henry Hopkins, director from 1974 to 1986, spoke of his need to contain costs if he were to retain his independence and that of his curators. Yet that proved impossible. When he arrived in 1974, he could mount a major exhibition for $50,000. Ten years later, he complained, a comparable show cost $3 million, because of increased costs in insurance, shipping, royalties, and requirements from lenders of work exhibited that the museum publish a sizable catalogue. The more expensive shows grew, the greater the importance of scheduling "blockbuster" exhibitions that attracted large crowds (Hopkins, 2008).

The new emphasis on finding new sources of income that could pay for rising costs required a transformation of how the museum viewed its public. For the first fifty years, trustees and staff conceived of the museum as an educational institution contributing to raising the cultural standards of the broader community, and therefore, entry needed to be free. The museum staff also spent more time organizing frequent exhibits outside the museum walls in community venues. Since the late 1970s, as subsidies from the city and state governments declined, public outreach has been measured by ticket sales. The value for visitors is demonstrated by their willingness to pay a $12 admission fee, plus additional charges for special exhibits. The experience not only has to be "worth a detour," but it should "knock your socks off," to quote two phrases curators repeated in the interviews, language borrowed from one of the museum's most generous trustees, who used them to explain why the museum needed to spend considerably more money for the art it purchased.

In discussing the purchase in 1998 of René Magritte's *Personal Values* (1952) for $6.5 million, curator Gary Garrels cited the importance this particular painting had had for Jasper Johns and other post-abstract expressionist U.S. artists. Garrels combined an erudite historical interpretation of the painting's position in the trajectory leading to contemporary art with appreciation for the buzz the painting generated when it went on the market. The excitement the work generated among potential buyers served as a measure of the painting's importance, an excitement indicated both by the talk the painting generated and by the price it commanded. The institution had never previously spent more than $100,000 for a single work, on the assumption that a contemporary art museum should husband its meager financial resources and buy widely among living artists. The decision to compete in the auction for *Personal Values* involved a major psychological leap that required all involved to rethink the criteria they brought to evaluating the work the museum wanted to acquire. Given this dramatic shift involved, the decision to compete for Magritte's painting when it unexpectedly came on the market appears in many interviews as a marker of enhanced professionalism resulting in enhanced international stature (Garrels, 2011).

Imagining oneself in competition with the Museum of Modern Art or the Tate Modern may well have been a more important development than the amount of money spent, but an upward redefinition of the peer institutions against which one wants one's work judged could not happen without increased financial resources, and the rise in costs of the museum's operations reflected the ambitions of its leaders to elevate the institution's stature. Henry Hopkins observed that he came in with the goal of making the museum the most important museum of modern and contemporary art on the West Coast, and the effort to compete with museums in Los Angeles in particular, contributed to the rising costs he experienced. Competition as a value had not been part of the original mission for the museum. In her interview, Grace McCann Morley dismissed competition in favor of cooperation. Morley operated with an assumption of limited resources, but also with a conviction that the museum was part of larger mission to educate the public in visual culture. "In San Francisco," she said, "it is always important to try not to duplicate but to have each museum do those parts of the art picture that are its natural concern. In that way the parts fit finally together into a total report on art" (Morley, 1960:37). Cooperation with the Museum of Modern Art was important to her strategy of keeping her community informed of new developments in New York and elsewhere. The value of cooperation extended to having artists select the juried shows, creating a situation in which Morley assumed that artist-jurors would have to work hard to avoid prejudice against particular styles. Exhibitions achieved a greater unity, she thought, when the selectors had

to discuss their preferences and abide by majority vote, a process she called of achieving a "unity of standard of quality" (Morley, 1960:81, 87).

Far from being innate, quality seemed inseparable from questions of money and the power that its possessors enjoy, and those links were essential if the museum were to realize its ambitions of leaping from a local to an international arena. John Lane, director from 1987 to 1997, was clear about this aim: "It was my goal to create in San Francisco a great contemporary art collection. You can do that if you have enough money. . . . And not just do it with the museum, but to try and persuade and encourage those people who were art collectors in San Francisco to get involved and get ambitious, as well. The institution, working together with the collectors, it was my view that we could, coming together, make something that is truly great here" (Lane, 2008: 09–00:37:51). The museum developed a new approach to collecting that encouraged trustees and patrons to buy particularly expensive work for the museum, but it remained their personal property for a defined time before being donated to the museum collection. During that interim period, patrons enjoyed the work in their homes except when the museum wanted to borrow the work for special exhibitions. David Ross, Lane's successor as director, argued that this policy augmented the possibilities for what the museum could collect while defining collectors as a core public that the museum could educate and bring directly into larger conversations about the unique value of great work: "If you can allow a patron to spend their life with a great work of art in their home, in their lives, it does two things. One is, it inspires them and makes them feel reasonable about spending $10, $20, $30 million on a picture. That's a lot of money in any time, in anybody's terms, even if you're a billionaire, to spend $20 million or $5 million, or even $1 million. It's a lot of money. So if that picture's going to also remain in your property, or in your presence, in your home, you can rationalize it" (Ross, 2009: 02–00:12:38).

A pattern emerged that was both exciting and troubling to those interviewed: the more successful the institution in achieving its primary goals of exhibiting and collecting work while educating the public, the more money is required to achieve its goals. Success, however, meant a focus on work already widely accepted as important rather than taking risks with unknown artists or material not yet discussed in major art journals. In that sense, the museum moved away from the cutting edge of contemporary art, and other institutions emerged in the Bay Area to fill the gap of presenting the public the most intense and difficult new artists. When I asked about how the museum discussed the quality of work proposed for acquisition, David Ross insisted that a high-profile museum could acquire work only if it had already been vetted and was determined by a broad range of critics, historians, and museum curators to be a masterpiece. His response subsumed quality into questions of authority that a leading museum must exercise by respecting established critical opinion. This displacement served to establish that, contrary to what appearances might suggest, money cannot establish quality, but, if spent prudently, it serves as a marker of a previously formed collective evaluation in the art historical community. The issues debated during acquisition meetings are *never*, he insisted, about the quality of a work because the piece would even not be under consideration if it were not already a recognized important work by a recognized important artist. The issues under discussion are whether the asking price is doable and whether there are conservation issues.

This approach can be compared with Grace McCann Morley's vision for the museum she started in 1935. She defined the quality of her programs by referring to her most basic values: bring in the people, listen to the artists, and show as diverse a range of work as is feasible. That she

presented the first museum shows of artists such as Jackson Pollock or the first U.S. shows of artists such as Frida Kahlo, demonstrated the success of her approach as far as she was concerned, but she was also clear that the thousands of other artists she showed, most unknown, were equally important because only a broad range of artists allowed the public to see how "visual intelligence" was developing over time in the hands of a broad movement trying to solve shared problems. She was emphatic that her ability to get work into places like department stores, cafeterias, or high schools was equally important because the museum presence in these venues reinforced the ideal of the modern art museum as a bridge putting contemporary artists into dialogue with their fellow citizens.

Most of the interviews, including those with trustees (largely successful local business leaders and their spouses), reveal strong ambivalence about the increased role of money and the shadow it places on the independence of the intellectual work the museum performs. Those involved, each of whom has invested a considerable amount of time in the work of the museum, were clearly uncomfortable with any implication that money, quality, and success were indivisible. Each curator was eager to describe difficult shows he or she had organized to present important but difficult artists whose work baffled or even antagonized most viewers. They spent considerable time justifying the selection of these shows, describing how they overcame resistance from their peers and from the trustees, and then worked with the education department on developing a context to answer potential objections from the museum's public. A recurrent motif in these accounts was bemused confession that they often did not correctly anticipate what audience objections would be, a way of saying that as specialists, they really cannot know what the public thinks. Their work puts them in dialogue with the art objects, and the most important audience the curators address, they stated over and over again, consists of other curators at peer institutions.

Discussions on the stratagems curators developed to assure that their intellectual interests, and not money, define the quality of the museum's activities led into discussions of the place of the object in modern and contemporary art. Resistant to all stable interpretation, the object provided the firmest foundation for the work that they do because a great work can never be reduced to any evaluation placed on it. The integrity of the artist's accomplishment remains open to all who approach the work with open eyes. Because the object itself did not change, but its presentation and interpretation did, the ability of an object to provoke new responses demonstrated an innate quality to reveal core ideas and values at work at any given time in the professional world that art historians, critics, and curators comprised. The object itself retained an element of independence from the fluctuation of interpretive frameworks. The critic and the historian as the definers of quality were subjects of history, but to the degree that an artist's work stimulated new responses, it offered a glimpse into an effectively atemporal existence that stood above evaluation.

Graham Beal, curator at SFMOMA in the 1980s, currently director of the Detroit Institute of the Arts, noted that modern art as a movement had overthrown the authority of the connoisseur and critics. The victory of modern art was the victory of the artist to define what quality was by making the very definition of what art was project specific. Art was no longer a statement of values, whether eternal or socially constructed, but an experiment in creating an object that conveyed unusual thought-provoking sensations. The supremacy of the object as a vehicle for deconstructing concepts muddied the waters, he continued. By 1980, the object replaced the artist as the authority, and the artist had become a vehicle for producing objects valued for their unusual effects (Beal, 2008: 02–00:42:18 to 02–00:46:10). Another curator described a great work of art as an object

that started with the artist's intentionality and skill but then *escaped* the initial plan and achieved a complexity that no human mind could have ever imagined before the object took on its own reality (Bishop, 2010). If the object was potentially autonomous even from the artist who made it, collectors took on increased importance. The money value an object received seemed solidly objective compared to either critical testimony or subjective responses from curators. The interviews suggest that philosophical aspects of late twentieth-century contemporary art contributed to the triumph of the collector as the position within the circuit of exchange that an art object defines best suited to provide consistent, comparable, and socially relevant markers for the quality of art. The collector as repository of passion, knowledge, and money firmly established that quality was a social construct and not a universal revealed by acts of genius—simultaneously validating the autonomy of objects and the social constructionist interpretive position of postmodern cultural thought, which I discuss in more detail in the following.

Directors and curators interviewed for the SFMOMA project were asked to talk in detail about individual works in the collection, both masterpieces and personal favorites. They were urged to discuss the values that they perceived in the work and why they personally enjoyed it. Clear generational identifications emerged from these discussions. Every interviewee chose as examples of particularly important personal favorites, objects first engaged when in his or her twenties or thirties. In this section of the interviews, the narrators expressed the continuing joy they found in shapes, colors, and media that had moved them profoundly as young people just starting out in their careers. The exchanges took narrators back to their first jobs, to initial aspirations and ambitions, to hectic times when they worked long hours at impossibly busy, low-paying jobs, but still had energy to spend every waking moment with extended networks of young artist, critics, and curators who were their closest friends. Madeleine Grynsztejn, curator of painting and sculpture in the first decade of the twenty-first century, observed that those who dedicate themselves to the art of their own lifetime turn into human Geiger counters whose responses registered the passions of the moment. They believed then, and still hope, that objects and events that were most exciting personally would prove to be the masterpieces that continued affecting others for generations to come. However, then she confessed that when she was in her twenties working in New York City during the 1980s, she had hoped that the art she loved most would disappear completely, that it might be destroyed even. The important thing had been the way an object had expressed ideas; a moment that nobody could possibly understand if he or she had not actually been there (Grynsztejn, 2010: 02–00:14:38).

Curators working in new media, photography, and design needed to assert the value of the work they had brought into the collection despite the shift in collection emphasis after the end of the 1980s toward blue-chip painting and sculpture, and they had to deal with a not always hidden presumption that the objects they worked with, being less expensive, could not have quality equal to the best paintings in the collection. Sandra Phillips, the chief photography curator, responded to the shift with adventuresome thematic shows that demonstrated the wealth of work at the museum's disposal for making unusual statements about economic development in the West, newspaper reporting, surveillance as a cultural category, juxtaposing work by famous photographers with vernacular images usually not considered art to emphasize that it is the psychological load that makes some photographs particularly powerful. Aaron Betsky, curator of architecture and design in the 1990s, observed that he used the apparatus of a museum to force people to see the objects he collected in totally new ways:

It's all in something that we see every day, that we use every day, that most of us don't notice. And you put it on a pedestal, you put it in a gallery with white walls, you put a light on it, you put a guard near it, so that you know you can't touch it, and you are forced to look at it. And that's the most important thing that is accomplished, I think, by putting an object of design in an art museum. You look at it. Very simply. It does to that object what the art museum does to the Matisse and the Picasso. It builds this elaborate frame, from advertising to guards to value, and says, look at this. Stop. Turn off your cell phone or put it on vibrate, and just look. And that moment of looking is, for me, crucial. (Betsky, 2010: 01–00:15:46)

As curators discussed the future of modern/contemporary art museums, the still-emerging web-based culture was invoked as a challenge and a hope. New audiences, raised to appreciate virtuality rather than objectivity, might well be indifferent to objects as such, they might not share the values that made SFMOMA and many other museums grow so rapidly after 1960 with the goal of collecting as many masterpieces as available funds would permit. This sense that their work had occurred during a special moment that might be slipping away was followed in several interviews by a hope that object-centered institutions might just fade away, a hope that echoed much of what André Malraux had predicted in the 1950s would occur as a new culture of easily circulated images took hold (Malraux, 1953). I heard visions of a new world where curators would only occasionally hang work in a gallery, but instead spend most of their time in a studio assembling images, recombining them in unexpected ways, and sending them out to the computers of the world in a continuous stream of programming. For Madeleine Grynsztejn, new technologies were transforming the basis of how modern and contemporary art museums had developed, and the danger was that no one had yet figured out how to synthesize the best of an older object orientation so that what museums had accomplished could be preserved for a world with very different practicalities guiding how people interacted with images and objects:

The ground is changing from under the museum's feet, and it has to acclimatize to a twenty-first-century position. It is in the process of still getting out of a nineteenth-century originary model, which was, grossly speaking, two pronged. Object centered. Out of that, we have inherited a continued obsession with owning what we're showing, acquiring. Acquiring masterpieces. Those two things are increasingly under threat, because we can afford fewer and fewer of those masterpieces. The very concept of masterpiece is also under question. The second prong that drove the originary model at museums is a social Darwinism; that if you went to the museum, you would become a better person. So you will receive this information from on high, and you will evolve. This model has sustained, *shockingly*, up until now. I mean, a hundred years, up until the end of the eighties. It's only in the nineties, it's only really, I think, in the last fifteen years, that a new museology has begun to infiltrate and be listened to, that is demanding that the museum be more responsive to an increasingly varied public, with an increasingly varied education, and that it be less object centered. The latter which, by the way, I disagree with. I think we still need to be object centered, but I think we need to be real about how the notion of the masterpiece has changed, and what we can achieve. (Grynsztejn, 2010: 02–00:22:03 to 02–00:24:41)

The epistemologically free-floating character of the object consistent with postmodern conceptions of art fitted comfortably with everyday practices concerning acquisition and exhibition in a

museum of modern and contemporary art. The understanding that social relationships stood at the heart of what made artwork powerful could largely be taken for granted and expanded opportunities for interpretative exhibitions, but older ideas of quality as something immanent in objects retained practical importance. The question of what were to be compelling standards that could settle disagreements about work to be collected and/or exhibited remained.

In this set of interviews, a social constructionist perspective of art returns insistently to money as a marker of quality if only because in the current structure of art institutions in the United States, money has become the basic reality determining the limits of what can be done, though not of specific choices made. Money in its various forms—earned income, operating expenses, salaries, donations, value of work acquired or exhibited—has served as a marker of growth, opportunity, dilemmas, and dangers. Money plays as well a deeply symbolic role that is part and parcel of being "postmodern," that is, rejecting modernist faith in the reality of transcendental universals that works of art can reveal. Instead, the object reveals the flux of contemporary passions, and the money some are willing to spend helps to measure the intensity of the feelings a given body of work has generated. The symbolic role escapes the limits of social construction to take those working in the art world into a set of epistemological dilemmas that curators faced, growing from the relation of the object to the explanatory language curators develop to explain the value they have found in particular work. The solutions they arrived at were practical, not theoretical, even if broader philosophical implications might be discerned. The curator engaged in an equivalent of Charles Sanders Peirce's four denials that provided the foundation for his system of semiotics (Peirce, 1992:11–27):

No introspection
No intuition
All thought operates through the medium of signs
No conception of objects except through signs

By denying introspection, Peirce insisted that all knowledge of internal states must be inferred by external facts. Knowledge of psychological responses to art must be derived from external facts, or else it remains an ineffable feeling of the sublime. The psychological load of a given work is discovered in the complexity of the language used to describe the relation of content, form, artist intention, and an idealized viewer response. The work itself stands as a sign for the circuit of responses it has generated.

By denying intuition, Peirce argued that all cognition grows from previous cognitions, which is to say that direct physical encounter with a work is shaped by the language available for those involved to describe and debate what it might be, what it could be, and what it should be. Language "catalyzes" new, deeper perceptions. The curator's job rests on an ability to mediate and direct the relation of verbalized response and physical encounter. The encounter grows deeper the more the languages a curator offers stimulate new perceptions, often connected with an ability to link the work to other works not immediately present but available in archived accounts of art practice across time and geography.

If all thought operates through the medium of signs, a work of art is a sign that evokes a response that circulates as it is thrown off into words. Its quality, in terms of its position in circuits of exchange, is its continuing ability to generate new efforts to explore a wider range of meanings

that can be imputed to the sensations the object produces. These meanings can be registered in the money that a collector or a museum is willing to offer for it, or in the words a curator develops to explain why an object is worth a detour to fellow curators, to trustees and potential donors, as well as to the museum-going public that views it. It is axiomatic that meaning does not lie inherently or solely in perception as an individual relation to the object, but in the exchange of interpretations that follow interaction. An object, in Peirce's semiotic universe, does not directly cause ideas to form; objects present puzzles that cause observers to consult the archive of previous experience and formulated knowledge to offer an interpretation, that if actionable becomes an experience contributing to new knowledge of the world. It was precisely this quality that David Ross found in Marcel Duchamp's *Green Box*, an acquisition Ross pointed to as one of the most important he made during his short tenure as director. "For me, of course," Ross said, "Duchamp is at the foundation of the entire generation of artists who questioned art's ontological purpose and its role as a provoker of questions, rather than an answerer of questions" (Ross, 2009: 07–00:12:58).

Peirce's fourth denial, no conception of objects except through signs, illuminates the centrality that curators have in a conceptual framework where objects retain autonomy but are also translated into signs of the responses they have the potential to generate. Curators define the terms that allow the emotional and intellectual effects artworks generate to be exchanged. They establish the art object as an expression of particular social conventions, but also as a living autonomous entity that continues to generate responses that cannot be fully predicted nor limited by the languages of a given time and place. Curators articulate the purposes that much farther down the road incorporate money into an ongoing circuit of interpretation; to that degree, they establish the parameters for monetizing value, translating objects into exchange values that establish the relative ranking of museums and galleries. They mediate the social and the natural by proposing first and foremost by placing objects in new relationships in exhibits and, secondarily, through writing meaningful ways for observers to think about the object and by stimulating desire to find out more information about the object and deepen that meaning.

In his last published work, the poet Stéphane Mallarmé proposed that every thought is a roll of the dice, not like a roll of the dice but actually a gamble that brings into sight another way of being in the world. Every thought is a proposition about what the relationship is between "me" and everything else. "As if" is the only law revealed since every statement is unique and something will emerge momentarily to take its place. Every thought is the kernel for a new mind, which, if it shoots out roots, becomes a new form of life. Most do not because most propositions cannot pass the test of leading to a life that would be better or, more tragically, are not in the realm of possibility given the conditions of the moment. In terms of art, every new development will appear as a "half-art" or an "almost-art," "what merely verges on art" (Mallarmé, 1994:122). Older generations protest the absence of what made art emotionally powerful in their day, but for the new entrants into the profession, quality is a state of excitement that that they are helping something new become present. One will write a book that will clarify some topic. One will curate a show that will change those who see it. One will turn a local cultural center with limited resources into a global institution. No dreams ever take place as anticipated even when successful, but the anticipation sustains work and generates support, both moral and material. All that may take place is a conviction that one's work is meaningful because it has provided a life, because it has changed others as well, even if they do not recognize it yet.

REFERENCES

Mallarmé, S. (1994), "Preface to 'Un coup des dés,'" in S. Mallarmé, *Collected Poems*, tr. Harry Weinfeld, Berkeley: University of California Press.

Malraux, A. (1953), *The Voices of Silence: Man and His Art*, Garden City, NJ: Doubleday.

Peirce, C. S. (1992), "Questions Concerning Certain Faculties Claimed for Man," in N. Houser and C. Kloesel (eds.), *The Essential Peirce: Selected Philosophical Writings*, vol. 1 (1867–1893), Bloomington: Indiana University Press.

Interviews

Unless specified otherwise the interviews were conducted as part of the San Francisco Museum of Modern Art (SFMOMA) 75th Anniversary. See also <http://www.sfmoma.org/about/research_projects/research_projects_oral_history>

Beal, G. (2007), Curator of Painting and Sculpture interviewed by Richard Cándida Smith and Lisa Rubens, Regional Oral History Office, University of California, Berkeley, and San Francisco Museum of Modern Art.

Betsky, A. (2009), Curator of Architecture and Design, interviewed by Richard Cándida Smith and Jill Sterrett, Regional Oral History Office, University of California, Berkeley, and San Francisco Museum of Modern Art.

Bishop, J. (2008), Curator of Painting and Sculpture, interviewed by Richard Cándida Smith and Peter Samis, Regional Oral History Office, University of California, Berkeley, and San Francisco Museum of Modern Art.

Garrels, G. (2009), Curator of Painting and Sculpture, interviewed by Richard Cándida Smith, Regional Oral History Office, University of California, Berkeley, and San Francisco Museum of Modern Art.

Getty (1991–2002), Interview with Art Historians, 1991–2002, Getty Research Center Library, <http://www.getty.edu/research/> accessed May 23, 2011.

Grynsztejn, M. (2008), Curator of Painting and Sculpture, interviewed by Richard Cándida Smith and Lisa Rubens, Regional Oral History Office, University of California, Berkeley, and San Francisco Museum of Modern Art.

Hopkins, H. (2007), SFMOMA Director 1974–1986, interviewed by Richard Cándida Smith and Lisa Rubens, Regional Oral History Office, University of California, Berkeley, and San Francisco Museum of Modern Art.

Lane, J. R. (2006), SFMOMA Director 1987–1997, interviewed by Lisa Rubens, Richard Cándida Smith and Peter Samis, Regional Oral History Office, University of California, Berkeley, and San Francisco Museum of Modern Art.

Morley, G. M. (1960), interviewed by Suzanne B. Riess as part of the project Art, Artists, Museums, and the San Francisco Museum of Art, Regional Cultural History Project, University of California, Berkeley.

Ross, D. (2007–9), SFMOMA Director 1998–2001, interviewed by Lisa Rubens, Richard Cándida Smith, and Jill Sterrett, Regional Oral History Office, University of California, Berkeley, and San Francisco Museum of Modern Art.

7.

VOICES IN ART HISTORY
liz bruchet

The Association of Art Historians (AAH), Britain's national organization for professional art historians, commissioned the *Voices in Art History* oral history project to document recollections of those involved in the establishment of the AAH in the early 1970s. The sixteen audio interviews were semistructured, with some life-story questions focusing on education and early exposure to art and art history. They positioned individual experiences in relation to a period of extraordinary expansion and change within the discipline. More-focused questions addressed the specific history of the association.[1]

At the onset of each recording, I asked the interviewees to introduce themselves. One participant, retired art historian and museum director Alan Bowness, responded by succinctly outlining his professional background in relation to key factors in the development of the discipline in Britain, concluding five minutes later with a tidy summary: "So that's really the background in the '60s which I think was going to lead inevitably to the formation of an association of art historians in the 1970s" (Bowness, 2010:1–2). It seemed that my primary research question (how and why was the Association of Art Historians formed?) could be answered with little effort. The efficiency of his reply comes as little surprise. The *Voices in Art History* narrators are consummate academic art historians; at least four of them have published on topics relating to the recent history of the discipline in Britain (White, 1975; Onians, 1978; Pointon, 1986; Tickner, 2008). The nature of their work and their involvement with the AAH also means that they are teachers, presenters, administrators, and advocates for their subject.

This chapter explores the implications of undertaking an oral history project with art historians. It considers how their professional characteristics and attributes shape the telling of the story of the Association of Art Historians, highlighting in particular the aural and oral forms of their practice often omitted from written historiographies of the discipline.

HISTORICAL BACKGROUND

The expansion of higher education in Britain in the postwar era had a great impact on the *Voices in Art History* interviewees. The eldest members of the group attended university in the 1950s at a time when the history of art was a marginal subject, scarcely taught in Britain. When the Courtauld Institute of Art at the University of London opened its doors in 1932, it became the first and only educational establishment in the country to offer a dedicated degree in the subject. It would remain for some time a highly specialized area of research with its history firmly connected to the upper classes of society. Access to personal art collections, travel, and exposure to art through private school education or family connections were essential attributes of anyone pursuing the subject with any seriousness.

Yet, by the time of the formation of the Association of Art Historians in 1974, art history was being offered at more than twenty universities, colleges, and polytechnics across Britain. The expansion of the discipline was due to two key reforms in higher education: first, the creation of many new universities and polytechnics in the late 1950s and early 1960s and, second, the reforms to art education that made art history a mandatory academic aspect of arts degrees (Rees and Borzello, 1988:6). The new art history departments opening up around the country and art schools keen to consolidate degree-granting status rapidly recruited new staff. The sheer number of job opportunities in the latter half of the 1960s was repeatedly emphasized by the interviewees as a key benefit of the decade, with one interviewee commenting that "with my somewhat patchy qualifications I probably wouldn't get to interview stage now in job applications" (Kemp, 2009:30). As the subject spread beyond the traditional academic centers, it engaged a wider demographic of students and instructors. Publications aimed at nonspecialists, and the appearance of popular television programs like Kenneth Clark's *Civilisation* (1969) and John Berger's *Ways of Seeing* (1972) further increased its profile.

This rapid growth of the discipline roughly coincided with a reevaluation of its methodologies, described by some scholars as a crisis in the subject (Clark, 1974:561–2). The 1970s and 1980s in particular saw a marked shift away from traditional art-historical models, and methods that emphasized stylistic analysis, artistic genius, chronologies, and attributions. Instead, scholars moved toward a more social history of art, influenced by Marxism, feminism, structuralism, and semiotics that had come into academic favor in the 1960s. This radical change in approach came to be known as "the new art history." While this term and its connotations have subsequently been critiqued, it provided the *Voices in Art History* speakers and interviewer alike with a useful chronological benchmark, bringing preexisting characteristics of the discipline into sharper relief and allowing reflection on how things had or had not changed with time.

GENERATIONAL DISTINCTIONS

Most interviewees were sympathetic to the discipline's growth, but they also spoke about the anxieties that arose as the community expanded and the parameters of the subject loosened. Was it being diluted with the introduction of these new subject areas? Were scholars focusing too much on the production and consumption of art and losing connection with the original art object? Generational identifiers and talk of professional hierarchies helped the narrators to structure complex

positions in the face of these concerns. The members of the older generation were repeatedly described by interviewees as practicing an "old style" art history based in established universities. Members of the younger generation, by contrast, came to represent the new institutions with their more radical approaches. This characterization extended beyond scholarship to include descriptions of outdated professional standards. The elitist and sexist "old boys' network" stood in contrast to the more progressive, post-1968, class-conscious theoretical and educational approaches of the junior scholars.

The close-knit nature of the academic world of art history in the 1950s and 1960s meant that generational hierarchies could be defined on an almost familial scale. At a time when there were few senior academic posts in art history and a limited amount of literature produced on the subject, professional connections and benchmarks could be easily tracked. For example, Anthony Blunt, director of the Courtauld Institute of Art from 1947 to 1974, ran "a kind of placement service," according to one interviewee, with "tentacles everywhere" because he sat on hiring committees and academic boards nationally and internationally: "virtually every job in the British Commonwealth . . . went through his hands because people would call him and say, 'Who've you got coming out?'" (Kemp, 2009:5). The history of the AAH attests to this insularity: nine out of the thirteen interviewees had studied at the Courtauld over a period of fifteen years, and many of them credited Blunt with securing their first job in the profession.

Interviewees also applied these generational descriptions to the leadership and management of the early AAH. At the pinnacle were the older generation. On the whole, these were white European men, senior scholars concerned with the history of Western art. Their students, some of whom were interviewed for *Voices in Art History*, were mid-life and mid-career at the time of the establishment of the association. They positioned themselves as forward thinking in relation to many of their senior colleagues, taking the reins of leadership and helping to forge new territory in this postexpansion era. They expressed frustration at the exclusivity of the discipline, a dissatisfaction that prompted the formation of an inclusive professional body, open to art historians at any level in their career. According to accounts from two of the founders of the AAH, members of the senior generation had little involvement with—and little need for—this new organization. Finally, it was the new generation of "junior" lecturers who were actively being recruited to join the association and who represent the majority of the project interviewees. On the whole, these young scholars aligned themselves with the changes to the discipline. Yet a closer analysis of how these characterizations were applied to the story of the AAH suggests more apprehensive attitudes in relation to the eroding traditions of the profession.

SHIFTING HIERARCHIES: IMITATIONS AND ANECDOTES

The rapid growth of the subject and the subsequent plethora of jobs unsettled traditional career pathways. It meant many young scholars secured relatively high-level positions more quickly than had their predecessors. One junior AAH member described the tenuous gap between his generation and that of the men who formed the association:

> [The founders] seemed older at the time . . . because they'd always been in a position of teaching you and sometimes they perhaps exaggerated the distance in age. I was surprised

sometimes later on to discover that they hadn't been that much older, but they obviously had to make the distance. (Avery, 2011:41)

As the professional status quo came under threat, denoting that distance became more important. Another interviewee further qualified the depiction of this hierarchy as something implied but not directly expressed: "I think that what they seemed to have wanted was a small group of younger people to kind of supplement the leaders. It wasn't that they made one feel less important, except that one did feel [chuckles] slightly less important . . ." (Causey, 2011:55). In the context of the AAH, managing this new territory meant enacting or over-emphasizing a seniority that might otherwise have not been immediately apparent, but doing so implicitly.

Similarly, new possibilities of social mobility and the opening up of higher education to a wider demographic of students quickly led to a change in the background and social status of young academics. During the recordings, some interviewees used mimicry to help illustrate their position in relation to that of their senior colleagues. They imitated the voices of key establishment figures: an upper-class, nasally drawl for Anthony Blunt (1907–83), for example, or a high-pitched, authoritative tone for John Pope-Hennessy (1913–94). Through these reenactments, the interviewees marked, in the tone and grammar of their speech, how their background, education, and social manner differ from that of the person they imitated. By distinguishing their intellectual and professional "voice" from that of their elders, they also positioned themselves in contrast to the more traditional approaches that came under critique over the course of their careers. Imitations and accents were noticeably absent when quoting contemporary colleagues, even in instances in which the subject in question was deceased and the risk of offense was mitigated.

Anecdotes provided another means of illustrating these positions. Charles Avery, then deputy keeper of sculpture at the Victoria and Albert Museum under the imposing figure of John Pope-Hennessy, told of an instance of being caught in the middle of a debate between senior academic figures: "This was the world we lived in, you know . . . the great monumental men were huge sort of behemoths: [Michael] Jaffé, [John] Pope-Hennessy would lay about themselves and you just had to take cover" (2011:21). Avery's story suggests that not only intellectual acumen but also authoritative social manner and fierce professional and personal competition gave these "behemoths" their stature. Such performances depict attitudes that may still be taken for granted or perceived as irrelevant to official accounts, and as a result are likely to be lost in official written histories of the subject. Yet rivalries, prejudices, and factions can inspire professional change as much as any academic writing.

Interviewees also told of instances of intellectual challenge and instruction given in conversation. John Onians, the inaugural editor of the association's journal *Art History*, studied under famed Warburg Institute scholar Ernst Gombrich (1909–2001). Applying a thick Austrian accent to his impersonation, Onians reflected on the advice of his supervisor:

> I would write something . . . and he would say, [imitates] "Well Onians this is only an aperçu." What he meant was . . . you've seen something, you're on to something that's interesting but you haven't sort of demonstrated that it really is there. You're sensing something, not describing it or analyzing it. (2011:25)

Besides reinforcing well-worn caricatures, such anecdotes highlight the lessons provided by mentors, and emphasize the intergenerational teacher–pupil interactions responsible for much of the

discipline's intellectual development. The narratives also illustrate a personal familiarity with members of the older generation; citing the influence of a scholar's publication is one thing; knowing them personally and imitating their speech may suggest a deeper affiliation. So although some instances of imitation make the generational distance appear greater, others shorten it and reinforce the lineage between themselves and these revered senior scholars.

Through narrative descriptions, interviewees were also able to express their ambivalence about the direction of professional change, opinions that may no longer be in favor within contemporary academia. For instance, a revision of the professional conventions, on one hand, coincided with an increase in bureaucracy on the other. The loss of the old boys' network also marked a decrease in the subject's exclusivity, with jobs flooding the market and junior art historians advancing through the ranks with relative ease. One interviewee spoke about his desire to see the subject reach wider audiences, but then later described how his interest in art history was due in part to its status as a fringe subject. For others, tales about the old boys' network, about being under eyes of "the great behemoths" of the art historical world, were delivered with a tone of nostalgia. Although there was certainly recognition that things needed to progress, the stories tell, too, of a perceived loss of camaraderie and the charisma of entitlement and leadership, both on an intellectual and professional level.

GAINING A VOICE

In light of these characterizations of the discipline, it is perhaps not surprising that the newly formed Association of Art Historians was founded on a principle of inclusivity and democracy. It would function as a lobbying body for the entire profession, giving the subject "a voice," as John White, one of the key founders of the AAH, described: "If you don't speak up, you don't get heard and it was a new subject, an expanding subject and it needed a voice and it needed to fight for its membership, it needed to fight for the subject" (2011:45–6). Giving voice to the whole profession meant including art historians practicing in newer arenas, including those teaching in polytechnics and art colleges, design historians, feminist scholars, and others deemed by some to be on the fringes of the subject. Indeed, when the interviewees reviewed a list of the early AAH committee members, most analyzed it according to the representation of these constituencies, noting institutional affiliation and geographic area, gender, and subject specialization, with a particular emphasis on the importance of having "non-Courtauld" art historians from outside of London.

Although archival documents suggest equality within the group, the oral history accounts also reiterate the ongoing impact of hierarchies and practical considerations on the association's operation. One interviewee spoke of a "slight sense of first-class and second-class members" (Causey, 2011:59–60). Another reflected on the strategic creation of subgroups within the organization: "Our campaign to have a subcommittee for art schools and polytechnics was accepted because it was easier for us to be a subcommittee as far as the powers that be [were concerned], than let us on the main committee" (Swann, 2010:28). Other comments remind listeners that despite female representation within the membership, gender also remained a contentious issue within the AAH for decades after its formation. In addition, as some interviewees noted, the membership numbers needed to make the organization financially viable could only be guaranteed by representing a wide range of scholars. Aspiring to become a representative organization may have been as much a practical concern as an ideological one.

THE SKILLS OF ART HISTORIANS

Assured of their abilities as historians and adept at tracing correlations and analyzing historical material, in many ways these scholars were in familiar territory when participating in oral history interviews. Most assessed the changes to their occupation in light of wider social and historical developments. It was not simply about telling a story—in many cases they would simultaneously reflect on the story's significance. They shared a desire for their contributions to resonate in perpetuity, and they aimed to provide insightful and accurate comments for future researchers. Many sought affirmation of their accounts, asking how their memories compared to those of others, with one interviewee bringing out his diary to confirm dates and others requesting that their statements be verified against papers held in the association's archives.[2] If they were uncertain of the accuracy of their statement, they felt confident including a caveat within their answer.

In seminars, lectures, administrative meetings, and informal discussions, art historians practice the art of convincing their listener through conversation and oration—a fundamental, but often overlooked, component of academic education and peer review. Anthony Blunt, for instance, was remembered by three of his former students for his famous lecture on Picasso's *Guernica*, which riveted and moved them with its emotion and depth of political conviction (Swann, 2010:6–7; Avery, 2011:15; Onians, 2011:13). Other interviewees spoke of the theatrical element of giving a good lecture and of being inspired or disappointed by a particular speaker. All of the *Voices in Art History* interviewees bar one have spent a large portion of their professional life teaching art history in universities and colleges, where most continue to hone their public speaking and debating skills. Many have presented television or radio programs, and all have lectured to large audiences. In listening to the cohesive, didactic narrative style of many of the narrators, it is easy to imagine we are listening to a compelling lecture. Indeed, the dynamic between interviewee and interviewer sometimes approached that of instructor and student, an effect perhaps emphasized by my position as a non-art historian and outsider of the community. It seemed that in choosing oral history as the means to investigate the formation of this professional organization, one could easily become, as Karl Figlio has suggested, "particularly vulnerable to the very forces that constituted the group and set it in motion" (1988:129).

Historian Paul Thompson has also noted how such professional characteristics can be a cause for concern among oral historians: "The more people are accustomed to presenting a professional public image, the less likely their personal recollections are to be candid . . . those who, through reading, have fixed upon a view of the past which they propagate professionally—such as historians and teachers. They can be the most insightful, but equally the most misleading sources" (2000:149). This is not to suggest that the interviewees intentionally misrepresent events, but rather that in excelling at their work, they provide a challenge for oral historians—the challenge not to become swept up by their skills and expertise. Otherwise, the interviewer and researcher risk resting on the authority of accomplished historians, affirming existing narratives and methods of inquiry and missing possible avenues of new insight implicitly communicated through speech.

PROFESSIONAL SKEPTICISM

In my role as oral historian, I was not alone in my caution. Despite their inherent sympathy to the project, half of the *Voices in Art History* interviewees expressed concerns about the nature of oral

history as both a method and source for historical studies. This is not surprising considering that the "unique and precious" characteristics of oral history emphasize the very subjective nature of our efforts to understand the past (Portelli, 1998:37). Lisa Tickner, another early member of the AAH, spoke on record about her ambivalence in using oral histories in any research project:

BRUCHET: My last question is what do you think of this project that we're doing right now, which is the Association of Art Historians oral history project?

TICKNER: [chuckling] I much prefer to be on the other side of it. I don't like being interviewed. I much prefer to think of oral history as a rich repository for me to enjoy and use, rather than actually having to say things that other people will have to listen to. But if I try to project myself back into my other position as user, then I have to say I think it's a very good thing to do. I mean oral history is no shortcut to truth, as you know, because everybody has different experiences and says different things and I know having used it, that it can get you into hot water. In some ways it's easier to have very reduced sources—to juggle three plates is sometimes easier than to juggle twenty-five. But it's crazy not to have it, and it's crazy not to use it. (Tickner, 2001:74)

The art historians that were interviewed understood that by participating in an oral history project, they were putting themselves forward as subjects for future study. However, accustomed to being the authors of history rather than its subjects, passing the torch to an oral historian required—at least for some—a leap of faith. The nature of oral testimonies exposes these scholars to potential misunderstandings in unfamiliar ways, as the interpretation of speech can be harder to navigate than that of written documents. Similarly, as Lisa Tickner pointed out, juggling distinctly subjective sources poses new challenges. Furthermore, a misconstrued statement or a "wrong" answer may undermine professional credibility. To that end, any analysis of these oral histories must consider the particular biases and skills of art historians and how these biases and skills may shape testimonials in an effort to be both compelling and relevant to contemporary and future listeners.

CONCLUSION

The *Voices in Art History* project can be understood as a self-affirming exercise, validating the raison d'être of the association while helping art historians to capture their history for posterity. Yet, the interviews also offer insight into the practice of art historians, illustrating in particular the often-unacknowledged contributions that they make through verbal communication in its range of registers. It offers both the interviewee and the interviewer a chance to reflect critically on the process of relaying and recording history, asking how their particular professional characteristics influence the telling of their histories.

The ways in which the interviewees identify with the intellectual and professional development of their discipline become in turn a backdrop on which to rationalize the establishment of the Association of Art Historians, along with its initial configuration, aims and priorities. The theme of finding a voice and being heard that reoccurred in the interviews, along with the characterizations of different generations of art historians, led to an understanding of the degree to which hierarchical

structures motivated the formation of AAH. In addition, the "new art history" represented not only intellectual concerns but also social and professional ones, resulting in a collective drive to see the academic community embrace the challenges brought on by the expansion of its discipline.

In the end, it seems that the territory of contemporary art historians is not so far from that of the oral historian. Analyzing our pasts is an ongoing negotiation between being cautious, rational, and analytical while reflecting on the subjective and persuasive elements of human engagement and dialogue.

NOTES

1. Out of the sixteen interviews conducted between 2009 and 2011, fifteen interviewees were actively involved with the Association of Art Historians during its first decade. All of the interview subjects were art historians with the exception of an arts administrator and a publicity and marketing professional. Although much can be learned from the nonacademic contributors, this chapter focuses on the thirteen art historians who share an experience of the early days of the association. Biographical notes on all interviewees can be found at www.aah.org.uk/projects/oral-history.
2. The archival papers of the Association of Art Historians, including the *Voices in Art History* recordings, are held at the Archive of Art and Design, Victoria and Albert Museum, London.

REFERENCES

Clark, T. J. (1974), "The Conditions of Artistic Creation," *Times Literary Supplement* (May 29): 561–2.
Figlio, K. (1998), "Oral History and the Unconscious," *History Workshop Journal* 26/1: 120–32.
Onians, J. (1978), "Art History, *Kunstgeschichte* and *Historia*," *Art History* 1/2: 131–3.
Pointon, M. (1986), "Art History and the Undergraduate Syllabus: Is it a Discipline and How Should We Teach It?" in A. L. Rees and F. Borzello (eds.), *The New Art History*, London: Camden Press.
Portelli, A. (2006), "What Makes Oral History Different," in R. Perks and A. Thomson (eds.), *The Oral History Reader*, 2nd ed., London and New York: Routledge.
Rees, A. L. and Borzello, F. (eds.) (1986), *The New Art History*, London: Camden Press.
Thompson, P. (2000), *The Voice of the Past: Oral History*, 3rd ed., Oxford: Oxford University Press.
Tickner, L. (2008), *Hornsey 1968: The Art School Revolution*, London: Frances Lincoln Ltd.
White, J. (1975), "The Association of Art Historians," *Times Literary Supplement* (March 21): 313.

Interviews

The following interviews were conducted as part of the project Voices in Art History: the Association of Art Historians Oral Histories.
Avery, C. (2011), interviewed by Bruchet, London, April 7.
Bowness, A. (2010), interviewed by Bruchet, London, May 5, July 27, and November 5.
Causey, A. (2011), interviewed by Bruchet, London, February 11 and March 22.
Kemp, M. (2009), interviewed by Bruchet, Oxford, November 27.
Onians, J. (2011), interviewed by Bruchet, Oxford, February 4 and May 31.
Swann, F. (2010), interviewed by Bruchet, Newcastle-under-Lyme, September 23.
Tickner, L. (2011), interviewed by Bruchet, London, June 7.
White, J. (2010), interviewed by Bruchet, London, May 28 and July 8.

(I found these couple of letters that were a part of an exchange we had in) (passes paper) Oh, good heavens! (in 1974,) How amazing, yes. (Yeah and) I remember writing to you but I, (and and this one, in this one, you talked about the spectrum um yes, yes (appearing, performing in composition) Yeah, I was just thinking it out, yes um and um the idea of music as an enacted event, um here. But this one was very interesting. um um You said um you'd like to have an instrument made, that's little more than an amp, which gives you the structure of a piece, like the membrane of a loud speaker, um and that would give great precedence to percussive event um and and that would obviously be, you know of interest um in Time-Base Theory) er yes es because an instant is percussive um and um the beginning of an extendedness. And um I'd I'd forgotten this) / (and um so I found these letters, recently, um which I'd kept, amazingly. um and um Very interesting to ...) / mm (um articulating time, the problem, was something I think you said also about *Finnegan's Wake*, that *Finnegan's Wake* was a breakthrough.) mm / I've managed to get quite a lot of uh (car) memorabilia from the uh time when I was er uh getting into James Joyce. (mm) / I didn't read the um, I haven't read Ulysses, I've just not been interested really, it didn't really get me. (yes) / But the other one, *Finnegan's Wake*, is the last one, and the Cambridge Audiological Institute had made a a recording of Joyce actually reading from a a (cars) piece about Anna Livia Plurabelle and it stuck in my head, (mm) as a poem would, (mm) and I could almost go through it again now but I wouldn't even try. (ha) (mm) You have to er you have to have a aaah an image of er a non-spatial / conti-continuum / in

Plate 1. David Toop, *The Body Event* (2009), booklet designed by Matthew Appleton, Modern Activity. (Image courtesy David Toop).

Plate 2. Michael McMillan, *A Living Room Surrounded by Salt* (Instituto Buena Bista/The Center for Contemporary Curacao Art, 2008). (Image courtesy of Michael McMillan).

Plate 3. Michael McMillan, *The Beauty Shop* (2008). (Image courtesy of Michael McMillan).

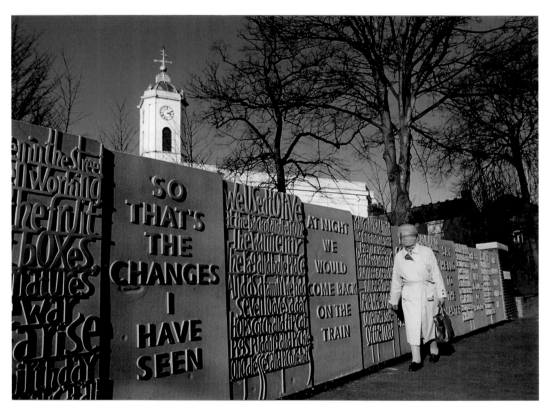

Plate 4. Bettina Furnée, *Witness* (1998), Church Street, Bilston, West Midlands. (Image courtesy of Richard Heeps).

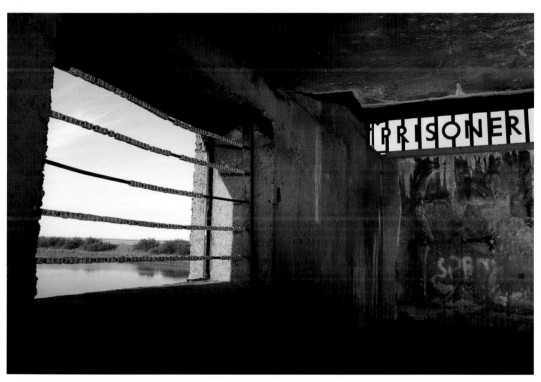

Plate 5. *Prisoner of War* (2005), detail of first-floor installations. (Image courtesy of Douglas Atfield).

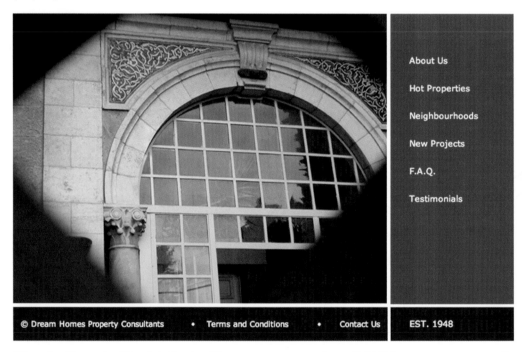

Plate 6. Alexandra Handal, *Dream Homes property consultants* (2012) homepage, new media documentary. (Image courtesy of Alexandra Handal).

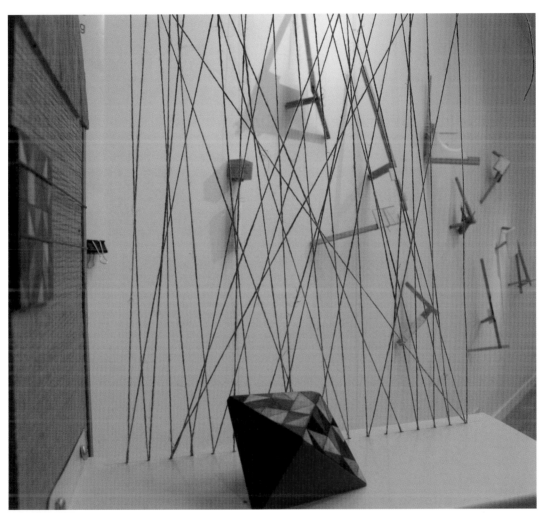

Plate 7. Making in Interaction. The work of Intelligent Trouble, 2011. (Photographer: David Gates).

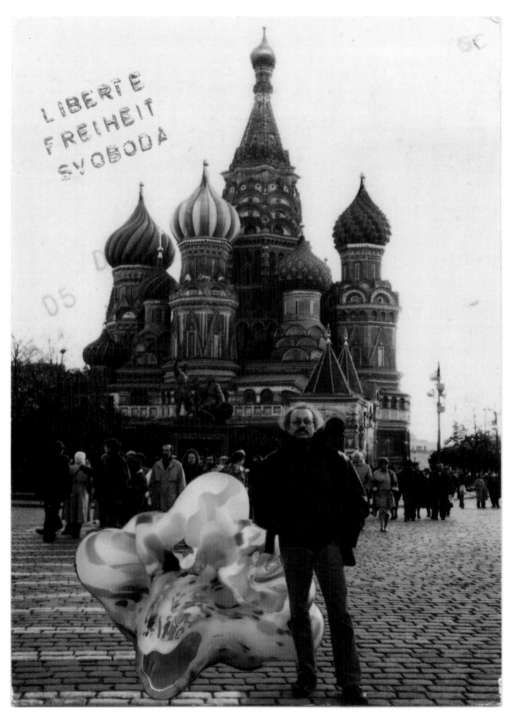

Plate 8. Marvin Lipofsky holiday postcard to Patti Warashina and Robert Sperry, postmarked February 6, 1990. Patti Warashina papers, Archives of American Art, Smithsonian Institution. (Image courtesy of The Archives of American Art, Smithsonian Institution).

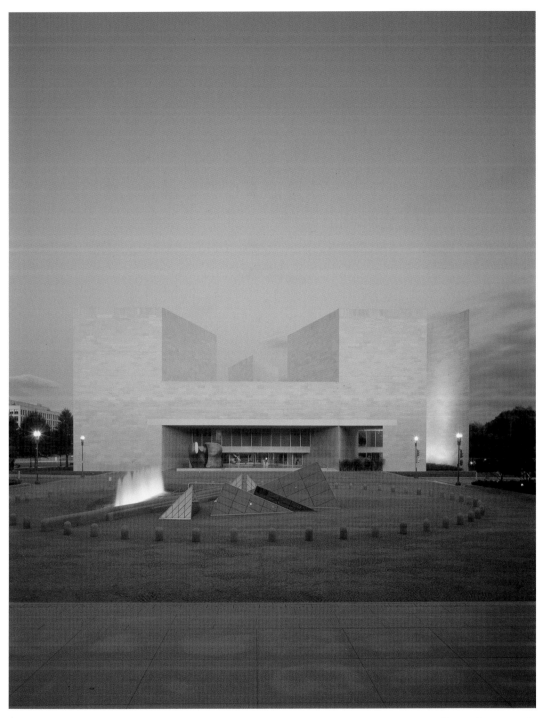

Plate 9. National Gallery of Art, East Building, Washington, DC. (National Gallery of Art, Washington, Gallery Archives; Photograph © Dennis Brack/Black Star).

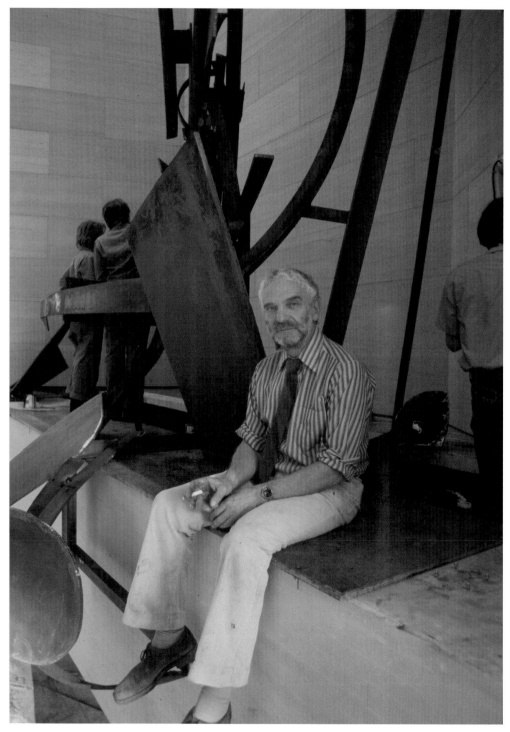

Plate 10. Anthony Caro during the installation of *National Gallery Ledge Piece*, March 1978. (National Gallery of Art, Washington, Gallery Archives).

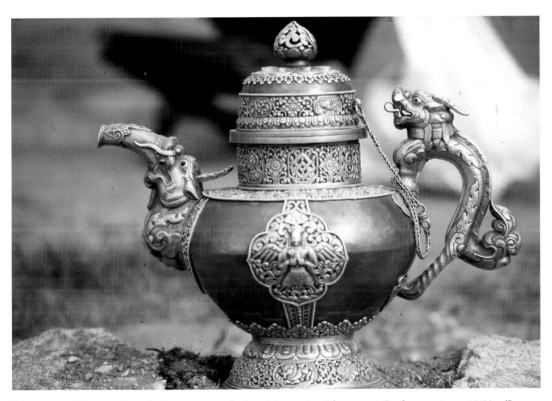

Plate 11. Dragon handled teapot made by Meme Le Phuntsog Spalzang circa 1950. (Image courtesy of the author).

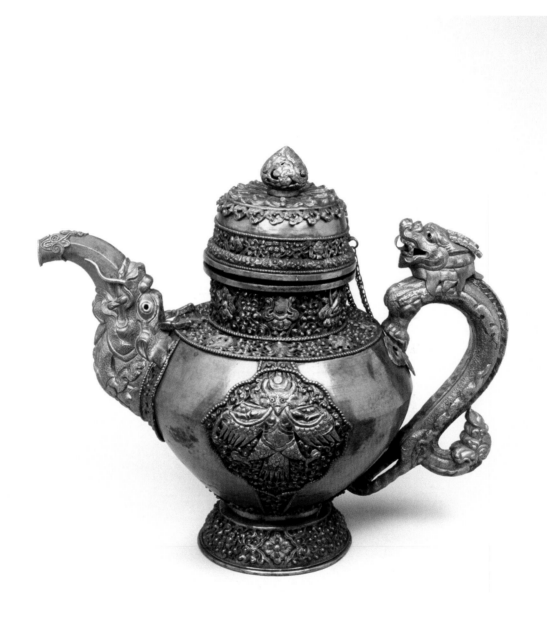

Plate 12. Teapot, brass, copper, and silver, from Hemis monastery in Ladakh; late nineteenth–early twentieth century, Victoria and Albert Museum, museum number IM 154–1921. (Image courtesy of the Trustees of the Victoria and Albert Museum).

Plate 13. Handprinted flyer for the Cork Craftsman's Guild, 1977. (Photographer: Bob Wright; designer unknown).

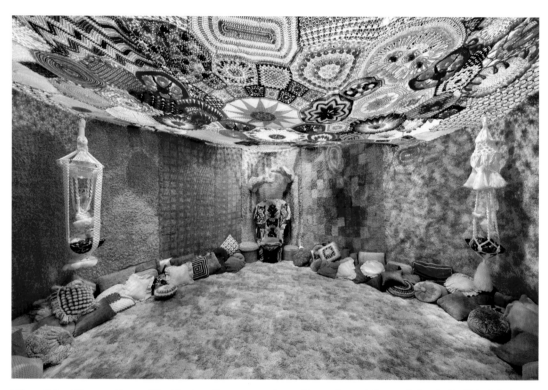

Plate 14. *Hungry Purse: The Vagina Dentata in Late Capitalism,* Allyson Mitchell. "Visible Vaginas" exhibition, David Nolan Gallery, New York City, 2010. (Photographs by Tom Powel Imaging, New York, courtesy David Nolan Gallery and Francis Naumann Fine Art, New York).

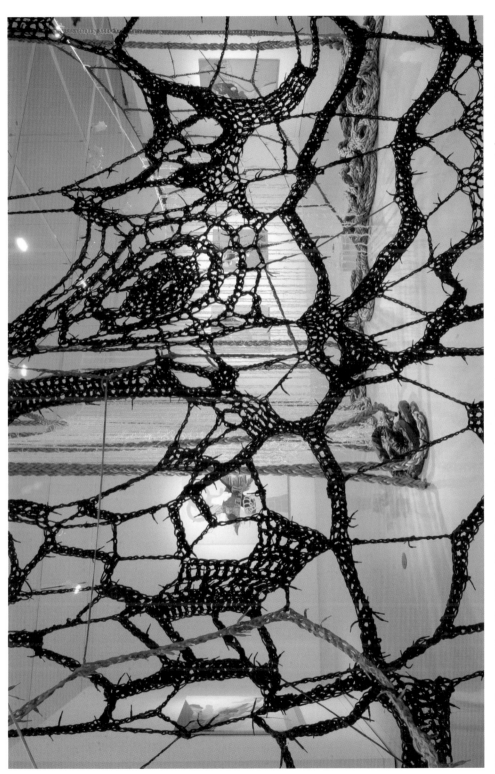

Plate 15. *Gowanus* (detail), 2004, Sheila Pepe. Nautical towline, shoelaces, shopping cart. Commissioned for *Two Women: Carrie Moyer and Sheila Pepe*, Palm Beach Institute of Contemporary Art (PBICA), Lakeworth, Florida. (Photograph by Jacek Gancarz).

Plate 16. Brightly colored child's play dress was probably made using two 100-pound feed or flour sacks. (Image courtesy of the author).

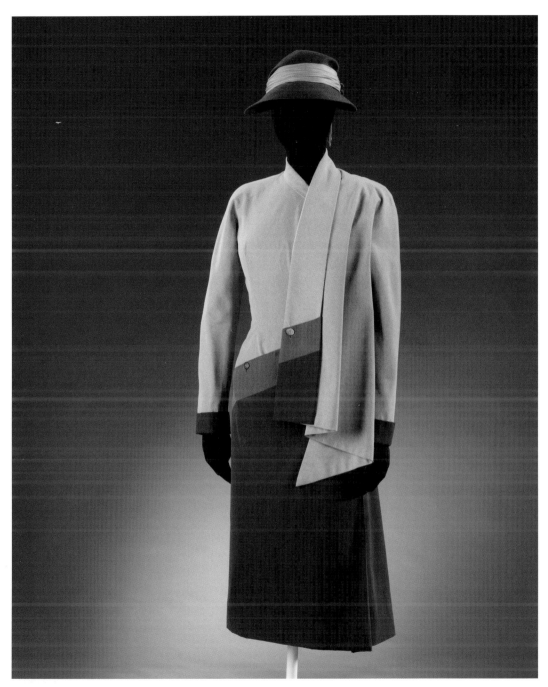

Plate 17. Gabardine day dress made for Lady Dacre in 1950 by the Paris couturier Jacques Fath. He amended the dress during her pregnancy and then again after the birth of her son. Lady Dacre recalled that the dress was "not altered in any way except that [it] could be let out." The matching scarf provided additional camouflage. Victoria and Albert Museum T.182–1974. (Image courtesy of the Trustees of the Victoria and Albert Museum).

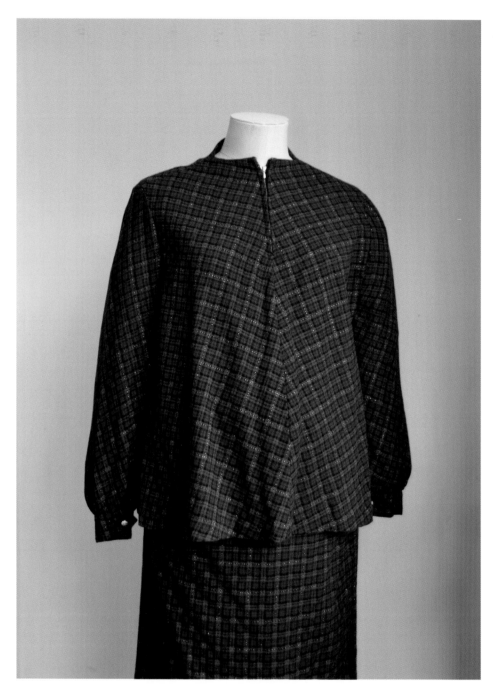

Plate 18. Two-piece maternity outfit worn by Honor Warner (1957–8), purchased at Webbers, Oxford. The maroon-and-blue-check wool fabric is shot through with silver Lurex. The flared top is bias cut and fastens at the neck with a zip. The skirt has adjustable zips at either side at the waistband. It is labeled "Maternity Model by Kruger of London." (Image courtesy of the author).

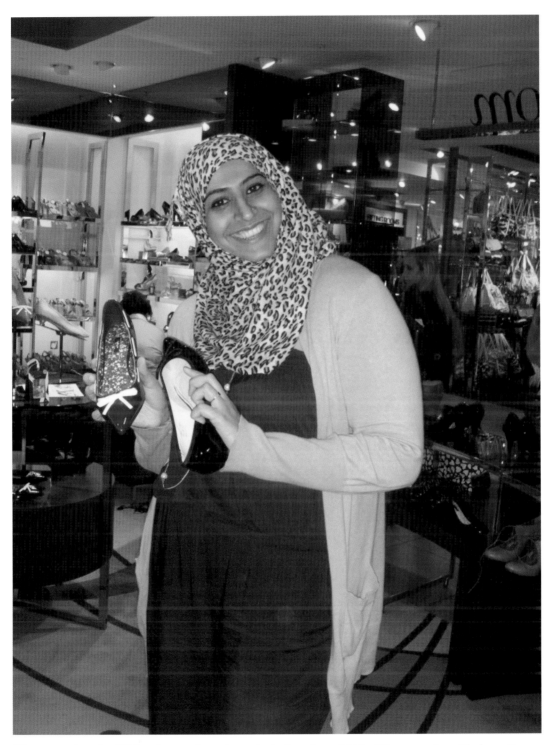

Plate 19. Annika Waheed on a shopping trip in London, 2011. (Photographer: Shehnaz Suter-walla; image courtesy of Annika Waheed).

Plate 20. Example of high street scarf used as hijab. (Photographer: Shehnaz Suterwalla; image courtesy of Annika Waheed).

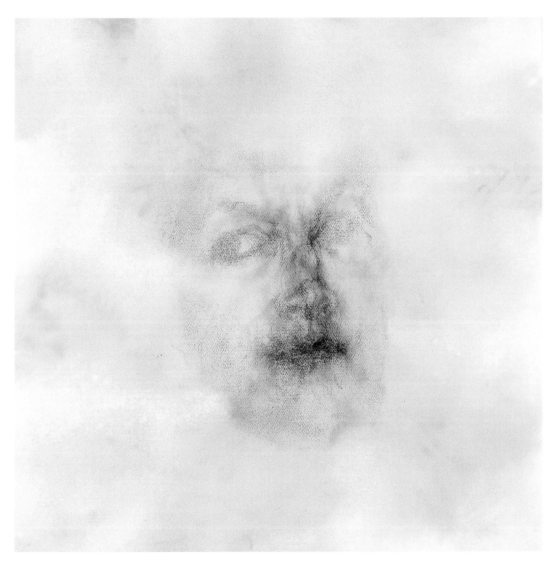

Plate 21. Gali Weiss, *MotherDaughter (as self-portrait)*, detail 1(2008); one of six parts, watercolor, photocopy transfer, charcoal, graphite, 75 × 75 cm. (Image courtesy of the artist; Photographer: Max Loudon).

Plate 22. Gali Weiss, *MotherSon* (2008), photocopy transfer, graphite, 37 × 30 cm each of fifteen drawings. (Image courtesy of the artist; Photographer: Max Loudon).

Plate 23. Crownhill Crematorium, Milton Keynes, Adrian Morrow of Architecture MK and MKC Environmental Health Architecture Team, with Robert Potter and Partners. (David Thrower, Redshift Photography).

Plate 24. Kimbell Art Museum, Fort Worth, Texas, constructed 1969–72. Louis I. Kahn (1901–1974), architect. (Photograph: Robert LaPrelle, © Kimbell Art Museum, Fort Worth, TX).

SPEAKING OF CRAFT
THE NANETTE L. LAITMAN DOCUMENTATION PROJECT FOR CRAFT AND DECORATIVE ARTS IN AMERICA
liza kirwin

The Smithsonian's Archives of American Art exists to foster scholarship in the field of American art by collecting, preserving, and making available primary source material documenting the history of the visual arts in the United States. Founded in 1954, the Archives was initially conceived as an agency devoted solely to microfilming records, but it soon became a repository for papers donated by individuals and groups who wanted to place them where they would be most effectively used. While it is hard to imagine today, in 1954 American art scholarship was in its infancy. As art historian William Innes Homer recalled, in the 1950s, "exponents of American art history were few, and those who were interested suffered from a shortage of courses nationwide. Dissertations in the subject were rare. There was an unwritten policy at many prominent graduate institutions that American art was not to be taken seriously, and as a result they offered little advanced instruction in the field" (2000:4). The Archives of American Art has grown up with and helped shape the field of American art history.

The Archives' oral history program began in 1958 with funding from the Ford Foundation. Collecting and interpreting human memory was a logical step for an organization committed to gathering and preserving primary sources. At that time, there were a number of living artists whose

memories stretched back to the early twentieth century. The first taped interviews were with painters Abraham Walkowitz (1878–1965), Charles Sheeler (1883–1965), and Edward Hopper (1882–1967). They not only had distinguished and influential careers, but all three had participated in the landmark Armory Show of 1913, the first large-scale exhibition of modern art in the United States. Their spoken reminiscences and observations of this event would be of obvious benefit to present and future historians. These first three interviews point out the unpredictability of a free and open dialogue with an interviewee: Walkowitz commented on the principal organizers of the Armory show; Sheeler remembered the collectors who purchased works from the show; and the person who interviewed Hopper did not ask any questions about the Armory Show. While each of these interviews contributes to a fuller understanding of the past, each is unique, revealing varying depths and personal experience and reflections.

Today the Archives' oral history collection includes more than 2,200 oral history interviews. Many of the transcripts are available online. They chronicle the great diversity of the American art scene, augmenting our perception of individual artists and their social worlds. It is the largest collection of its kind in the world. The best examples yield a richness of detail and a sense of character not available in written records. They preserve the voice of the artist, curator, or collector recalling the details of their lives in their own words. They allow scholars to eavesdrop on the ebb and flow of questions and answers and discern the particularities and the partial truths of a unique exchange. Although the Archives of American Art typically seeks to produce in-depth, lengthy oral autobiographies in multiple sessions, we have also created interviews around narrowly focused issues such as a particular artist or movement.

One of our most comprehensive oral history projects is the Nanette L. Laitman Documentation Project for Craft and Decorative Arts in America, a national collecting initiative in partnership with Museum of Arts & Design (formerly the American Craft Museum). In 2000, Nanette L. Laitman, an art collector and philanthropist, gave the Archives a substantial grant to capture, through oral history interviews, firsthand accounts of artists who have shaped the history of the studio craft movement in America. We sought to interview artists working in clay, glass, metal, wood, and fiber whose work is exhibited and owned by museums, whose reputations are national in scope, and whose advanced age make documenting their singular contributions a matter of urgency. To date, we have produced more than 200 interviews as part of this series using a range of expert interviewers. When a good interviewer/interviewee match is not apparent, we ask the interviewee to recommend a knowledgeable interviewer. This strategy not only empowers the interviewee in the process of creating an oral history, but also engages him or her in the success and completion of the interview.

Each interview is recorded digitally, is at least three hours long, and is completed in multiple sessions. The transcripts are edited in consultation with interviewer and interviewee. All the interviews start with a common set of questions that serve as a point of departure for individual lines of inquiry. Built around such topics as the artist's educational background, working methods, technical interests and innovations, and issues of patronage and influence, the interviews also touch on experiences and preoccupations that emerge across media—for example, apprenticeships, teaching, criticism, and sources of inspiration.

The Laitman interviews provide a broad and deep, and occasionally conflicted, history of studio craft in America. Taken as a series of related recollections, they offer many fruitful areas for further exploration, such as issues of identity, gender, ethnicity, class, and sexual and political orientation

that shape art historical discourse. With these interviews, one learns about distinct political agendas, as well as inescapable circumstances (see Cándida Smith, 1995). For instance, artist Patti Warashina, whose ceramic sculpture is not known for overt references to her gender and Japanese heritage, is nevertheless influenced by her cultural condition (see Figure 14). She recalled, "Even as a child, I have always been aware of my Japanese heritage because of my parents' mantra, 'to study hard,' and 'to not bring shame to your family name,' words I have always found very hard to live by. So, I do subliminally access that portion of my Japanese background in my art from time to time, when it seems pertinent for the moment" (Warashina, 2005:7).

Craft is a spectrum including a range of media and a range of forms—from utilitarian vessels, to idea-based works, to environmental installations, and wearable art. Innovation and experimentation both define the field and make it difficult to define. As a group, these interviews document the twists and turns of artistic influence and intention and allow us to apprehend each artist's aesthetic sensibilities in his or her own words. More often than not, these interviews enhance our understanding of the practice of craft within American art history. Craft is a process of breaking the rules. Ceramic artist Jim Melchert said, "And the nice thing about learning rules is that you have something to question. And you can learn a lot by starting out with your academic training and then gradually dissembling it" (2002:12).

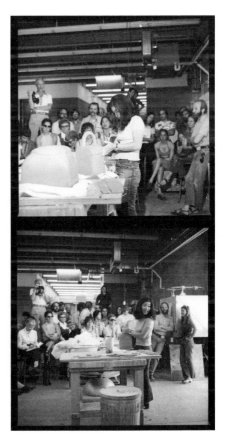

14. Patti Warashina workshop demonstration, ca. 1970. (Photographer unknown. Patti Warashina papers, Archives of American Art, Smithsonian Institution).

CRAFT NETWORKS

The multiple conversations captured in the Laitman project dovetail to provide an oral history of the development of networks and regional communities around craft schools, organizations, and institutions. For instance, many of the Californians interviewed for the Laitman project lamented that the craft world on the West Coast lacked a sense of community, compared to the social networks created around schools such as the Penland School of Crafts in Penland, North Carolina; Haystack Mountain School of Crafts in Deer Isle, Maine; and Arrowmont School of Arts and Crafts in Gatlinburg, Tennessee. However, ceramic artist Ron Nagle in San Francisco, commented, "I'm not really part of any community. . . . I'm just kind of on my own little island, and that's okay with me" (2003:62). Weaver James Bassler, based in Los Angeles, said, "The only kind of connections that I felt in terms of there being a craft community on the West Coast was through [curator] Eudorah Moore and 'California Design' [a series of exhibitions held at the Pasadena Museum of Art in Pasadena, California, from 1954 to 1956]" (2002:38). When he first taught at Penland, he noticed an East Coast network of craftsmen: "These schools [Penland, Haystack, and Arrowmont]

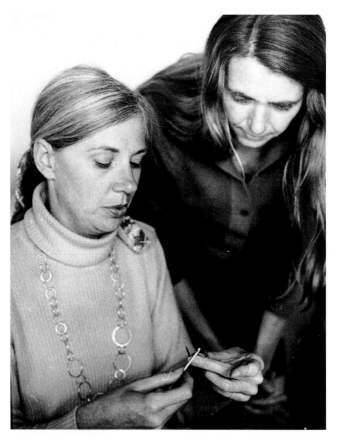

15. Arline M. Fisch teaching a student to crochet wire, ca. 1972. (Photograph by Arline M. Fisch. Arline M. Fisch papers, Archives of American Art, Smithsonian Institution).

are close enough together that they share experiences; they share noted craftspeople. They get on this little circuit. . . . And that's something that we never experience on the West Coast." San Diego jeweler Arline M. Fisch remarked, "The sense of community is so strong in these schools that that's what people talk about. That's what they remember . . . not so much what they learned, but what they experienced" (2001:54; see Figure 15).

TRAINING AND INFLUENCES

Various educational methods, from informal learning and apprenticeships to academic training, are described at length. Artists talk about variations on the theme of "learning by doing," and "learning by seeking out other artists." Dorothy Gill Barnes realized that her best teaching was not in the classroom, but was out in the field where she could show students how to properly harvest their materials—bark, vines, twigs, grasses, and the like. She said, "I knew from the start that if

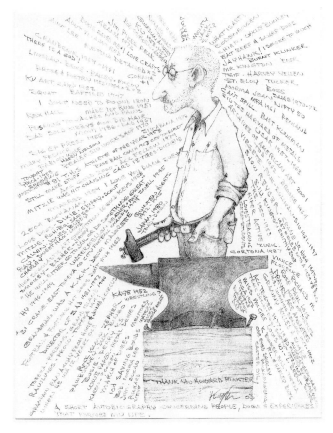

16. L. Brent Kington, "A Short Autobiography concerning People, Dogs and Experiences that Formed My Life," 2003. (L. Brent Kington papers, Archives of American Art, Smithsonian Institution).

they didn't have the material experience, that [students] weren't going to catch on to what we were talking about" (2003:52).

Glass artist Toots Zynsky talked about her aversion to apprenticeships, and the danger they engendered for artists wanting and needing to forge their own identity: "I've seen a lot of people apprenticed to people and lose themselves. They may be acquiring skills, but they lose themselves. And that's just my personal view of it. I'm sure you could talk to someone who had a wonderful experience apprenticing to someone, and it gave them the boost they needed. But for me, I wanted to stay away" (2007:20). However, many of the artists interviewed for the Laitman project, such as L. Brent Kington, Marvin Lipofsky, William Kesyer Jr., Robert Ebendorf, and others, established major departments of metal, glass, wood, and ceramics in their respective universities. Their firsthand accounts of the growth of those departments are central to the history of art education and the institutionalization of craft in America (see Figure 16).

It is surprising how many of these artists recalled outdoor adventures as a Boy Scout, a Girl Scout, or a member of a 4-H club, whose motto was "learning by doing," as formative experiences in their artistic careers. Metalsmith J. Fred Woell, who uses found objects in his metalwork for political and social commentary, points to scouting as his strongest influence. "It became my life," he said. "In fact, I almost became a professional Scout, you know. I loved camping and the outdoors. . . . I've tried to put myself into places where there is a strong sense of the environment; and in my own creative work there's often comments about the environment and protecting it, appreciation for it, or anger about what we're doing to trash it. And I think that all got started in those years" (2002:7).

MAKING: REPETITION, SERIES, AND MATERIALS

Repetition and series calls attention not only to the meditative qualities of craft making as a kind of therapy, but also to the demands of serial production that require consistency. There is a curious tension between a Zen-like, centered, contemplative effort and a commercial demand for uniform products—a hundred tea bowls, a set of glass goblets, a patterned textile, modernist cufflinks— but what is most intriguing is the artists' idea of imbuing objects with meditative properties. Fiber artist Norma Minkowitz said, "I like being able to repeat the same thing over and over again as I think of what I'm going to do with it. When I do it, I always start with a circle. I think that's from the days when I was doing doilies when I was a little girl, but also a circle is symbolic of the eternal—what word am I looking for—like movement, motion; it's continuous" (2001:3). Fiber artist Dominic Di Mare considered repetition to be the very essence of life: "I think what it [repetition] expresses to me is that whole idea of all aspects of one's life, that it's a mere repetition of itself. And you can equate to even the process of listening to your heartbeat, or the fact that you take in a breath and you exhale a breath" (2002:48; see Figure 17).

For J. Fred Woell, the greatest value of producing a series is the "serendipity element"—by allowing chance to enter into how he put things together, the process itself generates new ideas and surprising results (2002:31)—whereas Walter Nottingham works in series to limit his choices in a kind of "structured freedom," that is, the greater limit the artist places on him- or herself, the greater the creativity (2002:17). In many cases, these artists have spent a lifetime working with their chosen material and have a profound connection to it and a deep appreciation of its

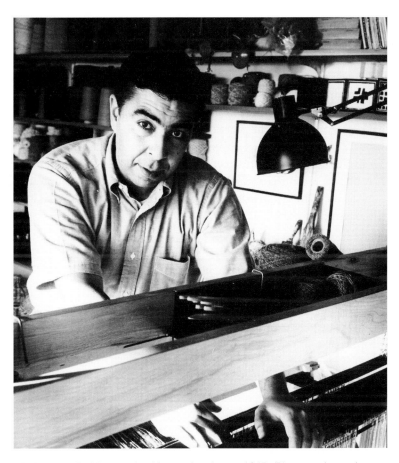

17. Dominic Di Mare at the Maccomber Loom, 1965. (Photographer unknown. Dominic Di Mare papers, Archives of American Art, Smithsonian Institution).

expressive limits and possibilities. Ceramist Paul Soldner is a case in point, when he praises the expressive and expansive qualities of clay:

> Well, there's no other material that I know of that will do as much as clay. First of all, it's truly plastic. . . . clay has the unusual property of being movable, stretchable, shrinkable, plastic, even when it's cold. Clay can also be glued together without any other glue, by itself, just with a little water and a little slip. . . . there are so many different ways you can work with clay. You can make a liquid out of it, pour it in a mold. You can make it semi-solid, put it on a potter's wheel and form open vessels and closed vessels. You can carve it. You can sand it. You can pull it. . . . you can make it waterproof. If you heat it up high enough, you can make it beautiful with glazes that can be colored and they will last almost forever. (2003:49–50)

Through these interviews, one gains an understanding of how concepts and skills are intertwined, or of how craftsmanship is not only the means of representing ideas in material form but also integral to the idea itself. For fiber artist Gyöngy Laky, her process is about "thinking

physically" and "thinking mentally." She said, "I believe that my protracted process is also thinking time, both thinking physically with the activities and thinking mentally with the time. . . . It may be that I make pieces more complicated in order to slow down" (2007:35).

What does handmade mean in today's world? For instance, does one have to manipulate clay by hand to make meaning from it? Using Gestural Interface Technology, one can now "throw" a digital pot and have the 3-D drawing appear on a monitor. Is this handmade? Is it craft? Is it important to consider digital pottery as part of the practice of contemporary craft? These interviews open the idea of craft to a broader dialogue about art in global culture. While Jim Melchert acknowledged the importance of the handmade in craftwork, and that a great deal is communicated by the hand, he commented, "It doesn't mean that you've got to handle the clay, wet clay, in order to use it as a means of communication" (2002:7). Artists are questioning values and methods that seem fundamental to the field of American craft.

ORAL HISTORY AND THE ARCHIVE

While these interviews offer a wealth of raw material for writing histories of the American studio craft movement, as with all oral evidence, they should be used with caution. The first-person narrative is so seductive that researchers can take oral history interviews at face value as factual evidence. The fact is that people reinvent the past in response to their current circumstances and the particularities of the interviewer, and they often defend and distance themselves from their experiences. One has to consider the vicissitudes of time, absentmindedness, selective memory, suggestibility, and even current medications. As glass artist Marvin Lipofsky admitted, "Sometimes I remember I saw something but I can't remember exactly what it was. I know it was really important, but it was so many years ago that I don't have a strong visual image of it" (2003:74).

Interviewees are often asked to recall, in some detail, events that happened decades earlier. An artist's willful reinvention of the past is as valid to the biographer as the anecdotes that pass as reliable history, but one needs to discern the multiple truths of each life story. The common narratives, as well as the discordant accounts—provide a semblance of "truth." But what is perhaps more meaningful is the way in which the interviewees made sense of their lives. How they create coherent stories—the language they use, the structure of their narrative, the revisions to their retold life stories, reveal not only their interpretation of past events but also who they are in the present relative to the interview session (see Linde, 1993). More often than not, artists interviewed for the Laitman project gave structure to their narratives by talking about their lives as a series of experiments, full of trial and error but also a few stunning successes. By experimenting with materials, techniques, methods, and means, they charted their own paths with individual choices and consequences. They talk about their lives not in terms of artistic milestones, but as creative journeys. "Thirty-five, thirty-seven years now I've continuously experimented," said glass artist Paul Marioni, "I've developed a lot of techniques, and I used to be more well known for innovative techniques. But after years of saying it's not about the technique, people finally stopped associating me with that" (2006:39). For glass artist Richard Marquis, there is a moment of truth in his creative journey that he finds hard to articulate:

> Some of the things I make—when I'm making them, I don't even know what I'm doing. I'm just sort of experimenting. And so, that moment of truth, the thing I'm looking

for—it could be, it's kind of abstract. It could be right at the very end or it could be in the middle. There's something about glassblowing that I don't think any other material really has. You have this moment of truth where it works or it doesn't work. (2006:40)

In these life stories, craft occurs in a space between rigorous skill and happy accidents, where the imagination is set free. When fiber artist Dorothy Gill Barnes creates a basket, she leaves the outcome undecided: "I don't set out to make a basket as a functional object. I'm pretty much experimenting with materials from nature and some of them are vessels and many of them are not" (2003:25–26). Joyce Marquess Carey was attracted to fiber because her first weaving teacher, Larry Edman at the University of Wisconsin–Madison, gave her overt permission to experiment. She said, "So right from the very beginning when I was just taking beginning weaving classes, I wasn't making, you know, traditional placemats and that kind of stuff. Nobody in our class was. We were all stretching the limits of the technique" (Carey, 2002:20).

With the Nanette L. Laitman Documentation Project for Craft and Decorative Arts, the Archives of American Art has taken a build-it-and-they-will-come approach to laying the foundation for future scholarship. These interviews open the past to new discovery, understanding, and interpretation. There are many histories yet to be written about craft and these interviews are part of the raw materials for doctoral dissertations, book, films, and educational programs that will place the practice of craft within the history of American art and culture.

REFERENCES

Cándida Smith, R. (1995), *Utopia and Dissent: Art, Poetry, and Politics in California,* Berkeley: University of California Press.

Homer, W. I. (2000), "A Rolling Snowball," in *American Art*, Chicago: University of Chicago Press in association with the Smithsonian American Art Museum.

Linde, C. C. (1993), *Life Stories the Creation of Coherence*, New York: Oxford University Press.

Interviews

All oral history interviews cited are part of the Nanette L. Laitman Documentation Project for Craft and Decorative Arts, Archives of American Art, Smithsonian Institution. To view completed transcripts online, visit the Archives' website at <http://www.aaa.si.edu/collections/interviews>.

Barnes, Dorothy Gill, (2003), oral history interview conducted by Joanne Cubbs, May 2 and 7.

Bassler, James, (2002), oral history interview conducted by Sharon K. Emanuelli, February 11 and 14; April 9; and June 6.

Carey, Joyce Marquess, (2002), oral history interview conducted by Glenn Adamson, June 16.

Di Mare, Dominic (2002), oral history interview conducted by Signe Mayfield, June 4 and 10.

Fisch, Arline M. (2001), oral history interview conducted by Sharon Church, July 29 and 30.

Laky, Gyöngy (2007), oral history interview conducted by Mija Riedel, December 11 and 12.

Lipofsky, Marvin (2003), oral history interview conducted by Paul Karlstrom, July 30 and 31, and August 5.

Marioni, Paul (2006), oral history interview conducted by Mija Riedel, September 18 and 19.

Marquis, Richard (2006), oral history interview conducted by Mija Riedel, September 15 and 16.

Melchert, James (2002), oral history interview conducted by Renny Pritikin, September 18 and October 19.

Minkowitz, Norma (2001), oral history interview conducted by Patricia Malarcher, September 17 and November 16.

Nagle, Ron (2003), oral history interview conducted by Bill Berkson, June 8 and 9.

Nottingham, Walter (2002), oral history interview conducted by Carol Owen, July 14, 15, and 18, 2002.

Soldner, Paul (2003), oral history interview conducted by Mija Riedel, April 27 and 28.

Warashina, Patti (2005), oral history interview conducted by Doug Jeck, September 8.

Woell, J. Fred (2001), oral history interview conducted by Donna Gold, June 6 and 11.

Woell, J. Fred (2002), oral history interview conducted by Donna Gold, January 9.

Zynsky, Toots (2007), oral history interview conducted by Tina Oldknow, July 27 and 28.

9.

THE MUSEUM AS A WORK OF ART

INTERVIEWING MUSEUM ARCHITECTS, ENGINEERS, AND BUILDERS

anne g. ritchie

Anyone who has visited the National Gallery of Art in Washington, D.C., knows that it is divided into two remarkably different yet surprisingly compatible buildings. Their styles and their collections contrast as vividly as London's Tate Britain and Tate Modern—if you can imagine them side by side. The National Gallery Archives has used oral history to consider the museum buildings themselves as works of art, by interviewing not the artists whose work is displayed inside but the architects, engineers, and builders who envisioned the structure and then turned that vision into reality.

Washington's National Gallery of Art opened in March 1941. Andrew Mellon, a wealthy businessman from Pittsburgh, Pennsylvania, secretary of the Treasury, and U.S. ambassador to the Court of St. James, provided the funds for the gallery's building construction. Mellon also donated his considerable art works to form the core of the gallery's permanent collection. Having traveled extensively and visited numerous museums abroad, Andrew Mellon observed that Washington lacked a top-rate art museum similar to those in other capitals. He chose the site for the museum,

a desirable location on Washington's National Mall next to the Smithsonian's Natural History Museum, and at the base of Capitol Hill. He then selected the prominent neoclassical architect John Russell Pope to plan and design the building (Bedford, 1998; Cannadine, 2006). That original building, known today as the West Building, housed a small but growing permanent collection and featured modest temporary exhibitions. Given that he provided all the money to build it, it seems surprising that Mellon refused to put his name on the National Gallery, but he felt that not doing so would encourage other donors to contribute their own collections, which indeed they have. By the early 1960s, space in the gallery was becoming more limited, and the museum's leadership began to consider expansion. It was also broadening the museum's magnificent art collection beyond its classical and impressionist masterpieces to incorporate more modern art, much of which would need larger areas for exhibition.

Fortunately, Andrew Mellon had thought ahead and had acquired a trapezoid-shaped piece of property across the street from the Gallery, bordered by Pennsylvania Avenue, Constitution Avenue, and the Mall. For years, this little plot of land held nothing more than tennis courts, but in 1968, the gallery presented this odd shape as a challenge to the distinguished architect I.M. Pei (Cannell, 1995; Wiseman, 2001). Pei created a plan that incorporated a series of triangles to fit the space, and included a marble exterior that would match the original building but would use entirely different construction techniques to fit its more angular, modern appearance. In 1978, the National Gallery (Plate 9) celebrated the opening of this new East Building (McLanathan, 1978:2).

As the National Gallery's fiftieth anniversary approached in 1991, the then director, J. Carter Brown, collaborated with Maygene Daniels, head of the gallery archives, to initiate an oral history program. The program was designed to interview the gallery's early employees, some of whom had begun working even before the museum officially opened its doors in 1941. Although intended as a two-year program, because of its success it continues today as part of the ongoing functions at the gallery archives.

The first person interviewed for this program was Paul Mellon, the son of the gallery's founder Andrew Mellon, and an avid and generous supporter of both the archives and the oral history program. However, this was not to be just a "top-down" oral history program. Among the other interviewees were Thelma Thomas, the gallery's first and long-time telephone operator (whom others on the staff suspected of listening in on their calls), and the horticulturalist Noel Smith, who nurtured the gallery's landscaping including the beautiful wisteria that surrounds the West Building and blooms each May. Curators, administrative staff, executive officers, trustees, and donors also shared their stories and enriched the gallery's historical record.

Although the program began by commemorating the fiftieth anniversary of the West Building, it soon shifted its focus to those who had been associated with the design, planning, and construction of the gallery's East Building. We noted that although the West Building had opened in 1941, fewer than twenty-five years later, plans were underway for the East Wing. How did this new building come to be? What were the factors that urged the gallery's officers and trustees to consider additional space in a separate building on an odd-shaped piece of land? How was the building designed? Who built the building, and how was it paid for? How has the building been used since it opened to the public in 1978? How have curators and exhibition designers utilized the spaces within? How has the building that was designed with cutting-edge technology weathered over the years?

These are not just academic questions. The gallery archives preserves the architectural drawings and specifications for the building. In the 1980s, I. M. Pei & Partners donated all of their records relating to the East Building constructions including correspondence, meeting minutes, trade files, early design sketches, architectural and shop drawings, progress photographs, and sample materials to the gallery archives. As a result of housing these records, the archives are constantly consulted by construction companies and art handlers who are either repairing or restoring parts of the building, or moving in weighty art works that the floors may or may not be able to support. The oral history interviews have become a valuable component of the archives because they explain the intentions, and the problems and solutions that lay behind the plans in our files.

In a 1994 interview, gallery director J. Carter Brown recalled the early discussion and planning for the gallery's expansion noting of his predecessor,

> John Walker's brilliance was to spot the need for some expansion of our visiting scholars program as a reason to nail down the adjoining site, which had been reserved with the incomparable vision of Andrew Mellon for the future expansion of the National Gallery. It boggles the mind to think that Andrew Mellon, who was giving a building with something like a hundred and thirty galleries in it, of which his collection could fill only five, thought that they would ever need more space. (1994:3)

The list of occupants for the new building grew quickly to include visiting scholars, the library, administrative offices, curators, and education programs. As always, a critical component would be art.

The gallery's board of trustees agreed to the expansion. Paul Mellon, the gallery's president, and his sister Ailsa Mellon Bruce, came forward to underwrite the cost of the building. Carter Brown noted that "the tea leaves were all favorable, and timing is everything in life . . . So we proceeded." (Brown, 1994:8) Another critical point was the selection of an architect. Careful thought, review, and on-site visits to buildings by notable architects took place. In July 1968, the gallery's board of trustees selected I. M. Pei as the architect for the new building.

The next year, Carter Brown succeeded John Walker as the gallery's director. Six months after that an exhibition titled *British Painting and Sculpture, 1960–1970* (Lucie-Smith, 1970) opened in the West Building, making it the first time that contemporary art was exhibited there. Carter Brown observed that

> in my youthful way I was able to parlay this into an exhibition of contemporary English art of a rather avant garde stripe . . . I had a terrible time hanging these big, frameless paintings against walls that had moldings. There were moldings, dadoes, and a very aggressive floor pattern with the beautiful oak floors. You can't put a Tony Caro down on top of that. It sits right on the floor and it's interfered with. (1994:6)

The room devoted to the Caro sculpture had a white plastic floor covering, and the walls and floor were all matching white; the sculpture seemed to float in a void in a room unsuited for it. For Carter Brown, this emphasized "a need for an East Building that did more than just house a center for scholars" (1994:6).

Carter Brown went on to describe his visits to other museums to study what worked and did not work, the challenges of designing a building on the irregularly shaped site, the effects of light

on visitors and art, personnel involved with the project, frequent meeting of the building committee, rising costs of labor and materials, the works of art that were specifically commissioned for the building and numerous other details that consumed him during the design and construction. At the end of the two-hour interview, I asked him, as I do with many interviewees, "Is there anything I've forgotten to ask you in our brief time?" Without missing a beat, he quickly replied, "There is lots! I mean, it was ten years of my life! I couldn't possibly in a few minutes summarize it all. It was day in, day out, decisions" (Carter Brown, 1994:42).

Even as the Gallery's former director, Carter Brown's time was tightly scheduled so I did not have the luxury of multiple sessions on one topic. However, I did interview him on two other topics: the design and installation of special exhibitions and the gallery's acquisitions during his tenure as director. The additional interviews we had planned never occurred, due to his untimely death in 2002.

Clearly, the next key person in the project was the architect I. M. Pei (see Figure 18). Carter Brown admitted that he "had been an admirer of Pei's work, and I just felt his sense of space and form was what you needed in an art museum" (1994:50). Shortly after Pei's selection as the project architect, he and his design team began to develop exploratory designs based on the program details and the ideas of pods for temporary exhibitions. The strategic location of the building, at the foot of Capitol Hill, meant that the design would be reviewed and scrutinized by several agencies: the Pennsylvania Avenue Development Corporation, the Commission of Fine Arts, and the

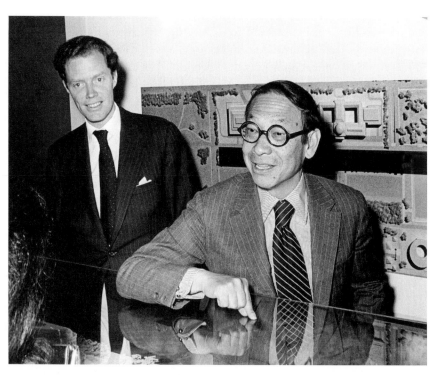

18. I. M. Pei with J. Carter Brown at press conference to announce East Building plans, May 5, 1971. (National Gallery of Art, Washington, Gallery Archives).

National Capital Planning Commission, not to mention the gallery's building committee headed by Paul Mellon.

Pei recalled one of the meetings he and Carter Brown had with the Commission of Fine Arts:

> They looked at it [the design] very, very carefully and they should. We were pleased with that because it also gave us reason to be very sure of ourselves before we went in to see them. We went in quite well prepared, actually, because we thought about all these—the axis problem, the height limit of the two avenues, having very different height limits, and how to accommodate this pivotal site. So those were the opportunities and also the constraints of the site. The constraints are very great, as you see. Also, because of that, it presented us with the opportunity to do a building that has a character of its own which is unique for this site, and wouldn't work in any other site. (1991:7–8)

Pei also cited the challenge of connecting the two buildings. A surface connection was out of the question so the underground (or connecting link as it came to be called) was developed. This too posed limitations as Tiber Creek still flows beneath the surface of Washington, making building underground expensive and requiring innovative technologies.

Some of the unique architectural elements, such as the moving walkway that now connects the two buildings, were once a matter of considerable debate. Today such walkways are commonplace in airports, but in the early 1970s, they were not yet so familiar or accepted. When it came to new technologies, Pei and his design team pushed the envelope. The space frame covering the East Building's atrium, the coffered ceiling in the large auditorium, architectural concrete, and the exterior marble all required engineering and building skills to put the concepts into reality.

Fortunately for the project, J. William (Bill) Mann, the project manager for Tompkins Construction Company (see Figure 19), was able to interpret many of these elements in a series of interviews. He greatly expanded our knowledge and appreciation for what goes into such a building. He explained construction joints, concrete pours, control lines, tie-downs, the exterior de-watering system used for the foundation, the essential triangular shape of the buildings elements—everything from the groundbreaking to the completion of the project.

Not only did he explain; he sometimes posed the questions. To connect the two buildings, a portion of the West Building's foundation was excavated. Mann said that the process demanded great precision to prevent the marble floors above, which had been in place for over thirty years, from cracking:

> So comes the question, how do you transfer the load without cracking the marble? No one knows the weight of the marble. No one knows the construction other than what you had from drawings. Steel beams will sag until they take up the weight. So if you just did it that way and let it sag you're going to break up all the marble. So we had to preload the steel beams. We had to induce a weight on the steel to approximate the marble, and then cut the piling out and let the weight of the marble come on the beams without moving the marble. So the structural engineer told us how much we should preload it. (1992:24)

Mann worked closely with everyone on the job and he valued good work. "The Washington Building Congress has what they call a Craftsmanship Awards Program," he recalled.

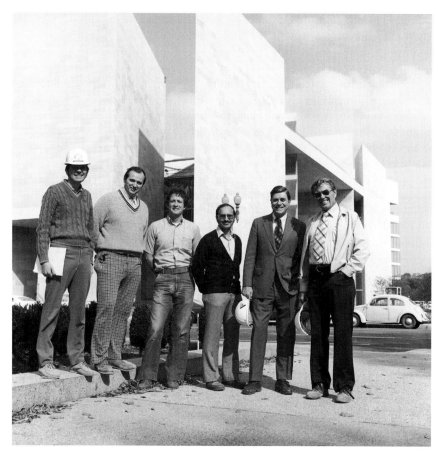

19. J. William Mann (second from right) with construction workers, c. 1978. (National Gallery of Art, Washington, Gallery Archives).

They honor outstanding workmanship in the various trades. So I thought, "Well, this is a good vehicle to create interest in the job," so I looked for outstanding work in whatever area to draw attention to the kind of workmanship we expected in that job. The job got twenty-six or twenty-seven craftsmanship awards, which was many times what any job had ever gotten in the history of the Washington Building Congress. No one had ever gotten one for reinforcing steel. That'd be ridiculous. Well, when they came down and saw what this man was doing, it took a real craftsman to understand how to do that, just as much as it takes a real craftsman or artist to paint a picture. He was painting his picture in reinforcing steel. (1992:12)

When asked if that meant he had to work closely with the subcontractors, he responded,

I knew probably 500 men by their first names, and I'd see them every day. I was constantly commenting on their work. If they did well, I'd say, "Why didn't you do this way yesterday?" If they did poorly, I would say, "You're capable of doing better. Let's get your mind back on your work." This constant talking to the men and the craftsmanship awards

drawing attention to good workmanship, instilled a pride in these people. I took each person by groups to see the model. (Mann, 1992:12–13)

As project manager for the construction company, Mann interacted with staff in the gallery's planning office, the numerous consultants on the job, the artists commissioned to create art for the specific sites in and around the building, and the members of the gallery's building committee. He described the work of that committee recalling that the meetings were well orchestrated:

> Pei would often make models of what he proposed. He would talk to the structural engineer ahead of time to learn if there were any pitfalls along the way so he could modify it. By the time he brought it up at a meeting, he'd already done his homework. He would say to me, "Can you build it?" I'd turn to the structural engineer and I'd say, "Can you design it? Will it stand up?" He'd say, "Yes." I said, "If you can design it, I can build it." (Mann, 1992:60)

As the building plans took shape, the gallery commissioned a number of works of art for specific locations within and around it. These included Alexander Calder's mobile *Untitled* that graces the atrium and Henry Moore's *Knife Edge Mirror Two Side* prominently placed at the building's entrance. The process of selecting, commissioning, and installing the works of art is a topic covered in many interviews. Most of the artists completed their work in their studio and they were then transported to the gallery. However, much to Mann's dismay and consternation, the sculptor Anthony Caro (Plate 10) arrived with tools to create and install *National Gallery Ledge Piece* on site. Said Mann,

> I remember Tony Caro came with his welding operation. He had this figure, this thing was to drape over our architectural concrete. I met him and I said, "Tony . . ." And he had union welders out there, union welders built everything under his direction. They'd weld it up, and he'd stand back and look at it, and he'd say, "Tear it up. Do it again." I told him when he started, I said, "All right, Tony. If you hurt my architectural concrete, I'll kill you!" Weld burns—when you're welding things and the weld metal flies about, if it touches glass or it touches the architectural concrete it burns on contact and you've got a burn place. There's nothing you can do about that. So we've got to have a complete protection of this architectural concrete that you're working with. You put your protection on, so when you get through you can take your protection off and our concrete isn't hurt. Because if you burn a place in it, I can't restore that the way it should be. So I was constantly on his back. He was a nice fellow, but he felt my presence the whole time he was there. He did a good job and he did not mess up anything. (1992:97)

When these interviews were recorded in 1992, at his home in rural Virginia, Mann generously shared his knowledge and enthusiasm for the East Building. He also gave the gallery archives hundreds of slides documenting the intricacies of the challenging processes he described. After the interviews were completed, he visited the National Gallery and gave the archival staff a top-to-bottom, behind-the-scenes tour of the construction project, pointing out all of the details he had described in his interviews.

Enough time has now passed that the "new" East Building has begun to show signs of age and has experienced some failures in those cutting-edge technologies that were used in its construction. The perimeter of the building is currently cordoned off, and a special passageway has been

constructed for entering the building. A serious problem was discovered with the exterior marble pieces coming loose; they were described as wiggling like a loose tooth and possibly falling to the ground below. When Mann read about the problem in the *Washington Post* (Trescott, 2009), he immediately called the gallery's office responsible for the repairs to offer his assistance in describing the original method of installing the marble.

In addition to interviews that document the planning and construction of the East Building, others recounted stories about the building before it opened. The curatorial staff has shared their experiences of designing some of the blockbuster exhibitions that have filled those spaces, ranging from *The Splendors of Dresden* (Metropolitan Museum of Art, 1978) to *Circa 1492: Art in the Age of Exploration* (Levenson, 1991). Using their remarkable talents, the designers have literally rearranged the gallery's interiors, adding walls and elaborate moldings, finding appropriate paints and fabrics for backdrops, adjusting the lighting, moving in plants, and otherwise staging exhibitions in ways that create atmospheres appropriate to the specific exhibitions. In fact, the atmospheres are so appropriate that most visitors are unaware of how much has gone into the exhibition's design, just as most are unaware of the contributions of the architects, engineers, and builders who made the setting possible.

What almost stumped the designers, however, was the exhibition on the fiftieth anniversary of the National Gallery, the very reason why the oral history program was launched. Although the designers were used to handling priceless works of art, they had never before hung a document on the museum's walls. The designers grumbled about having to handle history rather than art, but they mounted a superb exhibition, *John Russell Pope and the Building of the National Gallery of Art* (Thomas, 1992), which included construction photographs, architectural drawings, and archival materials. This was later followed with a smaller exhibition on the twenty-fifth anniversary of the East Building, *The East Building: Celebrating 25 Years*, which incorporated the oral histories. Those of us involved with the oral history program were especially pleased that a considerable part of the crowd that came to view the exhibition were gallery employees, the working staff at all levels, including the guards, who were curious to learn more about its history and who appreciated the buildings themselves as works of art.

REFERENCES AND FURTHER READINGS

Alofsin, A. (ed.) (2009), *A Modernist Museum in Perspective: The East Building, National Gallery of Art*, Washington, DC: National Gallery of Art.

Bedford, S. (1998), *John Russell Pope: Architect of Empire*, New York: Rizzoli.

Cannadine, D. (2006), *Mellon: An American Life*, New York: Alfred A. Knopf.

Cannell, M. (1995), *I.M. Pei: Mandarin of Modernism*, New York: Carol Southern Books.

Levenson, J. (ed.) (1991), *Circa 1492: Art in the Age of Exploration*, Washington, DC: National Gallery of Art.

Lucie-Smith, E. (1970), *British Painting and Sculpture, 1960–1970: An Exhibition Organised by the Tate Gallery and the British Council*, London: Tate Gallery.

McLanathan, R. (1978), *East Building, National Gallery of Art: A Profile*, Washington, DC: National Gallery of Art.

Metropolitan Museum of Art (1978), *The Splendor of Dresden: Five Centuries of Art Collecting*, New York: Metropolitan Museum of Art.

Thomas, C. (1992), *The Architecture of the West Building of the National Gallery of Art*, Washington, DC: National Gallery of Art.

Trescott, J. (2009), "National Gallery's East Building Needs a $40 Million Facelift," *Washington Post* (May 8).

Wiseman, C. (2001), *I.M. Pei: A Profile in American Architecture*, New York: H. N. Abrams.

Interviews

Carter Brown, J. (1994), interviewed by Ritchie, Gallery Archives, National Gallery of Art, Washington, DC, February 7.

Mann, J. W. (1992), interviewed by Ritchie, Gallery Archives, National Gallery of Art, Washington, DC, March 26 and April 14.

Pei, I. M. (1993), interviewed by Ritchie, Gallery Archives, National Gallery of Art, Washington, DC, February 22.

10.

ORAL HISTORY WORK WITH TIBETAN AND NEPALESE METALWORKERS (1986–91)

john clarke

My present role is that of curator of the Himalayan collections in the Victoria and Albert Museum. In this post, I have sought to develop a broad knowledge of Himalayan arts and cultures and especially those of Tibet. However, my specialization in Tibetan metalworking began far earlier, when, as a new employee, I was required to move large numbers of Tibetan metal objects as part of a storage project. The sheer physical encounter with the objects inspired me to delve into the subject. To my surprise, I found that very little had been written on such pieces or on the subject in general.

The eventual title of my PhD thesis was "A Regional Survey and Stylistic Analysis of Tibetan Non-Sculptural Metalworking, c.1850–1959," a degree awarded by the School of African and Oriental Studies (University of London) in 1995. I approached this subject neither as an anthropologist nor an oral historian—my training having been largely as an art historian. I had no experience in oral history work before starting, and I was using it pragmatically, purely as a means to an end, which was to understand several things about metalworking before the Tibetan uprising of 1959, which marks such a watershed in Tibetan history. After that date, direct rule from Beijing was imposed, and the previous social and political structures were comprehensively swept away. The inspiration behind my use of oral history sources were several fold. First, there was a paucity of published studies on this subject, only one thesis having explored some of the issues I wanted

to explore (Ronge, 1978). Second, there was the historical and cultural prejudice in the Tibetan world against writing about a subject such as metalworking. Blacksmiths, and by extension any other metalworkers, were considered of low social status in this deeply Buddhist country because they made weapons or implements, such as knives, that could take life. The result is that there is little indigenous literature on the subject. The pioneering study by Veronika Ronge, mentioned earlier, though dealing mainly with socioeconomic issues relating to a broad spectrum of crafts-people, also alerted me to the undoubted reservoir of knowledge existing among craft workers that was available through oral history work. As an art historian and a curator, I wanted to understand patterns of production and patronage before then: who was making things for whom, how commissioning worked, and where and in what social setting metalworkers lived. My other aim was to investigate the question of whether regional styles in metalwork, that is, domestic and ritual vessels, existed in this large region not only spanning a zone from Ladakh in Jammu and Kashmir state in India through the traditional heartland of Tibet but also including the western Himalayas eastward to present day Sichuan, Gansu, and Qinghai provinces in China. No one had seriously looked at these issues before. In my role as curator of the Himalayan collections, I had tried to make sense of the large body of Tibetan metalwork in the Victoria and Albert Museum's collection for the previous two years, with little success. I therefore felt that the best approach was to let myself be guided by the perceptions of older, experienced craftsmen who I knew were living in settlements in both northern and southern India. The huge loss of life and destruction that occurred in Tibet during the Cultural Revolution of 1966–77, together with the probable scarcity of older craftsmen and the potentially increased difficulties involved in conducting research in a politically sensitive area, had all been factors leading me to choose to work with craftsmen in exile and with others living in areas on the periphery of the Tibetan plateau. Interviews were carried out over periods of one to two months each year on a continuous basis between 1986 and 1991.

Dharamsala, the main settlement of expatriate Tibetans and home of the Dalai Lama, situated in the Himalayan foothills of Himachal Pradesh, seemed the obvious place to start. My first trip was in 1986 and my initial contact was with the then librarian of The Library of Tibetan Works and Archives, Gyatsho Tsering. The library is a publishing body and together with other institutions is part of a conscious attempt by the Tibetan government in exile to keep traditional culture alive. I sensed from the start that the keenness of Tibetans to have the outside world know more about their endangered culture would help me immensely, opening doors and inspiring informants to give freely of their time.

Through Gyatsho Tsering, I was provided with a translator, necessary as my spoken Tibetan was not sufficiently strong for me to work alone. He was Lobsang Shastri, who in 1986 was a 23-year-old student and is now a member of the Tibetan government in exile. Together, we interviewed craftsmen and members of the former government responsible for ordering metalwork in the old regime. These included government officers, members of the former Tibetan cabinet or *kashag,* Tibetan doctors, monks, and craftsmen in other media, including painters and woodworkers. We went together to interviewees, several of whom were still active craftsmen, and interviewed them in their workshops as they worked or were invited to their houses to talk over a cup of Tibetan salted butter tea. I made notes, relying on the time delay between my asking a question and Lobsang receiving the answer and translating it into English. The process could be laborious and sometimes slow as my translator sought the English words he needed to give the sense of the Tibetan. He would often revise a sentence or begin it again mid-sentence. Because Lobsang's own

English was not sophisticated, it was often necessary to ask the same question again or in a slightly different form in order to elucidate a point. Toward the end of my study, I realized that my concentration on getting the essence of issues being discussed had prevented me from taking verbatim quotes from interviewees. This meant that I was missing a certain personal element that linked my work with interviewees, and that became something that I later regretted.

The total numbers of metalworkers interviewed were five from central and southern Tibet, five from eastern and northeastern Tibet, seven from Ladakh, four from Bhutan, and nine from Nepal. In addition, there were five other craftsmen and government officials interviewed. Five of these were born in the period spanning 1911 to 1915; the majority, however, were born between 1920 and 1935. I had one or two key interviewees. Amongst these, Chemo Pemba Dorje stands out.[1] Chemo Pemba (Figure 20), a former member of the Tibetan government's own guild of metalworkers, lived and worked in a large building at the foot of the Potala Palace, the Dod zhol dpal 'khyil. He was sixty-seven when I first interviewed him in 1986. He worked in the 1990s as the head of the metalworking workshops at the Norbulingka Institute below the settlement at Dharamsala. The organization teaches traditional crafts to young Tibetans and is part of a conscious effort to keep traditional art forms alive in exile. Chemo Pemba Dorje was skilled not only in the techniques of repoussé and casting but also in the production of large Buddhist images with beaten or repoussé exterior and wooden interior support.

20. Chemo Pemba Dorje on the roof of his house, Dharamsala, Himachal Pradesh, India, 1987. (Image courtesy of the author).

With each interviewee, especially those that I returned to year after year, it was vital to build some sort of a positive personal relationship. One had to learn to be tactful and flexible about the craftsmen's commitments and work schedule, for example, and not to be too demanding of their time. If still active, they might be working to a deadline for the completion of a commission. All my interviewees gave their time free of charge, though presents were always welcomed. In general, craftsmen were pleased that someone from the outside world was interested in their craft tradition. There was undoubtedly a political element in this as it was evident that all in exile were painfully aware of the threat to their culture. It was also apparent that few Westerners had shown the type of detailed interest in metalworking that I had. The goodwill of the translator was also vital, and in several cases, through my translators, I accessed new interviewees. Almost all my translators were young, influenced by Western ideas, and wanted to practice their English. I paid them at the local rate per hour or by the day. Working with both the craftsman and the interpreter, it was important that I was able to judge the pace of an interview, to know when to stop, and not to push ahead if I sensed I was perhaps too demanding. This was especially the case when the craftsman was busy or tired and wanted to bring the interview to a close. Such a situation could be difficult when exciting new information was being given; there was always the feeling of wanting to find out more right away.

One of my main focuses was style in metalworking and often stylistic variations could be quite subtle. Because of the subtleties involved and the complex nature of the decoration on the objects being examined, I soon found, through experimentation, that showing craftsmen a photograph was a better way of approaching such questions than by using words alone. It was also much quicker as the interview process via a translator could be slow. Photographic images of pieces held in Western museums quickly became a mainstay of my work. My method was to show a series of different interviewees photographs of a museum object and then to ask the same questions about style and origin of the piece to each. My usual practice was to write comments directly on the back of the photograph at the time or to transcribe them to there after the interview from notes taken earlier. In this way, I built a body of evidence that enabled me to create an intellectual argument for regional styles. While in Ladakh (see the following discussion), copies of my photographs were requested by craftsmen so that they could copy details from them. In this case, therefore, objects held by museums were directly influencing a contemporary craft tradition.

Chemo Pemba Dorje first made it clear to me that there were regional styles, and he schooled me in being sensitive to the subtle variations in popular decorative emblems made in different parts of Tibet. It was noticeable, however, how points made to me in the field, which seemed quite straightforward, once analyzed in the process of writing in England, immediately became much more complex and threw up many more questions. For example, only one example of eastern Tibetan scrollwork was given to me during the first two years of my study. This was via a sketch made by a central Tibetan silversmith. Only after I had interviewed several eastern Tibetan gold and silversmiths did a full picture emerged of a number of variants on the original design that I had been told was typically eastern Tibetan. Even something as seemingly simple as a place name could throw up considerable difficulties. It was again several years before I was able to be certain that one informant came from Tsedong rather than Tsethang because, when pronounced, the difference between them is slight. In this case, the translator repeatedly changed his mind, both about how the word should be written and pronounced! This was even after guidance from the interviewee. I was fortunate, however, in that for a few years, I had the luxury of being able to return and put the same questions again to resolve particular issues.

For the first three years of my study, I also interviewed silversmiths and goldsmiths in Nepal and Ladakh. Nepal was important because the indigenous Newar metalworkers produced a huge volume of objects for Tibetans. They either imported already made things from the Kathmandu Valley via the passes into Tibet or more commonly had second houses in Tibet where they lived for several years at a time, mainly in the larger towns. It was encouraging to find the ideas about styles being given to me by Tibetan interviewees largely being echoed and confirmed by my Nepalese ones. This meant that I could rule out a purely local or nationalistic bias to my Tibetan respondents' information. In the end, I found it possible to distinguish separate Nepalese, Chinese, Central Tibetan, Eastern Tibetan, and Bhutanese styles. Another of the issues in the study of Himalayan metalwork concerns the extent of the borrowing of motifs and styles between areas lying, in some cases, far distant from each other. It was fascinating, on occasion, to witness the actual process taking place among the craftsmen I was interviewing as they copied objects from other areas or even from a book illustration. It was often possible to notice how the small changes they were making during copying helped to locate the new copy to their own local area rather than to the area of origin of the original object. In Nepal, for example, I saw a silversmith copying a photograph of a Bhutanese teapot but adding distinctively Nepalese details to the finished product.

I also visited Ladakh, an area of Tibetan culture now lying within Jammu and Kashmir state in India, over two years (1986–7), which was important for other reasons. As my study was almost entirely based on craftsmen in exile, it was mostly impractical to trace their products in monasteries or family homes or to interview patrons due to the inherent physical dislocation involved. Ladakh, however, provided an untouched area of Tibetan culture that had escaped the widespread destruction of family objects and monasteries that had happened in Tibet because of it lying within the borders of India. I found that monasteries there were full of commissions by past and present generations of metalworkers. Wealthy families similarly still retained the objects ordered over generations and indeed still commissioned ritual objects and domestic vessels. It was therefore possible to interview older craftsmen and older patrons and to trace the patterns of connections linking them.

A main focus in Ladakh was a special village of craftsmen/farmers at Chiling (Clarke, 1989:129–42) in the remote Zanskar gorge. I found a guide in a local young man Lobzang Tashi employed by the Save the Children Fund, which was carrying out work in the area. Having reached the end of the dirt road at Sumda Do, we set off along an often-terrifying path, with several sections of very narrow track six to eight inches wide cut in a scree slope that fell to the river a hundred or so feet below. At other times, the path was built out over a sheer rock face and consisted of slates laid over rickety poles slotted into holes in the rock. It was notorious even among the locals as a difficult path. By my second visit, a road had been built to the village, ending its extreme remoteness forever. The settlement consists of just a handful of houses on a piece of land a few hundred meters square, enclosed by mountains on every side. The place had been colonized in the seventeenth century by a group of Nepalese craftsmen who had been invited there by King Senge Namgyal (r. 1590–1624) to enable him to erect large metal Buddhist images. On the agricultural land, people raise crops and keep animals, but they practice metalworking at times when there are few agricultural demands, mostly in the winter months. The river itself has deposits of alluvial gold and copper, and of course, there is water and thornbushes, which make good charcoal for forges.

The most senior member of the craft community of twelve fully competent masters and younger twelve trainees was Meme Le Phuntsog Spalzang who, in 1986, was said to be "about" eighty years of age. *Meme Le* is an honorific meaning respected grandfather. Figure 21 shows him in his winter

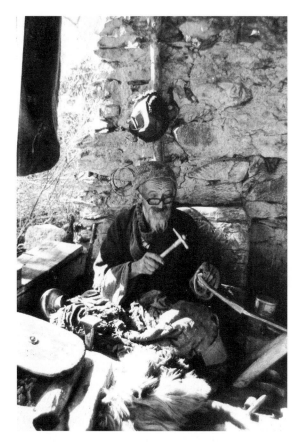

21. Meme Le Phuntsog Spalzang in his winter workshop at Chiling in the Zanskar Valley, Ladakh, 1986. (Image courtesy of the author).

workshop, a lean-to positioned to capture the winter sun, and as is evident, he was still working at the time I visited. I was not specifically gathering information on the techniques of metalwork production, a German thesis already existed on that (Rauber-Schweizer, 1976). However, I witnessed many techniques being carried out, and I decided to make notes on this aspect of the tradition also. The intention was partly to get a more rounded and complete picture of the craftsman's life.

The village craftsmen are called goldsmiths or *sergar*, but much more often work in silver, copper, and brass, though never iron. They make ritual objects for monasteries as well as domestic utensils. A type of highly decorated teapot (Plate 11) with a handle in the form of a dragon is a specialty. This piece was made in about 1950 by Meme Le using copper from the nearby Zanskar Riverand is in the possession of a local family. It is almost identical to pieces from the same geographical area in the collections of Western museums' including that of the Victoria and Albert Museum. (Plate 12), for example, shows a teapot from Hemis monastery in Ladakh, now in the Victoria and Albert Museum's collection that could quite possibly have been made in the same village. I stayed several nights in Chiling, sleeping by the fire in the smoky kitchen, and was able to interview three generations of Meme Le's family; his son and grandson were also craftsmen. It was possible to construct lineages of master and pupil through several generations from this. Returning to Leh, the former capital of the former kingdom of Ladakh, I interviewed other craftsmen and patrons. Several patrons showed me vessels or ritual objects made by named village craftsmen, including Meme Le.

I also visited monasteries and saw ritual pieces made by Chiling goldsmiths including *chorten* or stupas, the characteristic Tibetan reliquaries, made by Meme Le or one of his sons.

By 1988, I felt that I had a framework in which I could understand the former, and to a certain extent the present, metalworking traditions of the Himalayas. I had also received a type of aesthetic training by the craftsmen I had interviewed. I realized that I had also to make up my own mind on some issues especially when the information from craftsmen was contradictory or itself confused. In one or two cases, for example, opinion on the area of origin of an object was almost exactly divided between interviewees. It also became clear that I needed to broaden my range of interviewees because I had until then not gathered information from eastern Tibetan or Bhutanese craftsmen. From 1988 to 1991, I therefore sought out eastern Tibetan craftsmen in exile and visited Bhutan. Further oral history work was undertaken in eastern and northeastern Tibet during 2003 and 2004 with the specific aim of researching jewelry production and styles for a publication on that subject (Clarke, 2004). Much new information, however, did relate to the broader picture of metal production already developed, both helping to confirm and to broaden it.

At present, the results of this oral history project stand alone, there being only the one earlier study by Ronge that in any way overlap with it. An oral history approach to a stylistic analysis of the type being attempted in this case proved very effective. Success, in the sense of being able to draw definite conclusions, depended on having a broad range of interviewees across a number of geographical areas. This provided cross-checks among groups and helped to guard against errors based on the perception of one or two craftsmen. In relation to the actual interview process itself, in retrospect, I regret not having sound recorded interviews. Being able to go back over a point after the event rather than relying solely on notes taken at the time would have made the process easier and more efficient. This decision was based on the idea of keeping things as simple as possible. In reality, however, a reliance on paper and pen actually made the interview process more slow and cumbersome. By contrast, the use of photographs as a tool to elicit comments in interviews was an undoubted success and even in the first year became central to my study. As many of my questions related to visual aspects of the objects craftsmen had made or seen in the past it saved a large amount of time that would otherwise have been spent in laboriously describing objects and their varied decoration. Although traditional knowledge of the Tibetan arts will naturally be passed on to new generations, there may be elements that are lost and that a study such as mine may hopefully have captured in time to preserve them.

NOTE

1. *Chemo* is a contraction of *dBu chen mo* (meaning literally "big head"), an honorific official title given to the head craftsmen of each section or *bzo khang* in the guild system. Chen mo sPen pa rDo rje was given the title but was unable to take up the post because of the changing political situation in the 1950s.

REFERENCES

Clarke, J. (1989), "Chiling, a Village of Ladakhi Metalworkers," *Arts of Asia*, May–June: 129–42.

Clarke, J. (1995), "A Regional Survey and Stylistic analysis of Tibetan Non-Sculptural Metalworking, c.1850–1959," PhD thesis (unpublished), School of African and Oriental Studies, University of London.

Clarke, J. (2004), *Jewellery of Tibet and the Himalayas*, London, V&A Publications.

Ronge, V. (1978), *Das Tibetische Handwerkertum von 1959*, Wiesbaden: Steiner.

Rauber-Schweizer, H. (1976), "Der Schmied und Sein Handwerk im Traditionellen Tibet," PhD thesis, Robert Hofmann, Univerität Zürich, Zurich.

Interviews

Pemba Dorje, Chemo (1986, 1987, 1988, 1991), interviewed by John Clarke, Dharamsala, Himachal Pradesh, north India.

Spalzang, Phuntsog (Meme Le) (1986, 1987), interviewed by John Clarke, Chiling, Zanskar Valley, Jammu and Kashmir State, northwest India.

11.

THE DEATH OF SMALL THINGS

THE CORK CRAFTSMAN'S GUILD (1973–84)

eleanor flegg

The 1970s saw the development of a crafts movement along the west coast of Ireland, but particularly in the county of Cork. The movement was largely led by makers who had come to Ireland in search of an alternative way of life and who used craft as a springboard to do so. Although it derived from counterculture ethos, the crafts movement in County Cork swiftly developed an organizational framework: a community of makers who came to together to exhibit, sell, and promote their work. This essay uses oral history interviews to map the cultural context from which this movement emerged, and to trace the rise and fall of one of its pioneering organizations, the Cork Craftsman's Guild. All the participants are craftspeople, former members of the guild, identified within the community as people who might have something to say on the matter.

Oral history, in this context, is a necessity. Without it, the story of the Cork Craftsman's Guild would be at risk of disappearing entirely. It was a craft shop, marginal in the aesthetic and economic hierarchies, and did not create much of a paper trail; its documentary records are sparse, and its closure created no ripples of discourse beyond its immediate circle. But there is another layer to its history: the Cork Craftsman's Guild ended in conflict, and its closure created divisions within the local crafts community that lasted for over a decade. During the interview process, it emerged that the participants had different perspectives on the guild's demise. All expressed a persistent sense of

loss around the event, but there seemed to be no clear agreement on what had been lost. Some regretted the loss of a collective dream and some the loss of money, while others mourned the dead. Although there was no disagreement on what actually happened, the variation of emotional emphasis rendered events almost unrecognizable in the different testimonies. The differences between the accounts lie not in what was said, but in what was left unsaid: people concentrated on the aspect of the closure that they personally found upsetting, leaving areas of silence around some of the issues identified by others. Here, I took the decision not to probe but to observe both what was talked about and what was not talked about. I felt that it was important to respect the participants' "right to silence and understand the reasons for and the content of those silences" (Rolph and Atkinson, 2010:59). Although the closure of the guild meant different things to different people, their memories were generally expressed in a language that seemed akin to that of bereavement. Harding's work on oral history, which views emotions as both cultural and personal phenomena points to a possible way to understand this. She works with the idea of "emotions not in but between subjects, as inter-subjective processes, which are simultaneously part of the constitution of individuals and collectives, and the relationships between them" (Harding, 2010:40). This might help to explain why the participants gave different reasons for what can collectively be described as a sense of loss.

A note, here, on scale: most of the scholarship on oral history and traumatic memory relates to major trauma in comparison to which the failure of a craft shop seems negligible. However, the process of healing, or lack of it, seems to follow a similar pattern. The survivors of trauma—both serious and minor—seem to suffer lack of closure. They do not live with memories of the past, "but with an event that could not and did not proceed through to its completion, has no ending, attained no closure, and therefore, as far as its survivors are concerned, continues into the present" (Laub and Felman, 1992:69). Although Laub and Felman's study relates to a suffering on a much greater scale—war and holocaust—the insight remains applicable. Even the death of small things can bring lasting sadness.

The Cork Craftsman's Guild was born of a spirit of optimism (Plate 13). County Cork had seen, from about 1960, a significant influx of people from England, Europe, and the United States. Many of these saw the west of Ireland as a refuge from their own urbanized and industrialized societies. For refugees from modernity, Ireland represented a premodern idyll steeped in myth and magic. These heady ideas, along with the low cost of land, made an attractive prospect for those in search of a simpler way of life. The settlers came to fill a vacuum. The small farming communities that traditionally populated the west coast of Ireland had been drained by emigration, leaving the landscape scattered with empty properties, albeit in uncertain states of repair. Additionally, the availability of Industrial Development Authority funding for craft enterprise under a small-business model meant that the retreat from modernity was frequently subsidized by government grants. The local community was largely supportive of the incomers. The English ceramists Lynn and Ian Wright (2010), who moved to Skibbereen in 1973, outlined their experience of integration:

> We had to learn to milk the cow and kill pigs, so we got caught up with all the hippies who were doing things like that. Plus the local guys who tried to help us with tractors and pitchforks and everything else. The community was stunning. And we had an old Land Rover that ran on gas—it was lethal—but that was famous in Skib. Everyone knew us because often it would leak gas and people would have to come and find us and say that it was about to blow up.

Across Ireland, the settlers' ability to organize themselves into networks and groups sometimes aroused prejudice. On one level, some Irish craftspeople resented the imposition of "foreign" standards on emerging Irish work, especially when such criticisms were not tactfully expressed. On another, Irish retailers welcomed the professionalism of British and Northern European craftspeople, who they perceived as being more reliable than were the Irish. In both aesthetic and organizational terms, the contribution of the settlers to the crafts movement was immeasurable. They brought skills, initiative, and a certain utopian idealism into isolated parts of rural Ireland and linked the crafts movement there with creative activity in the world beyond. With a steady stream of British tourists coming over on the car ferry, there were seasonal opportunities for immigrant makers to market craft objects as souvenirs, often to their compatriots. However, it was difficult to make a living. Many craftspeople lived in remote parts of the county. Transport facilities were poor, and work was mostly sold through craft shops that were geared toward the tourist market and were open only in the summer. It was at least partly in response to the difficulties of negotiating sales that craftspeople in County Cork came together in 1973 to form the Cork Craftsman's Guild. This, from humble beginnings and within a five-year period, was to become one of the most important craft retail outlets in the country.

The Cork Craftsman's Guild opened in a backstreet venue on Paul Street, Cork, the word *guild*, with its connotations of English medieval tradition, conferring gravitas on an organization that was, to all intents and purposes, a shop. As a nonseasonal cooperative venture, it was intended to create a local market and to establish a cultural context within which the work of the guild members could be appreciated. Ireland had its own craft traditions, but the work sold in the Cork Craftsman's Guild was not traditionally Irish. Its members in 1973 consisted almost entirely of incomers: less than a third of these were Irish, and the Irish-born membership were largely Dubliners, locally considered almost as foreign as the English and Germans settlers. Most were recent immigrants who had moved to County Cork in the 1960s, bringing with them an exotic vocabulary of skills and techniques. Their work was a reflection of a wider trend in the 1960s and 1970s for a craft aesthetic "based on the rediscovery of 'lost' or 'foreign' techniques, such as handloom weaving, vegetable dying, enamelling, batiking, ash firing, raku, and celadon glazes" (Alfoldy, 2005:9). The work was made using techniques and aesthetics so unfamiliar to Ireland that many native Irish did not know how to tell good work from bad. To ensure the standard of work, guild members were vetted by a selection committee that was briefed to promote creative work once it had reached a certain standard and to distinguish it from work made with less skill. However, at least initially, the jurors struggled to evaluate the work of immigrant makers, which did not always fit their expectations of what craft should be. The ceramic tableware of Courtmacsharry Designs Workshop, which had been established in 1973 by the English potters Jane Forrester and Peter Wolstenholme, was rejected because it did not fit the committee's conception of craftwork.

> We left our samples in there and they looked at them, and the message came back "we don't want your work in the shop—it's too well made." They were very neatly produced tableware and everything was exactly the same. I think we must have got onto someone and said, "For God's sake—this is craft—if it's well made, it's better than stuff that's badly made." By talking to them we convinced them that well designed, well made pottery was better than badly made pottery. It looked industrial. It wasn't a brown lopsided

mug. Anyway we got into the Cork Craftsman's Guild and we started supplying them. (Wolstenholme, 2009)

Once members were selected, they were permitted to display their work in the shop on a sale or return basis, which meant that the shop did not have to raise capital to buy stock. Jim O'Donnell, furniture maker and secretary of the guild, felt that, in providing a retail outlet that was not solely driven by profit, the guild recognized that the craftspeople of the area worked from a combination of creative and commercial objectives.

> Craft workers are driven to do what they do, and not always for money. It's part of the spiritual aspect of things. And this is where the shop, the Cork Craftsman's Guild, was ideal. There were people who became members and had product on display that was not really commercial. They sold miniscule amounts. So the guild was not really commercial. Stuff would stay on the shelves forever. And some of those people went on then to be very successful. It was a gentle way of introducing people to the beginnings of being commercial. (O'Donnell, 2009)

The Cork Craftsman's Guild also had a social value: individual studios were scattered across the rugged Cork landscape; roads were poor, and vehicles unreliable. Facilitated by the lack of enforced drink-driving legislation, exhibition openings and meetings helped to combat the isolation of rural studio life. Initially the Paul Street shop was staffed by the members but, as Patricia Howard (2010), a ceramist, commented,

> It was quickly seen that it couldn't be run by the craftspeople. They were late, they didn't turn up . . . So we hired someone to run it, we hired two people, the third person was called Christine MacDonald and she was wonderful . . . I used to avoid her because she was always looking for stuff—God be with the days when people wanted loads of things from you! I made tea sets and coffee sets, and she'd sell and sell for you. She ran the place like a ship—it was very efficient. She made it, really. I think that without her it wouldn't have gone as far as it went.

The guild enjoyed a period of phenomenal success. In 1977, the Paul Street premises was sold, and the cooperative was offered the opportunity to move to the new Savoy Centre on Patrick Street. This placed the Guild in a centrally situated and much larger venue on Cork's main thoroughfare (see Figures 22 and 23).

By 1981, the Cork Craftsman's Guild represented around 250 makers, and the cooperative had expanded to include members from all over Ireland. MacDonald, a native Corkonian, was crucial to the success of the guild. With local knowledge and good organizational skills, she was able to mobilize her retail and promotional activities within the cultural hierarchies of the city and to broker the relationship between the craftspeople and the buying public.

> The Guild really boomed. From being a little shop in Paul Street that supplied about twenty people's work it became a shop in the Savoy Centre that had a turnover by 1980 of a quarter of a million Irish pounds, which was an awful amount of money in those days. I used to sell four thousand pounds of my stuff, wholesale, in December alone in that shop. People from all over the country were submitting to join. The single shop in Cork wasn't enough to sell all the work. Then we decided to go to Dublin. (Wolstenholme, 2009)

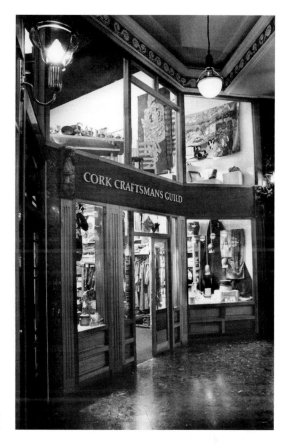

22. The Cork Craftsman's Guild (exterior), Savoy Centre, Patrick Street, Cork, c.1980. (Image courtesy of K. O'Farrell).

In November 1981, the cooperative expanded again, opening a second outlet on the first floor of Dublin's new Powerscourt Townhouse Centre. Overheads were high and the shop had to maintain a considerable turnover just to pay the rent. In retrospect, it was decided that the shop had opened: "at the end of a boom rather than at a beginning, off a main street rather than on it, and one floor up at that" (Crafts Council of Ireland, 1984:7). The craftspeople collectively lacked the business skills to ensure that the outlets survived the recession of the 1980s. Committee-based decisions were ponderously slow, and the cooperative failed to respond decisively to a situation of rising costs and falling sales. Despite high turnovers—an estimated 300,000 Irish pounds of retail sales in craft was channeled through the two outlets in 1983—the shop in the Powerscourt Townhouse Centre was forced to close early in 1984. There was also a lingering perception that the workload of management was unequally distributed. Bebhinn Marten, a knitwear manufacturer, pointed out that "too few people had to carry the entire burden, which was a contradiction of the coopera-tive idea" ("Cork craft guild shuts up shop," 1984:14). Her perspective was that the guild had run its course and that latent tensions within the committee would have, sooner or later, rendered the cooperative ineffective (Marten, 2010). Following the closure of the Dublin outlet, the energies of the committee were now focused on trying to save the Cork shop. Jim O'Donnell opened negotia-tions to decrease the rent. However, a number of makers, fearing that their work would be seized, decided to remove it. Vans lined up on the street outside the shop and, within twenty-four hours,

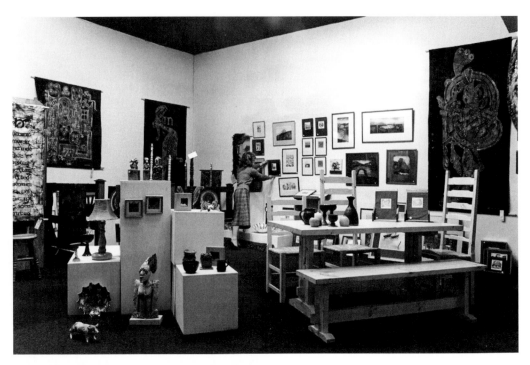

23. The Cork Craftsman's Guild (upstairs showroom), Savoy Centre, Patrick Street, Cork, c.1980. (Image courtesy of K. O'Farrell).

more than half the produce had been taken away. He described the incident in the dramatic emotive language of a heist movie.

> Unfortunately some of the craft workers had lost confidence and, precipitously, they pulled their stock out of the shop. It was, for all the world, like a run on the bank. More than half of the stock was pulled out of the shop basically in twenty four hours. Even though I was negotiating, I think quite successfully, to reduce the rent, some of the craft workers had jumped the gun and taken their stock out. They said their feelings were that the game was up and that the landlord, because he was owed back rent, would seize their stock. (O'Donnell, 2009)

The sale or return basis on which the shop was stocked, which had hitherto been one of the strengths of the venture, turned out to be its weakness. The Cork Craftsman's Guild was unable to recover and closed its shop in the Savoy Centre with a loss of approximately 40,000 Irish pounds. Wolstenholme, identified within the community as one of the makers who removed stock, did not mention the incident. For him, as one of a number of members who had personally guaranteed the Dublin shop, the drama in the situation was financial.

> The Dublin shop bankrupted the Cork Craftsman's Guild because the two shops weren't kept separate. The bank called in all the guarantees that we'd made. Twenty of us had guaranteed six hundred pounds to move to Dublin. And so twenty of us had to go into Cork and slap six hundred pounds on the desk of the manager in Cork and we were declared bankrupt. (Wolstenholme, 2009)

Those guild members who stood guarantor to the cooperative lost large sums of money that they could ill afford. Bebhinn Marten resented the fact that the bank would accept artwork in lieu of money from some members, but would not accept knitting. Interestingly, O'Donnell, who saw the closure of the shop as a betrayal of the collective ideal, did not mention that members lost money. The removal of stock by the makers seems less precipitous in the context of the closure of the Dublin shop, some weeks previously. Bernadette Madden, the Dublin-based vice-chairman of the Cork Craftsman's Guild oversaw the shutting-down operation.

> We had to close it down quite quickly. We closed it down over a weekend. It was really kind of in a hurry because we had to remove everything. And half the people that had stuff there never collected it. It was quite extraordinary that people didn't. And we sent out letters saying that if it's not gone by whatever, five o'clock on Sunday, then it's gone. And I thought that there would be huge recriminations, with people saying: "what did you do with my stuff?" But there wasn't a thing! And I gave all the stuff that was left to Stewart's Hospital, because at least I could say that I gave it to charity. (Madden, 2009)

O'Donnell did not mention that the closure of the Dublin shop had resulted in the loss of work and this account challenges his perspective that the removal of stock from the Cork shop was precipitous and unjustified. When members of the guild withdrew their stock from the Cork shop, their fears of losing work were not groundless. A few weeks after its closure, an unnamed participant wrote in raw and emotive terms echoed in the interviews that "The tragedy is that of confidence dented, of individuals' own business being affected, of a loss of IR£300,000 of turnover for craftsmen, of a loss of retail outlets where the public could see carefully selected stock of good quality crafts, most of all perhaps is the loss to the spirit of cooperation in which craftsmen worked and planned for their common good" (Crafts Council of Ireland, 1984:7).

Following the closure of the Cork Craftsman's Guild, the crafts movement in Cork came down with what has been referred to as "the old Irish disease of the splits" (Mullin, 2010). The picture of a divided community is supported by the fact that, by the end of 1984 there were two craft shops in Cork City. The premises previously occupied by the Cork Craftsman's Guild, was reopened as Craftworks under the management of Mary O'Donnell and Vivienne Foley, and continued in business for about eighteen months. Christine MacDonald (see Figure 24) opened Crafts of Ireland in a new outlet on Winthrop Street, where it persisted for many years.

> She lived above the shop in absolute chaos. It was one of those rickety old Cork Shops with two storeys over. It was a take-your-life-in-your-hands sort of place—it was in such bad repair. She got cancer and she jogged along, but then she got really ill. She's kind of an unsung hero because she was very low-key herself, but I think that she was very important to a lot of the studio makers. (Madden, 2009)

For both Madden and Howard, the sadness in the closure of the guild lay not in the loss of the shop itself, to which they were reconciled, but in MacDonald's death, after a long illness, in August 1998. Both spoke about this in detail and felt that it was unfair that MacDonald's contribution had not been recorded. Craft, however, continued to sell well in Cork. The English potter Leslie Reed, who moved to Cork in 1976, had the impression that the city had a sophisticated and educated appetite for craft.

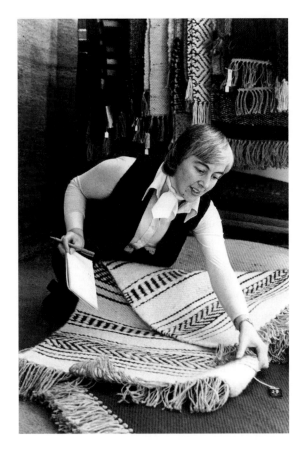

24. Christine MacDonald, manager of the Cork shop, c.1980. (Image courtesy of K. O'Farrell).

> When we had an exhibition at the new Triskel Arts Centre, it must have been 1981—I was selling pots for seventy two pounds. That was in Cork in 1981! We couldn't get over that in a small country, in a relatively small city, that there would be that many people who would be prepared to spend large sums of money on craft. It would have been based on a handful of people who were persuaded that anything that they perceived to have a cultural value was worth putting their hand in their pockets for. The debate about the relative value of fine art and craft didn't have as much hold on people then. (Reed, 2010)

Throughout the 1980s, the decorative arts in West Cork were recorded as well supported by its galleries. "The Crawford Municipal Gallery, the Cork Arts Society Gallery and the Triskel Arts Centre in Skibbereen all show their work regularly while the Forrester Gallery in Bandon is the best example of a gallery that combines both fine and decorative art" (Rose, 1989:22). It is likely that the Cork Craftsman's Guild, with its tireless public display of high-quality craft, played its part in the creation of this confidence.

The Cork Craftsman's Guild is perceived locally as something that happened a long time ago. When the West Cork Design and Craft Guild was formed in 1995, many of its members did not realize that it followed in the footsteps of a previous organization (Ospina, 2010:10). Although Irish craft of this period is poorly documented in general, the particular silence around this area is probably linked to the divisive way in which the Guild closed. Its end, and the silence around it,

also throws light on the way that endings, in a broader sense, are recorded. People have an affinity with beginnings: they are associated with energy and hope, and historical source materials congregate around them. Beginnings attract the mechanisms of promotion—the press release, the photographer, and the local newspaper. They generate records that have a fighting chance of survival. Endings, in contrast, are silent and sad, and people do not linger there in any way that creates a lasting record. They carry associations of failure and shame. Where written accounts exist, they tend to be brief, reflecting the tendency to move on from the place where things went awry. Even laudatory appreciations tread lightly over the circumstances of demise.

Small enterprises end quietly. Craft activities, which rate low in aesthetic and economic hierarchies, tend to slip away unnoticed, leaving scarcely more than a ripple in the historical record. However, irrespective of their perceived importance, endings have an impact on people's lives. Enterprises that end in ways that are divisive leave scars. These scars become areas of silence, around which people maneuver, at first with care and then habitually. Memories of painful endings become internalized, isolated, and entrenched. Oral history can release these memories and, by allowing the voices of the participants to be heard, has the potential to unfold as "work in progress, as individuals cognitively and emotionally grapple with the contradictions and complexities of their lives" (Rolph and Atkinson, 2010:58). Each personal experience has its own reality and can be woven into the story to reveal the layers of emotion—often obscured or undocumented—that run through the cultural matrix.

REFERENCES

Alfoldy, S. (2005), *Crafting Identity: The Development of Professional Fine Craft in Canada*, Montreal: McGill-Queens University Press.
"Cork craft guild shuts up shop" (1984), *Irish Times* (May 1): 14
Crafts Council of Ireland (1984), *Newsletter*, May/June: 7
Harding, J. (2010), "Talk about Care: Emotions, Culture and Oral History," *Oral History* 38/2: 33–42.
Laub, D. and Felman, S. (1992), *Testimony: Crises of Witnessing in Literature, Psychoanalysis, and History*, New York: Routledge.
Ospina, A. (2010), *West Cork Inspires*, Ammanford: Stobart Davies.
Rolph, S. and Atkinson, D. (2010), "Emotion in Narrating the History of Learning Disability," *Oral History* 38/2: 53–63.
Rose, D. C. (1989), "The Decorative Arts in County Cork," *CV Journal of Arts and Crafts* 2/4: 20–22

Interviews

Howard, P. (2010), interviewed by E. Flegg, January 22.
Madden, B. (2010), interviewed by E. Flegg, December 1.
Marten, B. (2010), interviewed by E. Flegg by telephone, March 12.
Mullin, M. (2010), interviewed by E. Flegg, April 28.
O'Donnell, J. (2009), interviewed by E. Flegg, July 10.
Reed, L. (2010), interviewed by E. Flegg, March 1.
Wolstenholme, P. (2009), interviewed by E. Flegg, July 8.
Wright, I. (2010), interviewed by E. Flegg, February 13.

Part 3

IDENTITIES

12.

THE CRAFT OF CONVERSATION

ORAL HISTORY AND LESBIAN FEMINIST ART PRACTICE

ann cvetkovich

What is an artist? In this chapter, I argue that oral history can provide new answers to this question because of its power to illuminate how art practices are embedded in everyday lives and social networks. I do so through interviews with two mid-career lesbian artists, Allyson Mitchell and Sheila Pepe, who challenge conventional understandings of art through installation work that combines art and craft (Cvetkovich, 2012a).[1] The impulse for this project comes from a feminist conviction that the careers of lesbian artists, shaped as they are by gender and sexuality, have unusual trajectories that make for queer alternatives to the norm. It also arises from a desire to demystify the artist's life by showing how art emerges from the material conditions of everyday life. Oral history interviews are a valuable resource because they provide accounts of an artist's process and everyday life that are not necessarily visible from the work alone. They are especially important for documenting the careers of artists such as Pepe and Mitchell, whose work with craft includes performances and installations that are ephemeral and who combine their art practice with activism, teaching, and curatorial projects. Moreover, oral history's populist sensibility is especially well suited to these artists, who challenge distinctions between art and craft not by elevating craft to the status of art but by treating art as craft in the sense of everyday activity or process.

Oral history can also document the friendship networks that facilitate the work of artists, and it thus reveals how the artists create new forms of collectivity and sociality. In my oral history work

with AIDS activists, for example, many of whom are also artists, the interview has been a way of tracking the intimacies that shape public work, tracking the relation between solo art practice and collective forms of production, including cultural activism (Cvetkovich, 2003, 2012b). The interview can be a way to avoid moving too quickly to the vocabulary of *community*, which has been criticized for its romanticizing qualities, or *public*, which has come to replace it. Not only can these terms be too abstract, but they also often imply mediated or impersonal relations and thus don't capture the specificity of the direct connections that characterize artists' friendships and relations with one another. Interviews can be a way to invent vocabularies for these social formations, which combine the intimate and the social, the informal and the institutional. Terms such as *salons, coteries, cells, networks, affiliations, circles, scenes, movements,* or *subcultures* can be explored and revised in conversation. Documenting these social formations is central to the history of movements such as modernism or postmodernism and cultural scenes, such as the postwar New York art world, that are both cosmopolitan and intensely local; these larger categories are often constructed monolithically from what are in fact smaller social formations that have yet to be fully documented. Another key motivation for my project is to chart the intersections of queer sexual cultures and bohemian art cultures. Although the latter have been central to queer public cultures, community-based histories of lesbian, gay, bisexual, and transgender (LGBT) cultures, which often rely on oral histories, have not fully articulated the role of art and cultural production in facilitating queer identities. Thus, for example, important lesbian and gay histories of New York and Cherry Grove (Newton, 1993; Chauncey, 1995) have been further amplified by scholarship on the intersections of art worlds and queer worlds (Muñoz, 2009; Vogel, 2009; Crimp, 2012). Moreover, queer theory offers useful tools for rethinking the friendship and sociality so central to the art world as queer bonds (Weiner and Young, 2011).

An oral history that focuses on an individual artist's career can make telling contributions to these larger projects. It is valuable to learn about how people become artists, as well as how they sustain a career. For many mid-career lesbian artists, for example, success has been modest or has come via unusual paths. Queer artists with a political vision may have an ambivalent relation to conventional forms of success or institutional forms of recognition, and the interview can be a way of exploring these feelings and their effects. (However, as is so often the case with the subjects of oral histories, the artists I have interviewed have frequently surprised me with their dreams of professional success and their unwillingness to subsume art into activism.) Although lesbian artists now have greater visibility and recognition, including greater flexibility about the extent to which their sexual identity is part of their identity as an artist, challenges remain, and earlier generations of artists have important stories to tell about how they have negotiated sexism, homophobia, and other obstacles to success. Oral histories can also be a valuable way to explore the relations between subcultures and the mainstream, and the complexity of the traffic and tensions between them that is also present in the relation between art and craft (Henderson, 2013).

My interviews with Allyson Mitchell and Sheila Pepe focused on two areas: the forms of friendship and community that underlie their work and their views about the intersection of art and craft. Craft is central to their art practice, and they use it to create installations that challenge conventional notions of museum exhibition both through the use of space and through performative events that involve viewers as active participants (Plates 14 and 15). I was interested to know how their sense of both community and craft transforms understandings of what it means to be an artist.

In the sections that follow, I begin with a substantial excerpt from each interview; the subsequent discussion focuses on the emotional and performative dynamics of the interview that may not always be apparent in the transcript. I have been inspired by the model of *Bodies of Evidence* (Boyd and Ramirez, 2012), a recent collection on queer oral history methodology, which uses this format in order to enable its contributors to write more explicitly about the intimacies with their narrators that inform their projects. Boyd and Ramirez's aim is to show the broader methodological value of queer oral history's power to capture the secrets and feelings that are often part of sexual life. Their format is particularly appropriate in this case because my interviews with Pepe and Mitchell were more like conversations than interviews since I have long-standing friendships with both of them, although friendships that are shaped by our shared professional interests in art, feminism, and queer politics. One value of crafting is the conversation it facilitates, such as those among the knitters and crocheters who make new things from Pepe's "Common Sense" installations or those that Mitchell describes having with her artist friends while they are crafting together. I approached the interviews as a form of craft, a way of making ideas that reflect the thinking also embodied in these artists' installations and creative practices. Because both of them create installations and spaces that encourage people to gather, it seemed particularly appropriate to see our conversations as an extension of their work.

ALLYSON MITCHELL AND THE WHIRLPOOL OF THE CRAFT CLOSET

Ann Cvetkovich (AC): What friendships and relationships facilitate your art practice? Who are your people—are they fellow artists, are they queer? What scenes, or communities, or networks are you part of?

Allyson Mitchell (AM): I can picture the various closets in the places I've lived. When I was living on Augusta Street [in Toronto], my closet was my first studio space. There was a mash of materials inside and people would come over and pull out materials and we would fuck around. There was a craft room on Dundas St. People would sit around a table and go through weird baskets of hodgepodgery and put things together—collages, mini sculptures. There wasn't a mission, it was about process. It was an excuse to hang around together, something we could do together physically. We were exploring and making fun.

All of my crafting friends were queer . . . the affiliations were queer ones. I had known them for a while; they were established friends. Crafting was an excuse to hang around and not feel like we were wasting time. The people I hang around with are the people I am working with at the time. When projects end we don't see each other or it becomes an effort to find each other.

AC: Crafting seems to occupy an in-between world between professional obligations and pure play. Crafting is also connected to art insofar as it resembles some of the attractions of theatre and music performance, where you can work with a group of people over time and the final result is also collective. Writing can be more isolating, although people make it collective by participating in workshops or reading together in performance events such as those found in the slam poetry scene. You've also mentioned how your work as the editor of *Turbo Chicks* (Mitchell, Rundle, and Karaian, 2001) [a collection on young feminisms] created some exciting bonds that you hoped would make a more lasting community.

AM: We were all artists, with deadlines and projects of our own that were professional obligations. But crafting together wasn't completely random. It wasn't like a Frisbee game or a dinner party. It feels productive, but not in a creepy way. It's dreamy, it's doing the thing you want to do, and riffing on that, and gossiping. Including not just sitting down crafting but the process of going to thrift stories and dollar stores to find materials. I loved being in a place where you can find cheap inexpensive gaudy materials and seeing my friends respond to objects in a way that was surprising. Pointing to the beauty in something that seems sad or ugly. Pulling that into our whirlwinds. Loving it, and making it something else. In my thrift runs and craft runs with particular people like Andrew Herman or Cecilia Berkovic or Will Munro—you go in as queer weirdos in a town and you're in a bubble in a public space; you may even be in a hostile environment but the energy you hold supersedes that in a way that is different from if you were on your own and isolated. You can be hysterical. . . . "oh my good look at this!" People are staring but you're oblivious. [We try to figure out the word for this image.] You are a . . . whirlwind . . . sucking things in . . . what's the water thing in the pool? . . . everyone in the pool running in the same direction . . . cyclone, hurricane. The thing that pulls in the trucks . . . A queer cyclone. The circular energy that pulls in these objects. Another world.

AC: Why is making crafts together different from making art together?

AM: Calling it craft rather than art gives it a kind of permission—to not have the same expectation, to not be held up to criticism.

I first met Allyson Mitchell when we worked together at the Michigan Womyn's Music Festival, which is part of a lesbian feminist culture that creates shared networks, and I have since written about her work in a variety of contexts (Mitchell, 2009; Mitchell and Cvetkovich, 2011; Cvetkovich, 2012a). We have also sustained our friendship because we are both from Toronto, where she is part of a lively queer art scene, one that is based in neighborhood and community-based spaces. Although Toronto is the center of Canada's cultural scene, it is often not visible on the world art circuit, and artists have thus created their own local and internal networks, often with the support of national funding for the arts. Mitchell's description of the queer network of friends with whom she has crafted over the years in Toronto reveals the behind-the-scenes, literally the closets, that facilitate the movement from craft to art. She emphasizes crafting as a way of spending time together that is about process without an art product (although, in search of alternative concepts of productivity, she also insists that it is "productive, but not in a creepy way").

Mitchell developed her art practice from a background in women's studies and experience as a cultural activist, and she underscores the way crafting has given her permission to be an artist without having had formal training. Describing her family background, she also mentioned not having been raised to appreciate art or to aspire to become an artist, suggesting that the populist appeal of craft has a class dimension as well as a feminist one. In addition to discussing freedom from the forms of judgment and evaluation associated with art, Mitchell stresses the value of craft as process-oriented and ephemeral, as something whose power resides in time spent with others.

Mitchell's description of thrifting as its own form of craftmaking and community building challenges distinctions between handmade and manufactured goods that often underpin concepts of craft as an alternative to commodity cultures. Rather than making her own work, Mitchell works

primarily from found materials, often thrift store finds, and refunctions other people's craft projects and decorative items, such as crochet blankets, pillows, and hook rugs. In *Hungry Purse: The Vagina Dentata in Late Capitalism*, for example, the materials are used to upholster an entire room that playfully invokes feminist traditions of vaginal art (Figure 25). Mitchell describes collecting through shopping as itself a creative activity, one that sees objects, particularly objects that have been discarded, in new ways. Reminiscent of the performative qualities of queer direct action, the scene of shopping is a collective one in which the space of the thrift store is rendered queer by the company of others.

Oral history can play a special role in revealing the ephemeral collectivities and behind-the-scenes encounters that contribute to an artist's more public work. My conversation with Mitchell tries to document this collectivity and name it. Her use of the term *affiliation* in the above excerpt led to a side conversation between us about how to describe the special nature of her bonds with fellow artists and fellow queers and the working and creative friendships that crafting facilitates. They lie somewhere between the categories of friendship and community—more direct, personal, and small-scale than community but more collective and work-related than friendship. These are queer bonds—forms of intimacy that have public significance that transgress boundaries between work and play, and that remake the meanings of love and kinship.

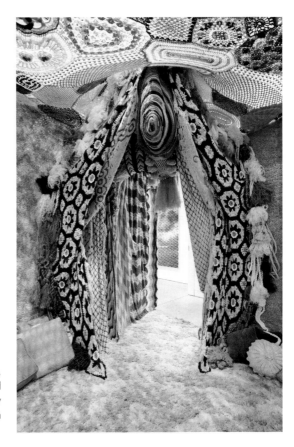

25. *Hungry Purse: The Vagina Dentata in Late Capitalism*, Allyson Mitchell. "Visible Vaginas" exhibition, David Nolan Gallery, New York City, 2010. (Photographs by Tom Powel Imaging, New York, courtesy David Nolan Gallery and Francis Naumann Fine Art, New York).

In the excerpt above, Mitchell also tries to find a vocabulary for the creative experience of shopping. In a way that is not fully captured in the transcript, the interview stutters a bit as she strings together possible terms to describe the collective creative energy of queer thrifting and the power of the relations it establishes between people and objects, or between artists and their materials. Calling it a "whirlwind," a "cyclone," and a "hurricane," as well as "another world," she turns to metaphor to describe the creative intensity of these shopping expeditions and the feeling of queer utopian sanctuary they can provide in the midst of straight consumer culture. We realized later that in her attempt to name "the thing in the pool," she might have been looking for the word *whirlpool*, but the cluster of words created by her search for the right term suggests how the interview became its own form of queer creativity by functioning as a brainstorming process to invent a new vocabulary. Being able to see beauty in strange objects (or words), fostering camaraderie through shopping (or talking), creating a "bubble" that holds the world at bay—these methods apply to both the practice of thrifting and the practice of the interview.

SHEILA PEPE AND THE MAGIC OF INSTALLATION

AC: What is your background as an artist and how do you think of that category?

Sheila Pepe (SP): There was a period when I didn't make anything, when I was completely rejecting the notion of the artist. I found my way back because I wanted to make stuff and I missed it. I missed the world of art I had been introduced to as a child. It was magical that you could make these things out of something else than what they are. It was a place where you could have imagination and that was a good thing. You could daydream and that was a good thing.

When I came out and was a separatist and was part of conversations with [feminist philosopher] Mary Daly, looking at that boy art was not good, not allowed. Working at a museum job brought me back around. Art was the thing I could and would do but also it was my way of having a place in the world outside of the home. Understanding the metaphors of elevating the craft of the home—that work had been done in the 1970s, '80s, even '90s, about radical knitting circles. I remember in the 1980s there was a radical sewing circle vibe. Consciously when I first came out . . . with making shadow drawings and doppelgangers that I wanted to work on preserving certain feminist art tropes but also wanted to marry that to modernist art tropes that were my inheritance. I felt like part of the feminist problem to be solved was to just assume it was all my inheritance. Eve Hesse understood that. And her alliances were with men and women artists. To watch the films of her in her studio—she is an empowered woman. She owns her identity as an artist in a way that is different from seeing Judy Chicago in the documentary about the making of *The Dinner Party*. (It would be interesting to watch those two films side by side.) My generation of feminism is about preservation to a certain degree, and also about assuming a place in the world without being reactionary.

AC: What is the nature of New York art scene and how do you relate to it? What communities are you a part of?

SP: My sense of community is heterogeneous. I like the old ladies—the older women who come in and say, "I crochet." Smith alums [alumni]. And kids doing the same thing. Part of the marriage of Hesse and Chicago is about being really interested in a popular community and a public forum. To bring together very available craft languages, including crochet and needlework, and elite obscure art paradigms that are metaphors for other things.

My work is about hybridizing, diversifying. I hang out a lot more with straight people. My mission as a lesbian is to show up. That has always been my activism. It's smaller in scale. I show up with my moustache and my plain talk.

A lot of artists spend time behind the scenes in their early life. I worked in a museum [at Smith College], young artists work in gallery. Like a stagehand. That is the place to become familiar with all this. I have the pedestal that the Degas is going to go on later, but right now I'm putting my coffee on it. You develop a familiarity with the scene where the lights will go up and there is a lot of aura. I learned a lot about my installation practice well before it ever started because I was taking notes while I was an assistant. Don't be an asshole, don't stay too late. I was watching the problems around how to accommodate, listening to curators who were women and overworked. Having no days off because artists were there over the weekend. Having to go to museum after hours to troubleshoot.

When Nancy Spero came to Smith in 1990, I got to watch and meet her and see how she related to her crew. Her whole temperament was lovely. She kept saying how happy and how grateful she was; you could be so bitter and she wasn't. She asked me about my work and she was so generous. The other part of it was to see the work itself . . . she moved into the situation and with very modest means took the space over.

AC: I have been focusing on community as a form of material support for art practice, but your comments are a reminder of how spaces and institutions are equally important.

SP: I spend a tremendous amount of time trying to remove the footprint. It's still an object, but it's magic, tactile, and kinesthetic for everybody. Something that is not normal or part of the everyday, that is special, that is connected to religion, that has a spiritual life.

One of the values of oral history is that interviews do not always go the way one expects. As an artist based in New York, and another long-time friend whose social milieu overlaps with mine, I anticipated that Sheila Pepe would have a lot to say about the city's multiple circles and networks. But when I asked her about her relationships with other artists, she sidestepped the question, emphasizing her work as a teacher (she is on the faculty at Pratt Institute) and the difficulty of making time for others in the city's hectic art scene. She sees herself as involved in "diversifying and hybridizing" the art world so doesn't want to be confined to an exclusively feminist or queer art scene. She aims to democratize galleries and museums with her large-scale crochet installations and the spider-web spaces they create, especially the new "Common Sense" series where viewers unravel the installation to make their own pieces (Figure 26). (Her work with craft thus also displays the interest in ephemeral performance that Mitchell finds in crafting with her friends.) She told me that some of her people are "ghosts," including the grandmother who taught her to crochet and the grandfather who was a cobbler and whose work she acknowledges by using shoelaces in her installations.

When she does talk about other artists, Pepe emphasizes her role as a generational bridge between different kinds of feminists such as Judy Chicago, known for her use of craft and her challenge to traditional art forms and institutions, and Eve Hesse, the post-minimalist sculptor and installation artist who brought new textures and materials, such as rubber and latex, to modernist vocabularies. Combining the sometimes disparate styles of lesbian feminism and formalism, Pepe refuses to distinguish between the populist craft world of feminism and high modernist interest in form. She seeks to create art that is "not either/or but both/and building a heterogeneous utopia."

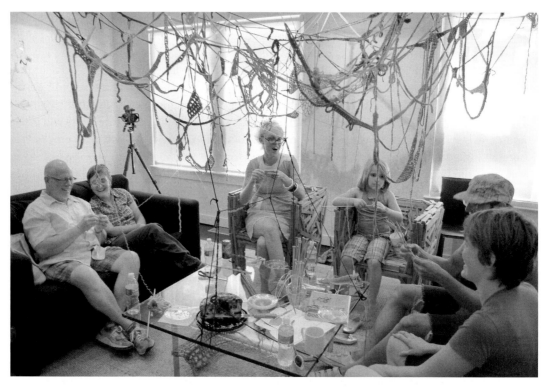

26. *Common Sense*, Sheila Pepe. A collaboration with curator Elizabeth Dunbar. Yarn/audience participation: Solo exhibition at Testsite, a project of Fluent~Collaborative, Austin, Texas, 2009. (Photograph by Kate Watson, courtesy of Fluent~Collaborative)

Pepe's responses to my questions moved between the naming of influences common to the artist talk and a history of radical feminist resistance to conventional art practice to create an unusual lineage from within and outside the art world. The interview has the power to help construct this queer transformation of the artist talk.

One of the defining moments of our interview was Pepe's discussion of how her work experience as a museum guard shapes her creative practice. Her discussion of aspects of installation such as respectful relations with museum staff reveals the social as well as material labor involved in producing exhibitions. Her desire to establish friendly relations with curators and installers comes from her own work behind the scenes in museums and from the model provided by her feminist predecessor Nancy Spero. Pepe also describes how her working-class background contributes to her interest in craft. It gives her a humble sense of the care involved in making something, whether a piece of art or a sandwich in her father's deli, where she worked as a child. Although she seeks to make magic by removing the traces of this labor, Pepe's interview makes it possible to see process in ways that demystify art without taking its magic away. Her spirit of inclusion, whether museum staff or the viewers who knit and crochet with the yarn from "*Common Sense*," suggests the ongoing impact of lesbian feminist values on her work, which don't need to be announced as such. As she puts it, she shows up as a lesbian (with a moustache) and reveals herself to be both professional and profoundly human.

TALKING ABOUT UTOPIA

Pepe's "both/and" sensibility echoes Mitchell's call, in her *Deep Lez* manifesto, for a feminism that combines generations, such as lesbian and transgender, and, by implication, art and craft (Mitchell and Cvetkovich, 2011). Both artists are working with notions of utopia: Pepe's heterogeneous vision turns away from the utopian dreams of lesbian separatism that she was once part of in order to embrace the art world and different kinds of people, while Mitchell remains more attached to lesbian feminist ideals but seeks to mix them up with other queer influences. Describing the planning discussions for the Feminist Art Gallery (FAG), which she and her artist girlfriend Deirdre Logue have opened in their backyard studio in Toronto, she characterizes utopia as an anticipatory feeling generated by conversation:

> Before the screening [of films at MIX, New York's queer experimental film festival] three people talked about queer utopia. Ginger [Brooks Takahashi] talked about how her most incredible moment is the night before the lesbian separatists leave for the land . . . pre hard labor, pre drama, pre history, the excitement of what is about to happen. It's more perfect than any reality. That feeling of stepping into a whole world change. Organizing around the Feminist Art Gallery feels like that. The talking about it feels like that. Vetting for opinions. Seeing how people are excited are about it.

Since its opening in spring 2011, the FAG has embarked on innovative programming, which as the name suggests puts a queer twist on the feminist tradition of the alternative gallery space. It is a place where not just art but also conversations and relationships can be nurtured. My interviews with Pepe and Mitchell also reveal conversation as creative process, and they suggest the value of oral history for articulating utopian conceptions of both art and artists and inventing vocabularies that combine art and craft, the oral and the visual, the material and the magical, and friendship and professionalism.

NOTE

1. My book, *Depression: A Public Feeling* (2012), features Mitchell's and Pepe's work in the context of a discussion of how crafting and other forms of daily practice can constitute a reparative approach to depression. As a result of my sustained consideration of their work for that project, I became interested in exploring more directly their ideas about the artist's life and about the relations between art and craft. Their websites (www.allysonmitchell.com and www.sheilapepe.com) can be consulted for further information about their work.

REFERENCES AND FURTHER READINGS

Boyd, N. A. and Roque Ramirez, H. N. (2012), *Bodies of Evidence: The Practice of Queer Oral History*, Oxford: Oxford University Press.

Chauncey, G. (1995), *Gay New York: Gender, Urban Culture, and the Makings of the Gay Male World, 1890–1940*, New York: Basic Books.

Crimp, D. (2012), *"Our Kind of Movie": The Films of Andy Warhol*, Cambridge, MA: MIT.

Cvetkovich, A. (2003), *An Archive of Feelings: Trauma, Sexuality, and Lesbian Public Cultures*, Durham, NC: Duke University Press.

Cvetkovich, A. (2009), "Touching the Monster: Deep Lez in Fun Fur," in A. Mitchell, *Ladies Sasquatch*, Hamilton, Ontario: McMaster Museum of Art.

Cvetkovich, A. (2012a), *Depression: A Public Feeling*, Durham, NC: Duke University Press.

Cvetkovich, A. (2012b), "Sex in An Epidemic: An Interview with Jean Carlomusto," in Y. McKee and M. McLagan (eds.), *Sensible Politics: The Visual Culture of Nongovernmental Activism*, New York: Zone.

Henderson, L. (2013), *Love and Money: Queers, Class, and Cultural Production*, New York: New York University Press.

Mitchell, A. (n.d.), Allyson Mitchell, <www.allysonmitchell.com>, accessed October 1, 2012.

Mitchell, A. (2009), *Ladies Sasquatch*, Hamilton, Ontario: McMaster Museum of Art.

Mitchell, A. and Cvetkovich, A (2011), "A Girl's Journey into the Well of Forbidden Knowledge," *GLQ: A Journal of Lesbian and Gay Culture* 17/4: 603–18.

Mitchell, A., Rundle, L. B., and Karaian, L. (2001), *Turbo Chicks: Talking Young Feminisms*, Toronto: Sumach.

Munoz, J. (2009), *Cruising Utopia*: *The Then and There of Queer Futurity*, New York: New York University Press.

Newton, E. (1993), *Cherry Grove: Sixty Years in America's First Gay and Lesbian Town*, Boston: Beacon Press.

Pepe, S. (n.d.), Sheila Pepe, <www.sheilapepe.com>, accessed October 1, 2012.

Vogel, S. (2009), *The Scene of Harlem Cabaret: Race, Sexuality, Performance*, Chicago: University of Chicago Press.

Weiner, J. and Young, D. (2011), "Queer Bonds," *GLQ: A Journal of Lesbian and Gay Studies* 17: 2–3.

Interviews

Mitchell, A. (2010), interviewed by Cvetkovich by telephone, June 10, Austin, Texas, and Toronto, Ontario.

Pepe, S. (2010), interviewed by Cvetkovich by telephone, July 23, Austin, Texas, and New York, New York.

13.

CRAFTY CHATS OR WHOSE CRAFT IS IT ANYWAY?
DOMESTIC DISCOURSE AND MAKING MARGINALITY MATTER
jo turney

One of the many discourses emerging from the crafts in recent years prioritizes and questions the ways in which both practice and objects have been marginalized within an arts hierarchy (Elinor et al., 1987; Coleman, 1988; Dormer, 1997). This is commonly described as the Art/Craft debate and has the dual purpose of elevating craft activities and objects while establishing a critical language suitable for their discussion. There is no doubt that this has been a worthy exercise, and the discussion of craft has moved from its critical and academic margins into museums, galleries, and contemporary critical theory (Freeman, 1986; Barnett, 1995).

Although the driving force of crafts criticism has promoted and extolled the work of professional makers, the distance between professional or fine crafts and domestic or amateur crafts has widened exponentially, creating a new marginality unrelated to numbers of participants, availability of products or enthusiasm for making. As the amplification of the gulf between professional and amateur has become more apparent, a popular crafts revival has ignited a new passion for making (see Figure 27).

Domestic crafts practice has historically existed as a paradox, bridging the gap between work and leisure, between necessity and frivolity, while simultaneously appearing as distinct from culturally constructed paradigms such as fashion, consumerism, and good taste. Yet, these practices and

27. *Knitting Makes the Ordinary Extraordinary, Yarn Bombing,* Bath School of Art and Design, Sue Bradley. Traffic cone with hand knitted cover, Reflective yarns and Acrylic, 2011. (Photograph courtesy of the author).

objects endure and are so prolific within our material culture that they appear mute. Using oral testimony from twenty amateur knitters and stitchers from southern England, gathered in 1999, this chapter examines the ways in which oral history can express marginal voices and practices, valorizing and emphasizing the contribution of contemporary domestic craft to the language of craft and to wider sociocultural concerns and discourses such as sense of self, place, home, well-being, and memory. Indeed, oral history not only offered an insight into why people make things but also offered a critique of the meaning of things in everyday life where the producer is also the consumer (Attfield, 2000).

Craft is often valorized in terms of use (Johnson, 1997) yet domestic home craft frequently has no use or value (Bourdieu, 1977) often acting as a purely decorative item, especially in the case of embroidery, which unlike painting is marginalized as derivative "women's" domestic practice (Parker and Pollock, 1982). However, the object acts as a cultural marker, representative of the making process, of a journey or a time that is symbolic not just of constructive leisure, but of wider relationships, with kin, community and global citizenship. Making, therefore, makes meaning, and acts not just as a time filler, or the expression of busyness, (although this is significant as this chapter demonstrates), but also as a means of self-expression, of identity formation, and as a means of establishing ones place within and beyond the home. The object of manufacture need not be useful, but the making process *must* make those engaged within it feel useful.

This suggests that a sense of self-worth, or a social system of valorization, acts similarly to a value system applied to craft commodities, that of utility. Our value, therefore, can be equated to our sense of personal usefulness, not just to ourselves but also to those we live among—community/kinship groups.

The way meaning is attributed to both activities and objects within the home are seen in terms of a moral economy (Putnam and Newton, 1990). This is a site in which memory and identity, of both personal and collective (kinship) type, are prominent, and this is where an analysis of the meaning of making can begin. It is also a site in which work and leisure become entwined and thus combine with contemporary anthropological and feminist debates surrounding women's domestic consumption and pleasure. It is important to note that a moral economy runs parallel to the dominant economy and consequently is both distinct and outside capitalist understandings of production and consumption. One might suggest therefore, rather unfairly, that amateur makers and homemade items largely (although not exclusively) exist as alternatives to work, culture, shopping, and so on.

Indeed, few respondents made goods to sell for personal profit; one respondent said, "I am reluctant to make anything for anyone else as I wouldn't feel it would be good enough. Though some of the things I have made are admired by my friends" (Tucker, 1999). The emphasis on amateur status inherent in this respondent's reply was indicative of many testimonies and appeared to coincide with the genre of project they chose to make (Dalton, 1987). Use was frequently a deciding factor, either in terms of home decoration, of family requirements, or of fund-raisers. Embroidery, it was implied, had a "limited" and personal use; one respondent commented that embroidery was "her pleasure" and was something she did "to pass time in the evenings" (Tucker, 1999), whereas knitting was "useful" as long as family and friends wanted it. Other items made were "gifts," "bazaar goods" (West, 1999), and charity items, such as knitted clothing for premature babies, which were donated to the local hospital (J. Turner, 1999). The emphasis on utility was qualified by a need for the maker to feel useful rather than pleasurably occupied. The emphasis was firmly placed on busyness, with interviewees seeing nonproductive or constructive leisure as an indicator of laziness, rather than a mark of gentility (Veblen, 1899:55). The testimonies of two retired women exemplify this. Interviewee Doreen West (1999), a former hospital worker said,

> I don't sit down unless I've got something to do. So I sit and knit all the time. I watch telly and knit. I don't miss nothing. If I want to sit and watch a programme, and I know I want to watch it, then I'll do a clown, because the knitting of the bottom is all plain and pearl. So I can sit there and go at it. Without looking at a pattern. But I've always got a pattern here. I'm doing a teddy bear at the moment. I can watch the telly and look at that. I've got my ear on the television and my eye on the pattern. As long as it's my good ear.

Conversely, Mrs. Tucker (1999) commented, "I don't do so much sewing now, but usually afternoons sewing and evenings knitting. Because I can watch the television and knit. I still knit now. I knit almost every night. I can't sit doing nothing. And now I'm not so mobile, I've got to do something."

These testimonies reiterate a desire for busyness, reproducing a sense of moral obligation supplied by what is generally called a Protestant work ethic. There are, however, other possibilities offered by a need for constructive leisure. First, this desire may be based in class ideology. Both of the preceding testimonies were made by retired working-class women. They both discuss in their

interviews how they made things, either sewn or knitted, because their families needed them. They both recalled how their mothers had done the same. This process of the cultural construction of repeated behavior patterns is highlighted by Pierre Bourdieu's concept of habitus (Bourdieu, 1977:72–95) in which actions are learned through environmental and familial systems of belief. However, middle-class interviewees, who equally felt an overriding need to keep their fingers busy, repeated these sentiments, which questions the significance of class in determining a "need" to make.

Second, this need may be the result of generational conditioning. The testimonies were predominantly made by women of pensionable age, who had lived through wartime and periods of subsequent austerity. Their actions may have been informed and necessitated by the social and economic needs of society, and by habit. However, younger women were also driven to make by a need to keep busy, but also to be creative.

The focus so far regarding the consumption of time as the fulfillment of a desire for busyness has been directed at the activities of women, and therefore, it may be assumed that this desire is gender driven, that women are biologically and psychologically driven by need to fill their time usefully. This definition is problematic, because similar testimonies were made by men. One male cross-stitcher outlined the way in which his engagement in his wife's hobby of needlework, had lessened the need to complete household chores within the home. Sewing allowed him both time and space. He stated,

> How many husbands have gone home tired after a hard day looking forward to putting their feet up with a glass of something, only to find that the nearest and dearest on finishing another row of the latest project, calls across the room "when are you going to do this job or that job, I've been asking for weeks now?" But since I've taken up stitching, we both say we'll do some stitching and then cut the grass, by which time it's raining anyway. Life's not so full of jobs now, just the occasional "bother, another knot," as we sit together. So come on chaps, get stitching and relax. (Ashby, 1999)

Consumption of time is a significant factor in the making of meaning in home-craft production. Like the concept of space, craft activities can be slotted into a fragmented schedule; they do not require vast quantities of time and can easily be put to one side when other *work* obligations intervene. All of the interviewees stated that their leisure time had to be constructive and productive. Watching television, and surprisingly, reading, did not fulfill these criteria, both provoking feelings of guilt. Interviewees enjoyed television but felt that they had to be doing something else whilst watching to justify this "wasteful" pursuit.

Although it appears that "useful" pursuits are valorized more highly, this consumption of time is a site of conflict. Useful pursuits were considered a mask for indulgence in the more pleasurable and wasteful pursuits (television) while qualified by the same governing properties of work. Making is, therefore, rewarded with the wasteful, in the same way that leisure is the reward for work.

Connotations of love, family, and femininity are central to the value of these activities and objects, and although the made objects are not made for financial gain, they often achieve heirloom status. Home-produced objects, predominantly those produced between mother and child, are symbols of age, the acquisition of knowledge, and development and are often sources of embarrassment to the naïve maker in later years. Kim Tucker (1999), now retired, fondly remembered the sense of achievement that she felt when her daughter learned to knit:

I taught her what I knew but I thought she would never learn to knit. We spent hours and hours; everybody tried to teach her to knit and she just couldn't get the hang of it. I suppose she was about twelve, before she finally got the sense to knit something, and she knitted herself a sloppy Joe jumper. And it was a great achievement you know it was in big wool and big needles and she actually did knit something. From then on, she's never without knitting.

This sense of pride is representative not only of a passing on of knowledge, but also of a shared interest that secures or provides the basis for a future relationship. This suggests that a passing on of a skill is representative of the transition from childhood into adulthood, a kind of rite of passage. The activities themselves are exercises in both bonding and learning, giving pleasure to both teacher and pupil, and are performed within the sanctuary, or controlled environment, of the home.

The exercises in craft making experienced between parent and child or teacher and pupil are not just indicative of the making of objects or of the learning process that such activity dictates. They are also exercises in discipline, method, and control. The development of motor skills through methodical and repetitive action is combined with the development and acquisition of social skills such as discipline and the engagement in the work ethic. As Ellen Dissanayake notes, craft making is often associated with "making special," and time and care spent in both the learning and the making of something, is indicative of its value (1995:44–6).

The pleasure of making, especially the shared making between mother and child is intrinsically linked to sentimentality, or as Dissanayake suggests, making special. We can see how the artifacts of the young become both sentimentalized and symbolic to their parents through their marking a passing of time, as souvenirs of educational and creative achievement, or as objects mapping personal landscapes, spatially and temporally. These aspects of making refer not only to temporal and spatial concerns, but also to experiences or the quality of life.

"Quality of life" is a phrase and concept, which is a familiar facet of postmodern society. It embraces a commonly held belief that life, generally, is somewhat lacking, but has the potential to be made better, more pleasurable, or happier. Ironically, the frantic search for this "good" life has overlooked what actually constitutes it, and thus, the search is never-ending (Bauman, 1995:77). This is perhaps why the women interviewed felt their tasks were never finished: "I'm always on the go. Once I finish one thing, I'm straight onto the next. Really I'm thinking about what I'll do next before I finish what I'm doing" (Roberts, 1999).

Sociologists and theologians have investigated the role of cultural practice in contemporary life—the making of meaning in the meaningless and the ordinary extraordinary. There is more to human existence than survival—we have medicine, technology, science, and supermarkets. Nevertheless, we need to make sense of who we are and where we are going, and thus, modern life has been described as a pilgrimage. This is a form of identity building in which our past and future create an objective language of space and time. The subjective here and now allows us to look back to our past and forward to plot our way into the unknown: "'Here' is the waiting; 'there' is the gratification. How far is it for 'here' to 'there', from the waiting to the gratification, from the void to meaning, from the project to identity?" (Bauman, 1995:86–8).

The mapping of time through the provision of cultural markers is manifest in the family quilt, the construction of which commemorates births, marriages, and other transitional events in the recipient's life. These domestic craft objects are passed from generation to generation, linking the temporal distance between the past, present and future. Following the American tradition in

quilt making (Cerny, 1991:106–20), quilts produced in Britain are embedded with the potential for sentiment and memory and thus act as significant cultural markers (Stewart, 1993; Calefato, 2004:87; Campbell et al., 2004:257). Craft, like narrative, cannot be understood as static, because in the making of each piece and with each telling of a story, time challenges and transforms, offers reflection and reappraisal, potentially adding to and enhancing both (Turney, 2009:190).

> My mum knitted the jumper when I was about three years old. I don't remember wearing it. You think that you do when you see your own kids in it, but I really don't. I must've worn it though because there are photographs of me in it. I remember them. We were living in Scotland at the time and my mum, gran and aunt all knitted. They were all very good. I had forgotten about the jumper until mum gave it to me a few years ago. I was really touched that she had kept it. (Williams, 1999)

Although not the maker, this interviewee outlined how the sweater was as a specific memento of her life, which goes beyond mere photographic representation. The signs, symbols, and motifs are specific to the recipient, representative of "happier" times, which she is able to revisit through the garment. However, the symbols do not purely provide imagery for reminiscence, but the knowledge, the memory of the making and wearing, and the potential for future wear mark time. The sweater, therefore, is a symbol of a past and happy life, offering the recipient and her mother (the maker) comfort in fond memories, which potentially offers safety in the present and future.

According to the interviewees, making is not only to make safe, to secure bonds and relationships, but also to pass time industriously and thus to divert attention from the public to the private. Yet, testimony uncovered a more significant and personal relationship with these domestic crafts; craft activities were intrinsic to a sense of the maker's self, their position within the family as well as the world outside. It became apparent that making objects with a purpose initiated a sense of purposefulness within the makers, traits that only became evident when these skills were no longer needed or wanted. Esther Harris (1999) noted that her knitting has lost its popularity among the younger members of her family: "It keeps me really busy, I don't mind doing it. I like doing it—if I didn't I wouldn't do it. I used to do a lot of jumpers for the children—grandchildren—but I don't now because they go to school, they don't wear them, they wear school clothes, there's not much point." The making can therefore be seen in terms of a means to an end—the achievement of self-satisfaction (pleasure in making and giving) and mutual gratification on behalf of the recipient.

Pleasure in making and giving has a sociologically symbolic base (Caplow, quoted in Kupler, 1995:168). Caplow believes that women—mothers and wives—engaged in paid employment outside of the home substitute gifts for lack of time spent with the family. This reflects the current dilemma faced by many women. It can also be extended to acknowledge that women who make gifts for family members do so because the act of making and the time it consumes is time that the maker cannot spend with loved ones. This may account for the fact that the most valuable gifts (those that contain the most "thought" and have taken the greatest time) are given to close family members, most notably, spouses and children (often adult).

Of course, home is not static, but is fluid, and relationships change as time progresses. Likewise, the making of meaning through home craft is not just restricted to traditional female concerns of home and family. The need to feel useful within a wider social environment was also evident in the makers' testimonies—to interact with and help the direct local community and less fortunate global citizens. This need to feel useful and to contribute within a wider sphere seemed to occur

primarily (although not exclusively) when family members no longer appreciated the products of their labors. Doreen West (1999) said, "I make jumpers and cardigans for my grandchildren, but they're not too bothered by them, so I make them now for that country where all the trouble is [Kosovo] terrible. . . . Women are giving birth to babies by the roadside." The obvious empathy many of the interviewees had with these less fortunate global citizens can also be seen as a reflection of a search for a wider family. No longer needed to make clothing for her family, this interviewee finds a niche for her skills, people who will appreciate her efforts and who visit her daily on the television news. Similarly, familial appreciation and bonding through making have encouraged other interviewees to increase production to include families who miss out on this kinship network. One interviewee knits jumpers for Oxfam, using the same care and attention as she would for her own family, in the hope that these gifts will bring the same pleasure to the "poor children in Africa" (Morris, 1999) as they bring her own family. Other interviewees followed the adage that "charity begins at home," choosing to make items for sale to benefit the immediate community: "I make for the club here. We make quite a bit of money sometimes. I sell the toys for about £3.00 each and all of the money we make goes on outings for the old folks here. We have some good days out and sometimes we have this bloke playing the piano" (Harris, 1999).

CONCLUSION

The testimonies demonstrate the significance of making in everyday life; how making makes and forges relationships, assuages guilt, facilitates busyness and creates a space for personal pleasure. Making makes meaning; one is literally making one's mark in the private and (sometimes) the public world. Ellen Dissanayake states that "[m]aking is not only pleasurable, but meaningful—indeed it is because it is meaningful that it is pleasurable, like other meaningful things: food, friends, rest, sex, babies and children, and useful work are pleasurable because they are necessary to our survival as individuals and as a society" (1995:45).

Oral history offered an invaluable insight into activities undertaken within the domestic environment or within the private confines of social groups and crafting clubs. The methodological reliance on qualitative interviewing practices facilitated the development of a model (albeit in microcosm) to assess the meaning of specific aspects of amateur or home crafting in contemporary Britain, which in turn could be juxtaposed with more general quantitative exemplar existent in popular needlecrafts magazines.

Indeed, home craft combines a perceived notion of femininity with the ways in which that femininity is directed within the domestic environment and the wider world (Kirkham, 1989:175). However, by utilizing the politics of place and responding to the hitherto silent voices of makers, we can begin to assess the role of home produced craft outside of the constraints of the dominant craft and design discourse. We can begin to assess the subjective values of pleasure, sentiment, familial ties, usefulness, and personal stability through belonging and to contextualize the experience of the everyday.

REFERENCES

Ashby, E. (1999), "Life With a Purpose," *Cross Stitcher*, February: 65.
Attfield, J. (2000), *Wild Things*, Oxford: Berg.

Barnett, P. (1995), "Afterthoughts on Curating the Subversive Stitch," in K. Deepwell (ed.), *New Feminist Art Criticism*, Manchester: Manchester University Press.

Bauman, Z. (1995), *Life in Fragments: Essays in Postmodern Morality*, Oxford: Blackwell.

Bourdieu, P. (1977), *Outline of a Theory of Practice*, Cambridge, MA: Harvard University Press.

Calefato, P. (2004), *The Clothed Body*, Oxford: Berg.

Campbell, N. et al. (2004), *Issues in Americanisation and Culture*, Edinburgh: Edinburgh University Press.

Cerny, C. A. (1991), "Quilted Apparel and Gender Identity," in R. Barnes and J.Eicher (eds.), *Dress Gender, Making and Meaning*, Oxford: Berg.

Coleman, R. (1988), *The Art of Work*, London: Pluto Press.

Dalton, P. (1987), "Housewives, Leisure Crafts and Ideology," in G. Elinor et al. (eds.), *Women and Craft*, London: Virago.

Dissanayake, E. (1995), "The Pleasure and Meaning of Making," *American Craft* 55 (April/May): 44–6.

Dormer, P. (ed.) (1997), *The Culture of Craft*, Manchester: Manchester University Press.

Elinor, G. et al. (1987), *Women and Craft*, London: Virago.

Freeman, J. (1986), *Kitting: A Common Art*, Colchester: Minorities.

Johnson, P (1997), "The Right Stuff," *Crafts* 146 (May/June): 42–4.

Kirkham, P. (1989), "Women in the Interwar Handicrafts Revival," in J. Attfield and P. Kirkham (eds.), *A View from the Interior*, London: The Women's Press.

Kuper, A. (1995), "The English Christmas and the Family," in D. Miller (ed.), *Unwrapping Christmas*, Oxford: Oxford University Press.

Parker, R. and Pollock, G. (1982), *Old Mistresses*, New York: Pantheon Books.

Putnam, T. and Newton, C. (1990), *Household Choices*, Middlesex: Futures Publishing.

Stewart, S. (1993), *On Longing*, Durham, NC: Duke University Press.

Turney, J. (2009), *The Culture of Knitting*, Oxford: Berg.

Interviews

Ashby, Eric (1999), interviewed by Jo Turney.

Harris, Esther (1999), interviewed by Jo Turney.

Roberts, Mary (1999), interviewed by Jo Turney.

Tucker, Kim (1999), interviewed by Jo Turney.

Turner, Julia (1999), interviewed by Jo Turney.

West, Doreen (1999), interviewed by Jo Turney.

Williams, Gail (1999), interviewed by Jo Turney.

14.

FEED-SACK FASHION IN RURAL APPALACHIA

A SOCIAL HISTORY OF WOMEN'S EXPERIENCES IN ASHE COUNTY, NORTH CAROLINA (1929–56)

natalya r. buckel

There are stories revealed with needle and thread that on their own do not tell the full narrative. An individual's testimony about the material culture of cloth can be invaluable in identification and analysis. Oral interviews alongside the use of objects as prompts to spark memories, and other written sources can create a more complete picture of women's roles in a changing society.

In the course of eleven interviews, I assembled fragments of a collective memory about experiences with textiles and apparel in Ashe County, North Carolina, in rural Appalachia. These testimonies provide insight into a developing consumer society, and the effect of cultural and technological changes taking place in the region in the early to mid-twentieth century. The interviews also reveal beliefs about class, gender, and race and how these values are communicated, avoided, or blurred through the media of cloth and dress.

Throughout the study, several questions are explored: Why did people make clothes and soft goods instead of buying them? Was there a social stigma attached to home sewing or using cloth sacks? Did this change as economic factors improved in the late 1940s? What can we learn about changes in dress and consumer habits from oral histories? Not all these questions offered clear

answers, and sometimes raised additional queries in the process. Nevertheless, the research points to the complexity of consumer culture and the variety of attitudes women expressed about fashion.

The combination of oral history and material culture as research tactics in the field of costume history is often overlooked despite its obvious relevance to the subject. Personal recollections reveal attitudes about dress that cannot be gained through object-based research and provide a narrative through which to explore broader social and cultural themes. In addition to highlighting how the use of oral history interviews brought a new depth to the study, this chapter discusses the author's personal ties to the interviewees.

STYLE, THRIFT, AND SOCIAL CHANGE

A 1950s promotional brochure by the National Cotton Council of American (n.d.) boasted about a feed-bag dressmaking contest between 1,500 women "down in North Carolina . . . which created so much excitement that New York newspapers carried stories about it. Highlights of the event were the smartness of the styles and the fact that no winning dress cost more than one dollar!" The emphasis placed on fashion-forward dresses made by skilled homemakers reflects the potentially contrasting themes of style and thrift that were used to market textile bags to rural women.

During the 1920s, resourceful Americans adapted the use of cloth bags in which manufacturers sold flour, feed, and sugar to create dresses, diapers, pillowcases, and other soft household supplies. As this practice grew in popularity (and necessity), companies caught on and began promoting products through the use of colorfully printed sacks. Yet, during the prosperous years following the Second World War, rural women's ideas about thrift and reuse were being replaced by a willingness to consume as the importance of fashion grew.

Rural women were acutely aware of the need to keep their family clothed. This was not easy when economic hardship and limited availability prevented them from obtaining fabric or buying new garments. When feed and flour producers started using cloth sacks as packaging in the 1850s, it was natural that women with restricted resources adapted them to new uses (Cook, 1990:3). The history of textile bags in the United States can be divided into three main phases. Shortly after the sewing machine was invented in 1846, manufacturers began making cloth bags to replace barrels and tins as packaging (Cook, 1990:3). Although more expensive to produce, they were conveniently transported and could easily be swung across a horse. Improved technologies facilitated textile bag production and by the First World War, machine-sewn fabric sacks were the industry standard for packaging commodity goods (Edgar, 1926:251). In 1924, the first sack with a fashionable pattern found its way into the hands of American women. By the time of the Great Depression, the appeal of "free" fabric in the form of cloth sacks increased and a variety of manufacturers embraced the idea.

The final phase, beginning around 1940, was marked by the mass production and skyrocketing popularity of feed sacks. Responsible for managing military and consumer products during the Second World War, the War Production Board changed American fashion through restrictions on fabric use and garment construction. Those restrictions did not apply to home-sewn apparel (Encylopedia.com, 2001) and had the unintended consequences of fueling cotton bag production.

Major bag producers and feed and flour mills joined to form trade associations. Marketing and distribution systems were becoming more complex, and the trend was toward increased

consumption. The popularity of the textile bag drew to a close when many manufacturers replaced cloth bags with inexpensive paper ones and the cost of off-the-rack clothing decreased in the 1950s and 1960s.

RURAL FEED-SACK FASHION IN ASHE COUNTY

The history of Ashe County is best understood with keen attention to the geographic conditions of the region. Located in the most northwestern corner of North Carolina in the Blue Ridge mountains of southern Appalachia, it borders the states of Virginia and Tennessee. Across 427 square miles are three major townships that once thrived as railroad stops and several dozen smaller communities in outlying regions. Europeans, mostly English, Scots-Irish, and German immigrants, settled in the area as early as the 1770s (Fletcher, 2006:11). Despite the rough terrain and cold winters, those who made their home there found rich soil and abundant natural resources. Referred to as the "Lost Province" because of its inaccessibility, it was unique from other parts of Appalachia because people were historically more self-sufficient and landowning.

During the early twentieth century, Ashe County saw steady growth of industry accelerated with the arrival of the Norfolk and Western railroad in 1914 (Ashe County Historical Society, 2000:18). Efforts by locals and the federal government to achieve widespread rural electrification in the 1940s also propelled these industries. To a certain degree, the county was becoming more prosperous, but this was mostly limited to residents of the main towns rather than to the county's rural occupants.

Nevertheless, when the Great Depression began in 1929, much of the county's inhabitants lived on farms and because of the close-knit social structure fared better than many urban Americans. Several people interviewed for this study remembered hearty meals during years in which others suffered from hunger. Although life was hard, it was not a drastic change for these cash-poor folks. Making do with what little was had a required skill for survival in southern Appalachia, as an anonymous interviewee (2010) recalled about her upbringing:

> I remember seeing a picture of my Mama and Daddy, well they had had a couple of children and there was no money so they used whatever they could and saved everything. They didn't throw away anything in those days.

This presented both challenges and opportunities for residents in the early twentieth century, especially for women of the region. The typical life of a rural woman in the 1930s and 1940s was far from easy. She often worked the farm with her husband and took charge of child rearing, cooking, and cleaning. This work was made more difficult by the fact that most rural homes in the county did not have access to electricity, and indoor plumbing was rare. It is notable that for families able to afford a sewing machine, it was often the only labor-saving device in the home (McLean, 2009:84). Women were responsible for making clothing for the entire family, although generally an exception was made for men's overalls and jeans, which were purchased from local stores or from the Sears and Roebuck catalogue (see Figure 28). She helped manage the household budget by making things herself rather than buying them (Gordon, 2007:2).

In rural Ashe County, women of every socioeconomic status probably did some sewing, whether they mended the few garments they had, made clothes for the family, or did fancy work

28. The McCoy family at home on the farm in their Sunday clothes in 1939. Stella McCoy was a talented seamstress who made clothes for herself and her youngest son, Bob. Don and Todd McCoy's suits were ordered from a catalogue. (Image courtesy of the author).

in leisure time. Evidence suggests that women paid attention to what others wore and tried to keep abreast of trends. Catalogues distributed by the rural mail route established in the late nineteenth century (Fletcher, 2006:268–9) were a welcome distraction from rural life. Zetta Barker Hamby, who was born in Ashe County in 1907, describes in her memoirs the importance of dress: "Since much of the clothing was made in the home, ladies, especially, always observed what friends and neighbors were wearing" (1998:132).

Printed textile sacks provided Ashe County women who were interested in following fashion trends with the tools to make stylish garments. Although not all women used them for sewing, there were strong opinions pertaining to their use, particularly for "best" dresses, feed and flour sacks increased opportunities to obtain material. Best dresses were typically worn on Sundays to church. Some women felt it was acceptable to make housedresses and aprons from feed sacks, whereas Sunday dresses should be store bought or made from bolt fabric. The ubiquity of dresses made from feed sacks led to the dresses being considered common and may be why some women concerned with social status rejected them.

Families who did not need or want to use them for home sewing gave them to a neighbor or sold them back to the feed store. Feed dealers and wholesale shops then resold the empty sacks. Joanne Hartsoe Kemp's father often brought her along to the store so that she could pick out the pattern herself (Plate 16):

Dad would take me to buy chop . . . and there was just these big stacks of feed piled in that feed room . . . and Dad, he'd say "Go in there and pick out the two alike that you like" cos it'd took two feed sacks to make me a dress. And I would go in there and I'd just crawl around on the feed sacks huntin two that I liked . . . sometimes one would be on the bottom stack and another over here on the top of one. And they'd go in there and move those feed sacks and get the two that I'd picked out. . . Mom would always tell me "Now when you pick outcha feed sack pick out some rickrack that matches it." . . . so they had all of that in this display case. They had embroidery thread and rick rack and things like that and . . . they'd hand you out some that looked like it matched the colors and they'd let you take it over and match it to the feed sack. (Kemp, 2010)

One of the first brands to supply the county with goods packaged in cloth sacks was JP Green Milling Company. Based out of Mocksville (approximately seventy miles away), the first JP Green flourmill was built in 1911. In the 1930s, the company distributed various types of feed, corn meal, and flour throughout Ashe and neighboring counties. According to Vice President Jack Naylor (2010), in the 1940s and 1950s, delivery trucks transported 200 to 300 twenty-five-pound bags of cornmeal to Ashe County a day, or two full truckloads. Most of the shipment was delivered to Bare & Little Company, the leading grocery and feed wholesaler in the county. The Daisy brand flour manufactured by JP Green was eventually packaged in cotton sacks that featured a printed border and were known as "pillowcase bags."

Tommy Little (2010) of Bare & Little Co. remembered selling colorful "dressprint" sacks in the early 1940s. Although not all of the products sold through JP Green and Bare & Little were packaged in dressprint bags or even cloth sacks (many brands used burlap or paper bags), there were a variety of regional and national brands available in the local country store.

Not only feed sack companies encouraged the use of their products. Pattern companies Simplicity and McCall's, feed and flour mills, cotton and textile bag associations, and home demonstration agents all encouraged home sewing with sacks (Jones, 2002:173). Hoping to instill confidence in the consumer to create fashion-forward dresses for less, promotional materials promised tidy, perfectly decorated homes and families, a concept embraced by Ashe County women. Mrs. Roberts (2010) recalled the importance of cloth sacks to the homemaker: "And that's when this [feed sack] really came into popularity because these were there and it gave them an access to material they didn't have otherwise."

Many of the prints that ended up on textile bags were available in a similar form on bolt fabric or ready-made apparel and reflected popular trends in thematic design. This diminished the distinct appearance of sack fabric and any stigma that may have been associated with the reuse of feed sacks for apparel. Bag prints produced during the height of feed-sack fashion echoed broader aesthetic trends.

Was there a growing desire for cheap fabric, or was it only after having more access to national trends that Ashe County women realized they wanted to be stylish? It seems unlikely. The clothing and interviews with women who lived in the rural mountain South in the early twentieth century reveal they were as stylish as they had the means. However, there was a palpable shift during the 1940s, suggesting that as women were exposed to the opinion of more tastemakers, they were increasingly eager to participate in clothing trends. What women made from the feed sacks depended on several factors: the availability and cost of cloth sacks, bolt fabric, sewing supplies, and ready-made apparel, the clothing and home textile needs of her family, their socioeconomic status,

and her comfort and skill with sewing. Home economics continued to be the driving force behind women's reuse of sacks until national and local economies improved.

After the Second World War, it became increasingly less desirable to use feed sacks for home sewing, particularly for dresses. Eventually, even home sewing would become an unwelcome badge of poverty, or lack of stylishness. Attitudes about what defined acceptable dress varied according to social status and personal values. Not everyone felt that homemade apparel was something to be ashamed of, but some were sharply opposed to the practice when it was no longer a necessity. As Bob McCoy (2010) points out, the most significant factor affecting consumer habits was the improving financial situation in which Americans found themselves: "As the economy picked up, people that wore homemade goods was kindy looked down on. It could mean your social status . . . Some people when the economy picked up they had means to get better jobs. Spend more."

So while there could be prejudice against women who sewed with feed sacks, it was not universal. In the earliest period of feed sack reuse, the ink logo was a dead giveaway. Yet, because so many other people were in the same economic situation, it was somewhat acceptable. In the 1940s, colorfully printed sacks became available of better-quality fabric and more stylish patterns made their origins as a sack less apparent.

Rural women placed an emphasis on dressing fashionably regardless of socioeconomic and geographical limitations. In Ashe County, people who were trying to "make do" aspired to be stylish just like those with the means to purchase ready-made apparel. Despite the do-it-yourself aspect of feed-sack culture, it incorporated national advertising campaigns and mass-produced goods into rural Appalachia, making it a complex trend (Jones, 2002:183).

FROM CUSTOMER . . . TO CONSUMER

Although consumerism in some form was present in American culture since the eighteenth century, modern patterns of consumer behavior were not widespread in rural Ashe County until the late 1940s. Clothing and home décor were two of the primary ways that women upgraded their environment with store-bought goods when economic circumstances improved. Subtle changes in the source and construction of home textiles and apparel are demonstrated in period photographs. One can see, for example, how home-sewn apparel was often complemented with ready-made pieces. Virginia Roberts (2010), referring to photographs of her 1948 Riverview School graduation, commented on the popular fashions of the time: "Every girl would have on saddle oxfords [shoes]—every single one. And you know that must have been difficult for some of them to pay for saddle oxfords and yet they all had them."

Oral history interviews reveal different attitudes, priorities, and behavior in the first generations of modern consumers in rural Ashe County. Yet, there was a growing consensus that store-bought goods were automatically superior, perhaps due to novelty. Although mass-produced goods obscure human involvement through complex systems of production and distribution (Strasser, 1989:20–1), over time most residents came to embrace the convenience of ready-made textiles, apparel, and foodstuffs.

One of the most significant changes in attitude was the belief about what constituted appropriate materials for clothing. Although this shift was not universal, over time, better-priced, factory-produced clothing became the status quo. Following the Second World War, improved roads

increased access to the town, department stores expanded their offerings, and women became even more style conscious. The rise of the contemporary department store as a popular tastemaker coincided with the emergence of the U.S. ready-to-wear industry. Women took pleasure in a new pastime—shopping. In rural Ashe County, those who were used to wearing home-sewn clothing viewed the first purchase of a ready-made dress as a memorable occasion. Joanne Kemp worked during the summer to save money to buy her first dress. She remembered how motivated she was after wearing clothing expertly sewn by her mother for most of her young life: "[I] would pick beans in the summertime for people at 50 cents a bushel and would save up the money. I bought probably two or three dresses, you know, maybe one each summer from my money" (Kemp, 2010).

The experience of making a dress in comparison to buying one are two different experiences, but both usually involved the input and company of other women shopping instead of sewing together. In the 1950s, shopping was considered a leisure activity. Rural families, many accustomed to material scarcity, sought opportunities to join the rising middle class, and some finally had the income to dress in fashions displayed in department store windows (Whitaker, 2006:113).

American reuse of cloth sacks for home sewing was not widely advertised or documented after the 1950s, and general histories of feed sacks suggest that they faded into obscurity shortly thereafter. However, interviews reveal a more complex story in Ashe County. In western North Carolina, there was a gradual decline in demand—textile bags were available as late as the 1990s—compared to other parts of the country such as the Midwest (Naylor, 2010). When Bob McCoy (2010) sold his store in 1969, he was still doing a brisk business in printed feed sacks supplied by JP Green Milling Co. and Bare & Little Co. This suggests a reluctance to change habits on the part of older women who found them convenient to sew with.

Although the phenomenon of feed-sack fashion involved sophisticated systems of marketing, production, and distribution, rural women transformed the material into something distinctive, reflecting the maker's talents. In this way, home sewers were not merely customers; they were also creators and producers. Cultures that make most of the objects they use have a different relationship to those objects compared to a society where the majority of objects are factory produced. How one acquires an object has an impact on how one feels about it, especially if one method involves a large amount of input and work. Women's relationships with textiles and apparel changed when they began purchasing goods rather than making them.

PIECING TOGETHER A SOCIAL HISTORY

Often, personal connections lead historians to their topics; it was no different for me. Because my grandparents (Joanne Kemp and Bob McCoy) grew up during the height of feed-sack fashion, their memories, stories, and photographs served not only as an inspiration but also as a connection to potential sources. My situation engendered the trust of my research participants that would not have been extended to so-called outsiders.

In order to understand the breadth of feed sack production, distribution, and use, I conducted interviews with users, wearers, and collectors, as well as feed mills, wholesalers, and merchants. In addition to interviews and other oral history collections (Cooper and Cooper, 2001), more traditional sources were also utilized for this study: photographs, store ledgers, government surveys and censuses, extant journals, newspapers, books, and material culture objects.

My grandmother enriched my understanding by sharing her experiences with fashion and home sewing (see Figure 29). In photographs, she was able to recall what she and everyone wore and whether it was store bought or home sewn. For textile objects that survived, she could tell me what it was made from and used for.

The ledgers kept by my great-grandmother, Mae Hartsoe, for a country store she operated from 1948 to 1955 provided insight into emerging consumer behavior. My grandmother was most helpful in answering my questions about the customers listed in her mother's ledgers: filling in the details of their occupation, race, family life, and reputation so that they became more than just names but also voices.

By focusing on groups of people that knew one another, either as relatives, as neighbors, or as acquaintances, it helped to reinforce individual experiences. It also gave new meaning to traditional written and material sources and often filled in gaps. In one instance, an interviewee couldn't

29. Joanne Kemp wearing a gray silk dress and jacket made by her mother for Easter 1956. The dress may have been inspired by a two-piece ensemble from a 1955 Sears and Roebuck catalogue. Annual catalogues were often the main source of fashion advice for rural Ashe County women. (Image courtesy of the author).

recall the name of a wholesaler that sold women's clothing to country stores (and to my granny's store in particular). Fortunately, the topic came up amid discussion with a friend (whom I also interviewed) who was able to remember exactly the information I was seeking. These insights all helped to piece together a more complete understanding of how women's dress, and more significantly, rural mountain culture, changed in the 1950s.

Contributing to the trend towards an increasingly interdisciplinary approach, this study utilized material culture analysis and oral history interviews combined with traditional written sources in order to examine attitudes about rural women's dress. This resulted in findings much richer—yet more complex—than could be achieved using a single research discipline. Moreover, it points to expanded opportunities for contemporary studies of historical dress and social change.

REFERENCES

Ashe County Historical Society (2000), *Images of America: Ashe County*, Charleston, SC: Arcadia Publishing.

Cook, A. L. (1990), *Identification and Value Guide: Textile Bags (The Feeding and Clothing of America)*, Florence, AL: Books Americana, Inc.

Cooper, L. R. and Cooper, M. L. (2001), *The People of the New River: Oral Histories from the Ashe, Alleghany and Watauga Counties of North Carolina*, Jefferson, NC: McFarland & Co., Inc.

Edgar, W. (1926), *Judson Moss Bemis, Pioneer*, Minneapolis, MN: Bellman Company.

Encylopedia.com (2001), *American Fashion Goes to War* [online], <http://www.encyclopedia.com/doc/1G2–3468301492.html>, accessed January 30, 2010.

Fletcher, A. L. (2006), *Ashe County: A History, A New Edition*, Jefferson, NC: McFarland & Co., Inc., Publishers.

Gordon, S. A. (2007), *"Make it Yourself": Home Sewing, Gender, and Culture, 1890–1930*, New York: Columbia University Press.

Hamby, Z. B. (1998), *Memoirs of Grassy Creek: Growing Up in the Mountains on the Virginia-North Carolina Line*, Jefferson, NC: McFarland & Co., Inc.

Hartsoe, M. (1948–53), Store ledgers, unpublished.

Jones, L. A. (2002), *Mama Learned Us to Work: Farm Women in the New South*, Chapel Hill: University of North Carolina Press.

McLean, M. (2009), "I Dearly Loved that Machine: Women and the Objects of Home Sewing in the 1940s," in M. D. Goggin and F. B. Tobin (eds.), *Women and the Material Culture of Needlework and Textiles, 1759–1950*, Surrey: Ashgate Publishing.

Strasser, S. (1989), *Satisfaction Guaranteed: The Making of the American Mass Market*, Washington, DC: Smithsonian Institution Press.

The National Cotton Council of America (n.d.), *Smart Sewing with Cotton Bags*, Memphis, TN: The National Cotton Council of America.

Whitaker, J. (2006), *Service and Style: How the American Department Store Fashioned the Middle Class*, New York: St. Martin's Press.

Interviews

Anonymous (2010), interviewed by N. R. Buckel, Jefferson, North Carolina, January 5.

Kemp, J. (2010), interviewed by N. R. Buckel, Mill Creek, North Carolina, February 23.

Little, T. (2010), interviewed by N. R. Buckel, Jefferson, North Carolina, March 5.

McCoy, B. (2010), interviewed by N. R. Buckel, West Jefferson, North Carolina, January 13.

Naylor, J. (2010), interviewed by N. R. Buckel, Mocksville, North Carolina, February 18.

Roberts, V. (2010), interviewed by N. R. Buckel, Jefferson, North Carolina, March 5.

15.

COVERING UP
claire wilcox

People tended to think when you got really enormous you should stay at home and not make an exhibition of yourself.

—Warner (1994)

This chapter reflects on an interview between a mother, Honor Warner (b. 1920) and her daughter, Rachel (b. 1954), conducted on December 27, 1994. The interview was part of a research project on the history of maternity wear, and recollected experiences of maternity in England in the 1950s. The chapter also explores the way that clothing associated with motherhood acts as a carrier and a trigger for intense and powerful memories The conflict between the visible, public manifestations of pregnancy and the hidden reality of childbirth (and inferred loss) is analyzed within the context of dress as a tool for concealment of the body, for "covering up," played out within the environment of the suburban, English postwar home. Among the many questions raised is the fine distinction between curatorial empathy and intrusiveness and how such ephemeral material can inform our understanding of dress history, for as Lou Taylor observed, "When clothing memories surface they are often startling in their wider social significance" (2002:251).

Until recently, the transcript of the interview existed as a type written document; as far as I knew it was the only surviving copy. It was kept in a black box file amid the notes and cuttings of a problematic and unfinished book on maternity wear called *A History of Concealment: Maternity Wear from the Eighteenth Century to the Present* that I began in 1993. In the intervening years, I had thought about the project often and knew that it remained a vital subject for further research. I also knew that failing to write it was a failure of nerve, for I did not feel emotionally or intellectually able to progress it. As my career shifted from freelance writer and curator to the stability of a curatorial post at the Victoria and Albert Museum, I became focused on delivering pioneering exhibitions on contemporary fashion, and the urgency to complete the project waned.

I did not meet the interviewee, Honor Warner, so have no memory of her voice, although its cadence and tone can be distinctly "heard" in the interview. The data exist in isolation, the only exemplar of all the numerous interviews that could have taken place, catching my mother's and grandmother's generations' recollections of what they wore during pregnancy. As such, it is fragmentary, for the material cannot be evaluated alongside other interviews conducted concurrently or within the same framework of references. Yet, one of its qualities is that Honor's words seem to capture something of the universal: to draw on a tacit, shared knowledge of maternity. Although in the interview she says, "It's difficult to remember what you did feel so long afterwards," she clearly articulates the ambivalence of pregnancy, "anxiety" against "high expectations . . . One against the other." At the time, I wrote in the Introduction to the book,

> So much of women's private history and the things crucial to their lives are unwritten. I had always felt that clothes could provide a key to an understanding of women's experience. Maternity clothes would not be high on a list of important issues for (male) historians to debate and, not surprisingly, very little had been written on it, even in the dress history world. Perhaps the combination of two "women's" subjects, clothes and childbirth, ensured its obscurity. Why make a case for clothes that are, after all, worn only briefly? Yet this is their fascination, and their special brief, to function—altered or specially made—for an organically changing body carrying not only a baby, but many of the expectations of society. (C. Wilcox, 1994)

I received nothing but encouragement for *A History of Concealment*. Colleagues in the museum world forwarded references to maternity clothing in their collections, while my mother wrote three pages of notes with comments such as "Concealment more important for poor women. More to lose." She knew this from experience, for many women in her family had been in domestic service and risked dismissal if they became pregnant. Amid her practical suggestions, memories of her own mother's many confinements crept in: her creaking stays as she did the housework and the tenor of her clothing. "Colour and texture of fabric important. Red unthinkable. Dull muted colours to match the mood of society, modesty—restraint. Fabrics—plain" (M. J. Wilcox, 1994).

Looking back, I found that one of the things I was seeking was evidence about how clothes make one *feel*: whether good or bad, uncomfortable or liberated—sensations always enhanced during pregnancy—and what their *meaning* was, "to match the mood of society" as my mother put it (ibid.). For curators, knowledge has always been sought within the heart of the object: its material qualities, historical significance, provenance, and quality. However, when objects are ephemeral and memories transitory, we need to explore wider resources such as archival material, fashion plates and photographs, private journals and public records, press clippings, and legal archives. Perhaps in the case of maternity wear, loaded with personal and social resonance, it is particularly helpful to investigate the function of clothing in terms of appearances and societal pressures as well as details of fashion, style, or function, for when children are longed for, pregnancy could be displayed positively.

When Rachel asked, "Was anything of the way you felt reflected in the clothes you wore?" Honor replied, "I was quite pleased in a way. I was careful to be clean and reasonably presentable, but didn't overemphasise the fact [being pregnant]." In contrast, she observes maternity wear of the 1990s with discomfort. "Well you see so many of these young women when they're very pregnant wearing skin tight dresses and they seem not to be bothered about it all, and I can't believe they're

comfortable." Rachel goes on, saying, "So the idea you sort of flaunt it is one you find quite difficult or you don't approve of it?" "Well, it's not that I don't approve," Honor responded. "I just think they could take a bit more trouble to make things a bit more attractive and not quite so well 'This is it!' and people have got to put up with how you look."

Like many of my generation, I was equally overt. I regarded maternity clothing as triumphal, writing in my introduction:

> The objective of *A History of Concealment* is to explore the changing experience of pregnant women over the centuries through an analysis of the codes of maternity dress. The idea for this book arose from the combination of a professional interest in costume history and my own experience of childbirth. I had been interested in what I looked like when I was pregnant; it brought me closer to my mother who, reviving her old dressmaking skills made me such stylish maternity clothes that people stopped me in the street. For the first time in my life I felt that I had found my style and a focus for my energies and that pregnancy was an opportunity to focus on an extraordinary, empowering physical change. (C. Wilcox, 1994)

When I first mentioned the idea of *A History of Concealment*, Rachel immediately told me about an interesting, rather dashing maternity outfit that her mother had kept from the 1950s, made of a bright maroon-and-blue-check wool shot through with silver threads of Lurex (see the following discussion). I was delighted to see it. Maternity wear rarely survives; early clothes were adapted and reinstated, and in the 1920s and 1930s, as my mother pointed out, "[o]nly [the] rich could afford special clothes. Poor people made do with bigger sizes and safety pins [and] cross-over aprons adjustable for all times," in contrast to couture garments such as a Jacques Fath gray day dress in the Victoria and Albert Museum's collection (Plate 17), which were often altered by the design house to fit the postpartum body.

The first few pages of the interview proceeded smoothly. "Can you tell me what maternity wear was available in the 1950s, and where you got it from—whether from mail order or special shops?" "Did you make any of your own?" Honor gives a precise response, the details memorized with a home dressmaker's eye:

> The only things that were available were two piece outfits—skirts with expanding belts and tops with buttons down the front and box pleats either side of the front opening. They weren't at all attractive . . . I made loose cotton dresses and smocks . . . The skirts had a moon shaped hole in the front . . . The edges . . . were done with bias binding.

Her response about the Lurex outfit (Plate 18) is the longest in the whole interview, and I quote it in its immersive entirety:

> I bought it at the end of 1957 in one of the big shops in Oxford—we were living in Witney at the time. The shop was Webbers I think. I bought it when I was pregnant with Cath. I was about 5 months pregnant and we were going to a Christmas party at the Technical College for staff and children, so I needed something nice. I think it was a little bit unusual. They were still selling a lot of pleated tops. That outfit was more flattering. It also had a brilliant brooch which I've still got, which attracted attention to the upper part of the chest rather than your stomach. I can't remember how much it cost. I think it was a little bit expensive for those days. I bought it by myself, you never took men to

those places. Dad came to Oxford with you and looked after you while I went shopping. The outfit was comfortable, really nice. It was thought to be quite smashing. At the party people said they liked it because it was different. I felt pleased wearing it.

Through the seventeen pages that follow, maternity clothing triggers discussion of family, work, the father's role, breastfeeding, complications, labor, convalescence, daily routines with young children, cars and the ability to drive, household appliances, and friendships. One of the characteristics of oral history seems to be the diversity of material that it generates, often triggered by the simplest of questions. Interviews such as Honor's gave unusual time and attention to an individual (for we rarely allow each other listening time) and allowed a rich vein of memory to emerge. Perhaps the only melancholy aspect is how much more there could have been, for as Rachel (2011) wrote recently, "Re-reading it now especially as she died in 2005 makes me feel rather regretful that we weren't able to have more conversations about her life. I am surprised about how much ground we covered in the interview, and how interesting it is."

It was difficult not to notice the complex undercurrents that emerged as the interview developed. Yet, the rhythm of question and answer and the neutrality of clothing permitted discussion of the most private of subjects, despite Honor's diffidence. As Rachel recalled, "Having had a rather difficult relationship with my mother, conducting a relatively 'formal' interview with a structure was a way of having a good conversation with her, which wasn't always easy" (Warner, 2011). Within this safe arena, Honor was able to tell Rachel about the complications that arose in her own birth and that she had been born under general anesthetic. She also discovered that her sister had "twisted at the last minute" and that the gap between the two sisters had been unplanned: "Catherine didn't work out to our plans." The stability of remembered childhood begins to shift, to threaten the equilibrium of memory.

One of my ethical concerns was whether it was right to share this material (see Partington in this volume), despite the fact that Rachel had given her consent, for Rachel's privileged position enabled her to ask direct questions that no one else could:

Rachel: Was he disappointed I was a girl?
Honor: I don't think so.
Rachel: I always had this idea he wanted a boy.

What kind of responsibilities lay with being in the possession of such sensitive subject matter for the outsider and, had I been acquiring this dress for the museum's collections, would anything other than the specific historical details of the dress—such as the date it was purchased, its cost, what is was made from (for the early use of Lurex is interesting), who it was owned by, and when and where it was worn—have been relevant for posterity?

I was also troubled by the matter of returning to old material and making sense of data remembered through the lens of time. Should this essay try to articulate what I had hoped to achieve with the research at the time, or analyze it in the context of the curatorial expertise I had gained since? How much of the interview should I cite, because its meanings only seemed revealed when read in its entirety? What, actually, did the interview mean—was it material about maternity fashions, or an essay on loneliness, or the pressure of social mores, or the role of women in the home in the

1950s? Should I focus on what was said or try to read between the lines and understand what was implied? Where was my own subjectivity in all this?

I began to appreciate the challenge of managing the interview's intersubjectivity given the particularly personal context of the research and the circumstances in which *A History of Concealment* began. I wondered whether it was right to reveal why I had been unable to complete the project, why the material began to overwhelm me, and whether I was drifting into the realms of the confessional, which seemed inappropriate. For the truth was that far from being an objective study of maternity wear, I had a confused agenda, centering on the loss of my first child. Soon, I became embroiled in the history of midwifery and obstetrics, lost in old journals and letters with their constant litany of loss. I was drawn to heartache in an attempt to make sense of my own. This was brought home to me one day when, looking at an old family bible, I saw a list of birth dates, the children's names crossed out one by one.

I also discovered that I was not the only person who had put a project to one side and then revisited it many years later and that far from being a transgression this could impart new perspectives that only added to our knowledge. In fact, such a technique seemed positively beneficial as proposed by narrative researcher, Molly Andrews: "Herein lies the impetus to return to data: the more vantage points from which we view phenomena, the richer and more complex our understanding of that which we observe" (Andrews et al., 2008:87). Perhaps this is the defining characteristic of the curator, the need to view and review our subject constantly while moving through time ourselves, in a compulsion to understand the past through its traces: the evidence that objects bring, the narratives that the spoken and written word carry, every forensic detail adding another piece to the jigsaw.

> All of us bring to our research knowledge which we have acquired through our life's experiences, and indeed how we make sense of what we observe and hear is very much influenced by that framework of understanding. This positioning is not static, but evolves over the course of our lives. New experiences, and new understanding of old experiences bring with them a new perspective not only on our own lives—our present, as well as our pasts—but on the way in which we make sense of the lives of others. (Andrews et al., 2008:86)

Perhaps as well as selecting significant extracts from our interviews, equally important are the questions we ask. Rachel was interested in life histories, interested in the subject matter of maternity wear, and interested in interviewing her mother. The Lurex outfit was a trigger, but, in what is ostensibly an information gathering interview, every page reveals insights into another world. For example, in contrast to the sociable and supportive network in which both Rachel and I were a part of in Brixton in the early 1990s, where, as Rachel pointed out in the interview, one could go "to classes and tea groups and meet new people," Honor's isolation is tangible. She couldn't get on a bus because the pram was too big. Breast feeding in public was not considered socially acceptable: "It wasn't considered the thing at all," and had to be done in the privacy of the home because only "a few places had ladies waiting rooms . . . but very few." She had a limited social circle where nobody could drive, and she and Rachel's father were living in a newly built suburb. Nor could she return to work, because who would look after the child? The personal impact of the breakdown of an extended family networks hits home, for as Honor says, "Well, this is it. It

was the start of the system whereby you'd moved away from your relatives and there weren't any aunts or grandparents to look after the children." When asked what she did in the evening, with her husband taking evening classes three nights a week, she says. "I just went to bed." As Rachel observed in the interview, almost to herself, "The thing that strikes me is how much more of a private activity it was."

Today, when sharing memories about objects has become a recognized way to enhance learning and to further a greater inclusivity in museums, oral histories have become a priceless resource, even challenging the might of curatorial authority. In my recent research for example, recordings of the photographer and co-editor of *The Ambassador* export magazine Elspeth Juda vividly imparted what it was like to be part of a cosmopolitan émigré couple arriving in London in 1933. During research for the Victoria and Albert Museum's exhibition *The Golden Age of Couture* (2007), listening to the life history of Percy Savage (2004) put aside any misconception that the role of fashion public relations is a recent phenomenon.

However, memories take up space (as the novel-length recollections of Savage show) as well as time to interpret and absorb their significance. I am aware that what we choose to extract from lengthy interviews to include in essays such as this throw an undue emphasis on data that could quite easily have alternative readings (see Sandino, 2009). Yet, it is tempting to read one particular exchange about the absence of photographs of Honor when pregnant as both a reflection of social conventions of the time and a metaphor for the innumerable women whose experiences of maternity have gone undocumented:

Rachel: I'm interested that there aren't any photos of you when you were pregnant, when dad took so many photos. Why didn't he take any photos of you?
Honor: I wasn't keen on having photos I don't think . . .
Rachel: Why?
Honor: I don't know.
Rachel: Do you think that was something to do with you taking into yourself that people didn't think it was very nice and made comments?
Honor: Maybe.

In her Introduction to *The Auto/biographical I,* Liz Stanley wrote that "social life, lives, and the writing of lives, are all intertextually complex and that to every statement about them should be appended another beginning 'And also . . .'" (Stanley, 1992:18). As such, perhaps the work we do through objects such as Honor's vibrant maternity outfit, and the memories it triggered, offers another chance to revisit the black box of memory, and make sense of it. As Rachel wrote to me, "I think she would have been pleased people were interested" (Warner, 2011).

REFERENCES

Andrews, M., Squire, C., and Tamboukou, M. (eds.) (2008), *Doing Narrative Research,* London: Sage.
Sandino, L. (2009), "News from the Past: Oral History at the V&A," *V&A Online Journal,* <http://www.vam.ac.uk/content/journals/research-journal/issue-02/news-from-the-past-oral-history-at-the-v-and-a>, accessed September 2010.

Stanley, L. (1992), *The auto/biographical I*, Manchester: Manchester University Press.
Taylor, L. (2002), *The Study of Dress History*, Manchester: Manchester University Press.
Warner, R. (2011), letter to author, November 16.
Wilcox, C. (1994), *A History of Concealment* [unpublished].
Wilcox, M. J. (1994), letter to author, n.d.

Interviews

Savage, P. (2004), interviewed by L. Sandino, Oral History of British Fashion, National Life Stories, The British Library Sound Archive, December 27.
Warner, H. (1994), interviewed by R. Warner, December 27.

FROM PUNK TO THE HIJAB
WOMEN'S EMBODIED DRESS AS PERFORMATIVE RESISTANCE, 1970S TO THE PRESENT

shehnaz suterwalla

Imagine listening to a female punk from the 1970s sharing dress experiences with a young British Muslim girl in hijab in 2011, who in turn compares notes with a 1980s black hip-hop femcee. Is it conceivable that their histories and experiences might intersect? Do their techniques of creative and critical style strategies overlap? What experiences might they have in common that subvert dominant forms of culture, knowledge, and history making?

Conventional fashion and design histories, traditionally rooted in object analysis, socio-anthropological or cultural studies methods, fall short in addressing these questions and either avoid or even worse ignore the tensions and strains of studying dress as a "fleshy practice involving the body" (Entwistle and Wilson, 2001:4). Alternative style has most typically been understood as discrete, as in "a" punk look, for example, that fixes not only the style but also the experiences of its agents, often reducing style identity into tropes (Hall and Jefferson, 1976; Hebdige, 1979).

Revisionist analysis since the mid-1980s has begun to discuss how the experience of style and the agentive impulses of the wearer are not static but performative and dynamic articulations that are temporally and spatially constructed. They are reflections of the nexus of class, race, and gender on embodied subjectivity (Entwistle, 2000). As a result, everyday style must be analyzed as a complex mix of mutating expressions. Understanding the experience of the wearer therefore becomes critical. Yet, as dress historian Lou Taylor has observed, of those methodologies

employed in the historical study of fashion, oral history is the least developed and practiced (2002:245).

By juxtaposing a seemingly unconnected series of case studies and by exploring threads that connect them, in this chapter I discuss my use of oral interviews to explore complex sets of "her-story" in how British women since the 1970s have used dress to challenge mainstream ideals of femininity. My focus is on women punks in the late 1970s, women who lived at Greenham Common Peace Camp in the 1980s, black British women in hip-hop in the 1980s and 1990s, and British Muslim women who have chosen to veil since 2001. I concentrate on women's experience to bring gender to the fore as a defining category of analysis, and thus to challenge the masculinist bias of traditional grand narratives.

I am aware that by prioritizing gender above other structural and discursive processes I do not resolve the methodological limitations of totalizing histories. Gender is only one part of many performative and dynamic factors that shape subjectivity. The gendered experiences of the women in my research are neither neutral nor transparent; they are part of a set of political articulations (Scott, 1999), reflections of their subjective consciousness within particular time and space. As an oral researcher, I need to incorporate enough methodological sophistication, partly by recognizing my own subjective biases, to account for these complexities and to remember that history telling and memories are set within the interpretative frameworks of an individual's politics of location.

With these priorities, I use oral interviews for my research. In particular, I am looking to compli-cate static narratives of dress and style by incorporating the desires, emotions, memories, fears, and fantasies that shape women's experiences of dress. These need to be included in historical records, even though traditionally they have been written out of formal accounts (Samuel and Thompson, 1990), if we wish to move toward a complex and multilayered understanding of dress studies and a richer analysis of identity. Such an approach is certainly encouraged by fashion theorists, who recognize the increasing use of oral history methods as a cultural turn in the discipline. As Taylor proposes, "there is no doubt of the positive excitement and innovation to be found within the cross-currents now whirl-ing through dress history/dress studies" (2002:271). Oral history helps to provide a healthy breeze.

PUNK WOMEN IN THE 1970S

The conventional histories of punk are for the most part either textual and visual histories that concentrate on London and its avant-garde bands, designers and fans, or a theoretical reading of punk style as an ideological resistance (Hall and Jefferson, 1976; Hebdige, 1979). On the whole, literature on the period determines punk style in a series of fixed iconographic images and cultural symbols lodged in the urban landscape. In these readings historical linearity has subsumed tempo-ral and spatial difference, creating instead a sort of heroic, romantic space that discursively conjures punk fashion as a homogenous style. However, when I listened to the real-life stories of ordinary women who were full-time punks in the 1970s, I discovered that very few of them had anything to do with the King's Road in London, with Vivienne Westwood, or with the Sex Pistols. Instead, locally and in the everyday, punk as visual and material culture was made up through the mixing of media representations of punk fashion, the commercial clothing available and a do-it-yourself, jumble-sale, make-do-and-mend philosophy.

Social theorists, like Dick Hebdige, have based their analysis of punk style on an ill-defined group, the "first wave of self-conscious innovators," as he calls them, the "authentic" punks who

understood the significations that Hebdige put forward (1979:122). For the ordinary punk, a more likely scenario would be that clothing was used as an expression of belonging as well as a marker of subcultural style. It changed constantly with the values of particular local punk communities (Cartledge, 1999:143). Style and fashion were not a homogenous or static construct. They were mutating forms of expression that reflected the embodied experiences of punks within different spatial and temporal sites and that responded to media representation. As a result, the potential to inscribe or create meanings within clothing was multiple; it cannot be claimed that the punk look was solely about symbolic resistance (Hebdige, 1979). Punk style was shaped to reflect the individual microclimates of punks within particular environments.

Oral testimony about the gendered realities of punk women in the 1970s undermines some of the stereotypes that dominated media representation, especially the idea that punk style was always abject, always about fishnet stockings and girls with panda eyes, stilettos, and spiky blonde hair.[1] For the more ordinary punk women I interviewed, abject punk style often had little to do with their individual realities. These women did not, nor did they want to, emulate the highly sexualized styles of the punk elite. For my interviewees, punk was less about the hypersexualized abject body and more about a quotidian androgyny, because the subversion of masculinity was, in the late 1970s, of great significance in national debates about gender politics and equality.

For example, one interviewee, Helen Reddington,[2] was part of a band called Joby and the Hooligans that was based in Brighton between 1976 and 1978. Reddington lived in an abandoned building and only wore items that she found there for free. She shopped for clothes very rarely. Photographs of her at the time show that she is wearing men's trousers and jacket, a fake raccoon tie, and a white shirt, all found in her lodgings (see Figure 30).

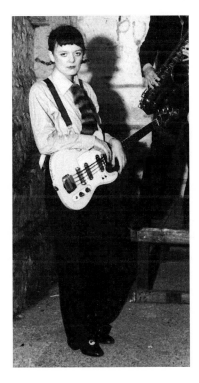

30. Helen Reddington in The Vault, Brighton 1976, practicing with her punk band Joby and the Hooligans. (Photographer Ray Renolds; permission granted by Helen Reddington).

Reddington could not dye her hair because the hair dye that was commonly used, called Crazy Colour, did not suit her hair texture, so she would wear it as "flat and shapeless as I could" (Reddington, 2009). For Reddington, this look was the extent of her punk fashion. She did not wear fishnets or fetish, unlike her male band mates. She found that the androgynous look was more powerful: it was disruptive, but it did not make her feel vulnerable or leave her open to abuse or attack. Reddington felt that she could "live this look," it was something real that could be sustained every day, and hence, it became a core part of her punk identity. "With an androgynous look I was more like the others in my band who were all men. Ironically their dress was much more hypersexualised than mine; but I felt comfortable and like an equal in my clothes" (Reddington, 2009).

It is only through oral history that I was able to revisit the personal stories of Helen and other ordinary punks like her, to prioritize their subjective experiences above objective social science making.

GREENHAM COMMON PEACE CAMP WOMEN IN THE 1980S

The same methods have helped me to interrogate the complex identities of women at Greenham Common Peace Camp in the 1980s. There were thousands of different types of women who arrived at Greenham in Berkshire (1981–6) to form a women-only peace protest against an American nuclear weapons base that was built there. Within a year, the women who lived at the camp attracted significant media attention, a large part of which vilified them as unfeminine and unwomanly, as lesbians, and as transgressive. A common theme that circulated in the right-wing press was that the women's unfeminine dress, their woolly hats and blankets, layers of jumpers and big clumpy boots, and their "dishevelled" presentation, meant that they were deviant and a threat to the social order. Consequently, moral and political judgments were made about their womanhood.[3]

By conducting oral interviews, as well as looking at photographs, banners, letters, artwork, and design objects (such as badges) from the camp, I have gained insight not only into the personal narratives of the women that lived there but also into how they chose to represent, record, and visualize their feelings and emotions. This material gives a fuller picture of the subjective experiences of the women there, and helps to contextualize accounts that are based on memory alone. A more complex history emerges, one that is quite different to the monolithic one represented in the media.

First, there were thousands of different types of women, of different races, ages, and sexualities, who lived at and visited the camp, ranging from hippies to conservative Tory wives, radical lesbians wearing women's symbols to punks and anarchists, and women with all sorts of politics and styles between. Each woman embodied her own gendered identity and situated knowledge. There was not a fixed or static Greenham woman, contrary to media representation. One interviewee remembers, "There were loads of different looks at the camp . . . the radicals looked very different to the eco-, cosmic lot. You know they were all cosy rainbow jumpers and long skirts and long hair. They looked like a bunch of teachers. And then there were the shaved-head lot in DMs [Doctor Martens] and women's symbols" (Walker, 2008).

Over time, the hostile conditions of outdoor camp life set in place a conventional "Greenham look" that was constructed around staying warm, dry, and in practical clothing. As well as

relying on donations, the women used traditional craft techniques as critical strategies to customize donated clothing so that it would suit their individual identities and politics. These techniques included do-it-yourself, make-do-and-mend, and other creative methods used elsewhere, such as in punk style.

What also happened was that a feminist ethos developed at the all-women camp, and the women's experiences formed an intense enactment of a separatist feminist project based on the politics and ideas emerging from the second wave and radical feminist activism that was part of the politics of the period. Mandy Walker, who lived at the camp for more than six months, said, "We never looked feminine, it wasn't really on. You wouldn't have worn make up and heels. Not because somebody told you not to, but because it just wasn't the space for that, it wasn't on" (Walker, 2008). Sasha Roseneil (2009), another "stayer" (someone who lived at the camp), recalled how "the idea of the self and the body as transforming through protest is consistent with the Greenham look."

Through oral testimony, I discovered that although the media had also spoken of a "Greenham look," what the women were referring to was in fact a state of being, an ethos, an embodied political position rather than a homogenous, one-dimensional, fixed, static style. Although there were many shared values at Greenham, there was never a single story, or look, that exactly matched another. Nor were the women's identities static during their stay.

BLACK BRITISH WOMEN IN HIP-HOP

The same is true for black British women in hip-hop during the 1980s and 1990s. The oppositional stance of hip-hop fashion in these decades, with its leisure wear as day wear, its baggy ill-fitting jeans, garish bright colors, and revealing Lycra, came about as a social critique for disenfranchised youth. The main emphasis within rap music and hip-hop during the period had been racial authenticity based on black legitimacy. This surpassed discussion of gender and class, and certainly in both mainstream representations of hip-hop and in its scholarship, issues of "blackness" dominated the discourse (Rose, 1994; Forman, 2002; Pough et al., 2007).

With a bias on race, the complication for women was that inadequate analysis of the sexual double standard in hip-hop had, from its inception, fixed the black woman in sexist and objectifying images that centered and privileged black male sexuality, desire, and agency. Images and representation of black femininity in hip-hop drew on and reproduced what black feminist scholar Patricia Hill Collins (1990:72) termed "the controlling images of black womanhood." She was referring to stereotypes of black woman as, for example, the hypersexualized jezebel or the black lady overachiever.

It is only through oral history that we can start to provide a critical counternarrative to hip-hop's racial and sexual tropes. What interviews highlight is that, first, rather than a monolithic culture based solely on racial authenticity, from the start, British hip-hop was a heteroglot scene. In the 1980s hip-hop crews shared the stage with punks at events like Rock Against Racism, and the urban breakbeat culture of the period created the rap scene. The men and women who participated in this scene were British born; their lives were embedded in British sociocultural and economic realities that meant that, for them, British hip-hop was cross-racial and syncretic. In short, it reflected their diasporic Black Atlantic experience (Gilroy, 1993).

In fact, all of my interviewees spoke of going to markets such as Wembley and Camden to buy African prints that expressed confidence in African history only in order to layer them with sportswear or high street fashions of the period. Interviewee Kym Mazelle (2010), who was a singer in the hip-hop band Soul II Soul, told me, "I picked it up on the African style, the braids . . . You know kind of [the fact that] the UK and Britain [is] in between America and Africa you kind of pull from both looks, you know?" Rather than highlighting an essential blackness, these women created a hybrid hip-hop style to portray what can be considered "postmodern blackness," a term popularized by Cornel West and further developed by bell hooks in her essay by the same name (hooks, 1996). This position acknowledges that blackness is diverse, complex, multidimensional, and constructed within a particular time and place.

Expressions of femininity through hip-hop style brought into central view black women's subjectivities from within their racialized histories. For example, hypersexualized clothing was used as a critical strategy to caricature, and thus undermine, stereotypes of essentialist and racialized black sexuality. Body-conscious Lycra dresses, bra tops, and cycling shorts were all part of the "pump 'n' grind" image of everyday hip-hop style; these clothes exaggerated the contours of the black female form, not only to bring the black gendered body into central view but also to parody the controlling images of the black jezebel. As Mazelle (2010) explained, laughing, "I am going to wave it in your face . . . but don't touch it, okay, you can look but you don't touch it. Don't touch it or else you are in a coffin!"

Simultaneously, there was a move in hip-hop style for women to adopt the same clothes as men. Baggy, loose-style unisex tracksuits, baseball caps, hooded tops, MA-1 flight jackets, and trainers were just some of the items worn by both sexes. Within black British women's politics of location, hip-hop androgyny was an important gendered move: not only did it emphasize the fluidity of male and female subject positions; it also undermined static representations of black womanhood, showing not only that women could dress like men but that they could own and display the same material possessions as them too.

MUSLIM WOMEN AND THE VEIL, 2001 TO THE PRESENT

These histories of women's subjectivities as expressed through critical design strategies also connect, rather surprisingly, with processes of embodiment of the contemporary hijab, or Muslim head covering. In contemporary media representation since 2001, the hijab is seen as an overdetermined signifier of gendered and political alterity. As such, it continues to carry a myriad of loaded, contradictory, and complex associations, some of which still resonate with orientalist histories that have long been criticized for essentializing Muslim subjects in totalizing tropes (Said, 1978; Abu-Lughod, 1998). A recurring question that surrounds the veil is, does it repress women and deny them agency?

Oral interviews with British Muslim women of different ages, classes, and races, who have actively chosen to wear the hijab since September 11, 2011, discloses a nuanced set of responses. My interviewees are British nationals, who, even if they were not born in Britain, consider Britain as their home. Within the urban framework of British metropolitan centers, these women have chosen to wear the hijab not because of tradition, but as an articulation of their British identity. In the context of the British street, for these women the hijab is a conspicuous stylization used to assert individuality.

According to my interviewees, hijab designs are created by adapting scarves and other materials from the British high street. Motifs, fabrics, and color from mainstream fashions are appropriated and rendered Muslim through the way they are draped on the head. Interviewee Annika Waheed (2010), a London-based 26-year-old teacher, told me, "My hijab are just scarves from the high street, I get them to match my outfits." As such, the hijab's aesthetic and cultural politics simultaneously defies yet also enforces continuous escapades in the mainstream: the hijab, while fashioning otherness, at the same time constantly borrows from global cultural industries. In this way, within the British context, the hijab creates a double discourse, one that seems to resist the mainstream but at the same time is part of it. For Waheed (2010), this means that she can feel like a "total fashionista" despite wearing the veil.

Waheed (see Plate 19) is British born but comes from a Pakistani background and has been wearing the hijab for seven years. Waheed adopted it to assert her Muslim identity in what she felt was an increasingly hostile climate of anti-Muslim sentiment following the attacks of September 11, 2001. All of Waheed's hijab come from high street stores (see Plate 20). She has never been to a hijab shop, nor does she intend to in the future.

Waheed's appropriation of high street fashion objects are used in a critical strategy so that, despite being Western and non-Muslim, the objects enable her to perform "Muslimness." Her style involves cultural synergy as much as oppositionality, and through embodiment, the mainstream fashions that she buys undergo a process of recontextualization in which the cultural objects from one environment take on a new purpose when applied in a different social context. "I always mix my high street shopping together to create my Muslim look, turning the scarf into hijab but making sure it goes with the rest of what I'm wearing, especially my shoes!" (Waheed, 2010). As a result, a hybridization of style occurs that engenders the opportunity to create new style formations that are British and Muslim at the same time. In particular, the layering, and combining of Western clothes into a Muslim look becomes like performing a dissident subjectivity, a disruptive performance that challenges the normative or stable structures of the fashion system: "This is my way of being British, I still think I'm mainstream" (Waheed, 2010). So it becomes apparent that through veiling, Muslim women like Waheed express their Muslimness, but at the same time, through cosmopolitan dressing, they have the opportunity to morph into "new" Muslim subjects where they can create hybrid identities beyond orientalist tropes.

CONCLUSION

Oral history in fashion and design scholarship helps us to deconstruct meta-narratives and to make space for full and inclusive histories that show experiences as embodied, performative articulations that reflect fluid identities, not discrete, fixed positions. The critical design strategies shared by the different groups of women in my case studies illustrate how their processes of style are markers of the relationship between popular expressions, commodification, urbanization, and political realities as well as their own historico-cultural memory. In the women's cultural borrowing and exchanges from different influences, dress and style become historical palimpsests. There is no essential or discrete style, just as there is no essential or discrete identity. Instead each case study's dress practices provides glimpses into layers of other historical styles, traditions and symbolic systems, just as women's subjectivities and histories are layered and complex.

Oral history is, of course, not without its own challenges. Issues of unreliability, subjective narrative conjecture and the essential fallibility of individual personal memory continue to be a source of concern for some researchers (Perks and Thomson, 2006; Abrams, 2010). However, oral history testimony still remains a critical means of giving voice to other or new perspectives that can challenge the foundations of previous historical assumptions. Although it has methodological difficulties, the benefit is "its ability to clarify the individuality of each human life and yet to reveal the contribution of each person within the wider community" (Taylor, 2002:260).

In this vein, I use oral history to present a reflexive rather than heroic analysis, one that privileges questions about why and how women explain, rationalize, and make sense of their past, what their perceived choices and cultural patterns were, and how they have negotiated the complex relationship between their individual consciousness and culture. Listening between the gaps of traditional sources is essential and worthwhile if we are in search of a full and inclusive history, if we are to push the debate regarding interpretations of subjectivity and expressions of embodied experience.

NOTES

1. For an example of hypersexualized punk style, see Siouxsie Sioux, lead singer of Siouxsie and the Banshees (1976–96).
2. Also known as Helen McCookerybook, http://www.mccookerybook.com/
3. See, for example, the front-page headlines and editorial about Greenham Common in *The Daily Mail*, December 13, 1982; *The Sun*, December 14, 1982; and *The Daily Express*, December 2, 1983.

REFERENCES AND FURTHER READINGS

Abrams, L. (2010), *Oral History Theory*, London, Routledge.

Abu-Lughon, L. (1998), *Remaking Women: Feminism and Modernity in the Middle East*, Princeton, NJ: Princeton University Press.

Cartledge, F. (1999), "Distress to Impress?: Local Punk Fashion and Commodity Exchange," in R. Sabin (ed.), *Punk Rock: So What? The Cultural Legacy of Punk*, London: Routledge.

Collins, P. H. (1990), *Black Feminist Thought: Knowledge, Consciousness, and the Politics of Empowerment*, London: Unwin Hyman.

Entwistle, J. (2000), *The Fashioned Body: Fashion, Dress, and Modern Social Theory*, Malden, MA: Polity Press.

Entwistle, J. and Wilson, E. (2001), *Body Dressing*, Oxford: Berg.

Forman, M. (2002), *The 'Hood Comes First: Race, Space, and Place in Rap and Hip Hop*, Middletown, CT: Wesleyan University Press.

Gilroy, P. (1993), *The Black Atlantic: Modernity and Double Consciousness*, London: Verso.

Hall, S. and Jefferson, T. (1976), *Resistance through Rituals: Youth Subcultures in Post-war Britain*, London: Hutchinson.

Hebdige, D. (1979), *Subculture: The Meaning of Style*, London: Methuen.

hooks, b. (1996), "Postmodern Blackness," in P. Rice and P. Waugh (eds.), *Modern Literary Theory: A Reader*, London: Arnold.

Perks, R. and Thomson, A. (eds.) (2006), *The Oral History Reader*, London, Routledge.

Pough, G. D., Richardson, E., Durham, A., and Raimist, R. (eds.) (2007), *Home Girls Make Some Noise: Hip Hop Feminism Anthology*, Mira Loma, CA: Parker Publishing.

Rose, T. (1994), *Black Noise: Rap Music and Black Culture in Contemporary America*, Middletown, CT: Wesleyan University Press.

Said, E. W. (1978), *Orientalism*, Harmondsworth: Penguin.

Samuel, R. and Thompson, P. (eds.) (1990), *The Myths We Live By*, London: Routledge.

Scott, J. W. (1999), "The Evidence of Experience," *Critical Enquiry* 17/4: 773–97.

Taylor, L. (2002), *The Study of Dress History*, Manchester: Manchester University Press.

Wilson, E. (1985), *Adorned in Dreams: Fashion and Modernity*, London: Virago.

Interviews

Mazelle, K. (2010), interviewed by S. Suterwalla, London.

Roseneil, S. (2008), interviewed by S. Suterwalla, London.

Reddinton, H. (2009), interviewed by S. Suterwalla, London.

Waheed, A. (2010), interviewed by S. Suterwalla, London.

Walker, M. (2008), interviewed by S. Suterwalla, London.

BECOMING AN ARTIST
LIFE HISTORIES AND
VISUAL IMAGES

maria tamboukou
and gali weiss

In this chapter, we consider the experience of an art/research experiment that took place in the context of the annual conference of the British Sociological Association (BSA), held at the University of East London in April 2007. The essay is in four parts: in the first section, the researcher gives the context of the project that underpinned the BSA event, mapping its theoretical directions and methodological moves. In the second section, the artist tells stories of becoming through words and images. The force of the artist's narrative challenges and reconfigures discursively constructed boundaries between the researcher and the artist, initiating a dialogic encounter that unfolds in the third section as a visual/textual interface. This encounter revolves around the quest for meaning, which is after all what oral history is about (Portelli, 2011). Our quest for meaning actually inspired us to write about and problematize the BSA event. In this light, the final section looks critically into some of the questions that have arisen, situating them within wider problematics in the field of oral histories and narrative research in the arts and beyond.

NOMADIC LINES OF BECOMING: NARRATIVES AS TRACES OF THE SELF

"In the Fold between Life and Art: A Genealogy of Women Artists" was a research project that looked into the constitution of the female self within the social milieu of art. The project combined

archival research of fin-de-siècle women artists' autobiographical documents and life-history interviews of contemporary women artists. The latter were invited to present their work and share their stories of becoming an artist in the context of a sociological conference. Overall, eighteen women were interviewed for this project. Although they were all invited, fourteen accepted to take part in the exhibition, eleven came to the round-table discussion, one declined, and the other two had prior commitments.

Convening an exhibition and staging a collective oral history event was conceptualized as an experiment, which attempted to cross-disciplinary boundaries between art, oral history, and sociology, as well as to challenge binarisms between academic and artistic spaces. What has come up as an analytical theme of the overall project is the emergence of multiple and complex paths in becoming an artist. Following Rosi Braidotti's (1994) influential theorization of female subjectivities in transition and move, I have called them nomadic paths since they do not seem to follow predefined trails or carefully designed schedules. It is not easy to locate their point of departure and even more difficult to pin down their final destination. These paths seem to start and end in the middle and what is interesting about them is the journey itself rather than its starting or ending points. Narratives, I have suggested, trace signs of such nomadic passages, charting histories, or rather genealogies of the constitution of the female self in art (Tamboukou, 2010; see Figure 31; Plate 21)

Opening a Box: Objects, Stories and Visual Images

There are times in your life when events happen or decisions are made that seem minor at the time, but that propel you in a direction that has such a major significance in your life, that nothing is the same anymore. One such pivotal time occurred for me after my mother's death. Some months after her death, my father, sister and I were trying to make sense of my mother's belongings, when I came across a biscuit tin amongst her collections. On prising the lid open, I found it full of half-used tubes of oil paints that had belonged to her. This discovery was to prove to be her legacy to me. It's not that I discovered painting after finding these paints—at that time I was 38 years old, and it was I who was the one in the family who had made art into a career—my mother had only taken to painting in her retirement years. The significance of finding that box was that I was compelled into some sort of action; my life was never to be the same again, and that box had everything to do with that.

My mother had been an opera singer. She had also been a hairdresser. In fact, all my life she had been a hairdresser. But it was her time as an opera singer that featured strongest in my psyche, the sense of my mother as another woman. That other woman was captured in photographic images that were a treasured part of my family's personal mythology, all the more so as they were interwoven with the history of the State of Israel and the early days of the Israeli Opera. In my psyche, they were the days when my mother was happy, and in her psyche too, this was so, for she repeatedly related to us many stories of fame and fun. It didn't matter that she had only sung in the chorus and had never had a major starring role on stage. To me, she was the central character in her stories because her eyes would fire up and she became someone else in the remembering. When after a meal my sister and I would wash and dry the dishes while my mum organized the kitchen, we'd make our tasks more palatable by singing her operettas in harmonies together, and we were transported to other places.

It's this transportation that I constantly seek nowadays in my artwork. Another place. Not so much an escape as a return. When it became clear that my dream of returning to live in the country of my birth was never going to be realized, I gave myself over to my work to an even greater extent. Here is where it is possible to travel to another place that is both my home and my challenge, and is a meeting point, a place of connection with at least one other, a viewer generous enough to experience it.

So those paints in the tin box had to be my legacy. No other member of my family had any use for them, and they couldn't be wasted—they were oil paints, big expensive tubes still bulgingly full of potential. My mother had died and there was a box of paints. This had to symbolize something: I had to instil in them some meaning, they were so specifically directed to me.

The paints became so significant to me at that time that I gained courage through them. I gained the conviction to build my own studio, and to position myself as the woman, the artist I was before I lapsed from my artistic vision through the demands of family and migration. The paints became symbols for a return of sorts, and through them, my mother was urging me to use my potential, and to do it now. (Weiss, 2007a)

31. Gali Weiss, *Torn* detail (2005), artist's book, photocopy on Magnani Velata Arvorio paper, tear as drawing, edition of two. (Image courtesy of the artist. Photographer: Max Loudon).

DIALOGIC ENCOUNTERS: MAKING ART, TELLING STORIES, AND WRITING NARRATIVES

Weiss's story recounted at the BSA collective oral history event, pops up from a tin box opened after her mother's death. The opening of a tin box marks an event and makes "a cut" in her life: it is definitely not the beginning of her artistic career, but rather a new beginning in her life when "moments of being" of the daughter-as-artist and the mother-as-artist are making forceful connections (Figure 32).

During her 2006 interview in Melbourne, Weiss had further reflected upon the significance of finding the box with her mother's paintings, linking it to her decision to have a studio and thus reclaim her professional identity as an artist:

> there were these oil paints, which she had left over and I was never an oil painter, I've always been a workshop paper person, but she left that and I took that symbolically as sort of some connection that she was telling me, I had to do something with this box of oil paints, which she'd left, even though I was doing some book illustrations and I was *still* doing things, but not that studio art, that self-reflexive kind of, that kind of art . . . So I got courage and that was in about 1995, so that would have been about 8 years after we returned to Australia and had a second child, at that stage I decided that I was going to

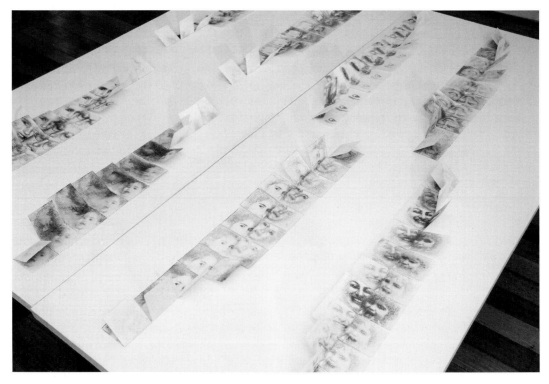

32. Gali Weiss, *Closed Books* (2008), photocopy transfer, charcoal, ten to twelve images each book, 8 × 16.5 cm each image. (Image courtesy of the artist. Photographer: Ponch Hawkes).

build a studio at the back yard, which was done and I think it was because of that confidence, that conviction, so I built a studio, a small studio and that was the beginning of sort of my coming back to, an exhibiting artist that I am . . .

Weiss's story of becoming an artist does not have discernible beginnings; there are continuous ruptures in her lifelines, comings and goings—both real and imaginary. It is always in the middle that Weiss starts afresh, taking up threads of broken lines and initiating returns. Her space and memory journeys in search of meaning about who she is initiate new becomings. These new beginnings, in the middle, always appear as discontinuous and fragmented events that can only leave their traces in narratives.

Indeed Weiss's story unfolds as an entanglement of narrative "lines of flight," as proposed by Deleuze and Guattari's (1988) conceptual vocabulary denoting resistance (see also Tamboukou, 2010), going away and coming back, migration and diaspora: every time she arrives somewhere, she finds herself in a different place. Spaces, objects, and movement are thus a strong material presence in her narrative, beautifully expressed in her art practices that revolve around "the anonymous portrait" (Plate 22).

> it's more than the migrant, it's the diasporic kind of existence that I am so familiar with . . . and also being brave enough, having that understanding that I am a diasporic subject, I am not an Israeli, I am not an Australian, I am not an ex-Israeli, I am not . . . I am a diasporic Jew, living in Australia, so that you know, even though it seems really obvious, it really blew me out to describe myself, like I always thought of myself as Israeli when I was in Australia, Australian when I was in Israel, the usual kind of thing . . . but claiming that identity of the diaspora was quite major for me and together with that . . . the love of the portrait . . . for me . . . portraiture is not about stories of diaspora, but it's taken me to thoughts of diasporic existence, sensibilities, and calling the portrait, or my way of doing the portrait—it is a very fluid portrait, and yet it's a portrait—and I call it the anonymous portrait which is an antithesis of the portrait, because the portrait is a named, it is about a named individual . . . but it's nothing about someone who has a name we refer to, so I am interested in that, I am interested in the relationship that when one views the portrait, the relationship, the relationship between the three kind of parties, the artist, the sitter and the viewer, it's that relationship that is the portrait, it's not the portrait in itself, the portrait is a tool, the object is a tool, so it all links into my life as artistic things do and I am sort of theorizing it . . . (Weiss, 2006)

Weiss's artwork is thus mapped as a return journey, a return to creativity and art inspired and driven by a box of paints left behind by her mother. Her story is about finding a meaning in life or rather returning to it, reclaiming the memory of being an artist through remembering her mother as an artist: an opera singer. Indeed her story sounds like a song, one of those she used to sing in the company of her sister and mother, three women brought together in singing, travelling back and forth to "other places." As Adriana Cavarero has beautifully theorized it,

> the woman who sings is always a Siren, or a creature of pleasure, extraneous to the domestic order of daughter and wife. The female singing voice cannot be domesticated; it disturbs the system of reason by leading elsewhere. Potentially lethal it pushes pleasure to the limits of what is bearable. (2005:118)

In Weiss's preceding story, the confined space of the kitchen initiates memory journeys through singing, but these songs can never pin down meaning, as they never settle down in a place: they carry the singers in other places and different times; they become the sound of nomadism by composing refrains. Weiss's story line of "the box" is indeed a refrain, a story told twice: once in the context of the interview in the space of her studio in Melbourne and then again in a lecture room at the University of East London. In some ways, both spaces could qualify as public: while interviewed within the intimate atmosphere of her studio, Weiss was quite aware that her story would become part of a wider project looking into women artists' life histories. The lecture room at the University of East London was nevertheless a different public space, wherein stories were told in the actual and not just imagined presence of others. In this light, the matter/space/ time conditions of the different public spaces wherein Weiss's story was told and retold were significant. Indeed, is a story told twice ever the same, and what are the effects of Weiss's narrative reiteration? We want to explore these questions by returning to the moment of their emergence, more specifically the space/time/matter conditions of the BSA oral history event, wherein subjects appear to each other through action and speech, constitutive practices of the political as proposed by Hannah Arendt. In Arendt's (1998) thought, human beings appear in the world through action and speech, which takes place in public spaces and creates conditions of possibility for political action.

As already noted in first section, the idea of the exhibition and the collective oral history event was to bring together a group of contemporary women artists who had been previously interviewed for a narrative research project. Thus, from the beginning were a number of spatial, embodied, and conceptual couplets not only creating conditions of possibility for the BSA event, but also imposing limitations and constraints on its realization: the gallery and the university, the art and the academy, the researcher and the artist. However, rather than being taken as oppositions or disjunctions, these couplets were initially considered as conjunctions, rich and potentially fertile multiplicities. Nevertheless, multiplicities are better theorized than practiced, and it is the minutiae, difficulties, complexities, and ultimately bright and dark areas of "doing multiplicity" that we discuss in the next section.

INTRA-ACTIONS WITHIN PHENOMENA: ON THE LIMITS OF NARRATIVES

In this section, we focus on the spatial, temporal, and discursive limitations of the BSA exhibition and round-table discussion as a scholarly event of an academic conference as well as a collective oral history project. The exhibition itself lasted for only three days, which is much shorter than exhibitions usually run, as the artwork was displayed in non-gallery conditions. It has to be noted here that there was actually an art gallery in a different building of the campus, but the researcher deliberately chose to have the exhibition at the center of the conference so that it could remain organically connected to its other events. What the researcher had not fully appreciated at the time of conceiving the idea about the exhibition was the importance of the complex matter/space/time relations of the BSA event. Indeed the setting up of the exhibition created a specific phenomenon wherein material conditions and discourses were intertwined, certain types of knowledge relations were enabled to emerge and unfold, while others were shadowed or marginalized; there was even a disjunction between women themselves, vis-à-vis their presence: two of the eleven women who

participated in the exhibition declined to take part in the discussion, while in communication following the exhibition, Weiss (2007b) revealed that the quest for meaning had gotten off track, at least for her:

> For me, the presentation was a beginning, a supposition. I saw it as an experiment, a question: what happens when a number of women who define themselves as artists are placed together and present themselves within a limited time and place, without predetermining their presentation as a group. What do they choose to present? . . . I would have liked to hear more of why we choose to do what we do. Why we choose to create, and why we choose to deal with our materials and subjects in the way we do. In other words: about meaning.

Indeed Weiss's intervention is crucial in highlighting the importance of materiality and space not just in allowing meaning to emerge, but also in creating conditions of possibility for the work of art to appear:

> There is always an initial unease for me at seeing the empty space of an exhibition site before setting up my work. On the one hand, it is a site of potential for transformation; on the other hand, it is complete in itself and I am faced with having to break the perfection of a "white" space. To help me make that break, an internal struggle emerges: the space is always either bigger or smaller than I'd imagined, the ceiling too high or too low, the light too artificial or too natural.
>
> Before coming to the BSA conference room selected for the exhibition, I could only imagine my own work, set in a non-specific space with the other artists' work somehow anonymously merged within the walls. Now that the space was a physical reality I was faced not only with the room itself, but with the other works, so alive and present, so different to my own conceptually and materially. How to recreate a unified space or a trajectory within the space out of seemingly unrelated artworks, whose connectedness lay in academic explorations rather than conceptual or material ones?
>
> In this light, the exhibition was more a presentation than an exhibition in my artistic understanding. It took me a while, till even beyond the time of the conference, to understand that the exhibition was not about the artwork itself. Meaning was not primarily generated by the works of art or the viewer response to them, but by their connections to the artists who created them. In other words, the context for each individual's artwork was not the place of exhibition, but the space created by the two presentations, the roundtable discussion and the exhibition of artworks, as one. (Weiss, 2011)

What Weiss significantly suggests in the preceding excerpt is that the exhibition and the oral history event cannot be perceived separately: the specific material, spatial, and discursive conditions of the BSA conference had a significant impact on how the art/research experiment unfolded. It was through forceful "intra-actions" (Barad, 2007) between the artistic and the academic that meaning was enacted and knowledge emerged.

Within this entanglement of matter and meaning were inclusions as well as exclusions. What we therefore want to suggest here is a skeptical approach to what emerges as a trend in narrative research and oral history: an uncritical celebration of the revelatory and emancipatory essence and function of narratives. Although narratives create conditions of possibility for the quest of meaning to be enacted, they cannot guarantee its emergence, neither can they bound or determine their

effects. As Olivia Guaraldo has argued, in opening sites of contestation, what narratives allow to emerge is the unpredictable and not the acceptable or the anticipated (2001:82).

Seen in this light, the BSA experiment was set up as a catalytic event in the quest for existential meaning: What is "the present" of women artists' lives today? How have they become what they are, and what are the possibilities of becoming other? This quest for meaning was conceptualized as an art event—the artists' exhibition—and as a narrative phenomenon—a collective oral history event. In this context, the exhibition revealed a multiplicity of perspectives, techniques, visions, and traditions among the artists as well as a range of sociocultural and discursive positions that constitute the repertoire of identity and subject positions available, desirable, and sometimes unattainable for women artists today. Indeed the artwork they chose to send and the artists' statements for the exhibition catalogue create a rich archive of "stories as multiplicities of meanings" (Tamboukou, 2010:2).

Things unfolded differently in the collective oral history event, however, which was framed and bounded within the theoretical requirements of the BSA conference: not all women artists felt comfortable or at ease stepping into what they perceived as a theoretical and abstract academic space: here lie the limitations and challenges of turning a reciprocal storytelling scene into an academic narrative research event, where all participants can attain public visibility. Storytelling can facilitate connections, but communication is not an essential property of narratives; neither is it a necessary effect. The communicative and relational elements of narratives emerge within certain sociocultural and political contexts, but this emergence is a performative effect, not a sine qua non condition of a supposedly narrative ontology. Even when rich stories emerge, as it was indeed the case with Weiss's narratives and artwork, they do not necessarily connect people; neither do they create anticipated meaning; the communicative, cognitive, and relational elements of narratives are possibilities, and effects, not essential or necessary conditions or consequences. Nevertheless, the responsibility of the narrative researcher or the oral historian is crucial in facilitating emergence, creating conditions for connections to be made and for meanings to emerge. Indeed, there is an urgent need for researchers to problematize their practices and to dig deeper into the political and ethical effects of the stories they listen to and which subsequently they write and tell.

REFERENCES

Arendt, H. (1998), *The Human Condition*, Chicago: University of Chicago Press.

Barad, K. (2007), *Meeting the Universe Halfway: Quantum Physics and the Entanglement of Matter and Meaning*, Durham, NC: Duke University Press.

Braidotti, R. (1994), *Nomadic Subjects,* New York: Columbia University Press.

Cavarero, A. (2005), *For More than One Voice: Toward a Philosophy of Vocal Expression,* tr. P. A. Kottman, Stanford, CA: Stanford University Press.

Deleuze, G. and Guattari, F. (1988), *A Thousand Plateaus: Capitalism and Schizophrenia,* tr. B. Massumi, London: The Athlone Press.

Guaraldo, O. (2001), *Storylines: Politics, History and Narrative from an Arendtian Perspective*, Jyväskyla: SoPhi.

Portelli, A. (2011), "Theatres of Memory, Memory as Theatre," Raphael Samuel memorial lecture, Bishops Gate Institute London.

Tamboukou, M. (2010), *In the Fold between Power and Desire: Women Artists' Narratives,* Newcastle-upon-Tyne: Cambridge Scholars Publishing.

Interviews

Weiss, G. (2006), interview by Maria Tamboukou, Melbourne, April 21.
Weiss, G. (2007a), British Sociological Association Annual Conference, University of East London, April 14.
Weiss, G. (2007b), e-mail communication, April 27.
Weiss, G. (2011), e-mail communication, March 14.

18.

NARRATIVES IN PRACTICE
THE SMALL AND BIG STORIES
OF DESIGN
arlene oak

INTRODUCTION

How might we best understand design practice? Through a "big story" approach (Freeman, 2006) in which a designer reflects on past work in an interview, or through a "small story" perspective (Georgakopoulou, 2006) that focuses on the brief narratives that occur during the conversational interactions of practice-based settings, such as professional meetings? This chapter looks at some of the connections and differences between small and big stories in relation to design. These connections and differences are revealed through examining an extract of conversation that occurred between a client and an architect in a design meeting and an extract of an interview that took place between the architect and a design researcher many months after the design meeting. Both the small and big stories overlap in terms of what they indicate about design, with the participants using both brief and extended narratives in ways that show practice happens through mutual cooperation and ongoing collaboration. However, the different types of story also diverge, with the big story indicating that design may also be decidedly idiosyncratic with highly personal, emotional, and embodied experiences acting as the impetus for the form and function of a new building.

NARRATIVES IN PRACTICE: THE SMALL AND BIG STORIES OF DESIGN

Researchers who seek to understand the production of designed goods have a complex task, partly because of the diverse settings in which design occurs: from business meetings with participants to

more private contexts (such as sketching alone). Those who seek to comprehend design may examine interviews with designers, perhaps conducted after a project, or an individual's career, is completed (The Henry Ford Archives, 2004–10). Such interviews are characteristic of oral history, wherein the interviewed person tells big stories, that is, narratives that entail "a significant measure of reflection on either an event or experience" with the aim to "*make sense* of some significant dimension of one's life" (Freeman, 2006:132, 133; author's emphasis). These narratives are based on an individual's memories, and so we may learn a great deal about the speaker's identities and the creation of objects (Sandino, 2006). However, if the interviewee does not speak of his or her design practice as involving others, then the more sociable aspects of design may be overlooked.

To counter a focus on the solitary designer, some researchers study the "institutional talk" (Heritage, 2005) of practice; that is, those natural interactions that occur during the settings of real design projects wherein participants work together on design-related tasks (for further discussion of institutional talk and design practice, see Oak, 2009). Such studies tend to use approaches associated with forms of discourse analysis to explore how participants perform and collaboratively construct both design practice and designed objects (Oak, 2006, 2009, 2011). As with interviews, these types of data also contain people's memories, but these recollections tend to be spoken of in small stories: those brief, situated instances of narrative, usually about fairly recent events, that occur as sequentially ordered, talk-in-interaction (Georgakopoulou, 2006, 2007). A small-story approach may reveal the highly social nature of real practice but, as indicated here, may miss some of the nuances of individual agency that underpin design.

This chapter considers what can be revealed about design practice through examining both a small and a big story, each of which relate to the same instance of architectural practice. After describing the data, this chapter focuses on the small story, which is from a business meeting held between an architect and two clients. This is followed by a discussion of a big story that has been extracted from an interview with the same architect. By considering both types of story, we can see how they intersect and how they provide different kinds of information about design and about the participants in practice, to the extent that if only one type of story is considered our knowledge of design is limited.

THE DATA

This chapter uses data from the seventh in the series of Design Thinking Research Symposia (DTRS), an ongoing cycle of scholarly meetings that studies design practice. A goal of DTRS7 was to understand "authentic professional design activity" (McDonnell and Lloyd, 2009:3), and so scholars analyzed a common data set of audio-visual recordings and transcriptions of real design meetings. The DTRS data used here concern architecture, in particular, the creation of a new crematorium that has been constructed near an existing facility in the United Kingdom (Plate 23). As well as recordings and transcripts of two meetings between the architect and clients, the DTRS7 data included images (drawings and photographs) that were referred to during these meetings and a background information video of the architect being interviewed by a researcher (an organizer of DTRS7). This interview was not considered part of the main DTRS7 data set, which focused on analyzing the meetings.

The design meeting that is featured in the first extract of talk here included the architect, Adam, and two clients: Anna, the registrar of the existing crematorium, and Charles, a local council

representative (names are pseudonyms). Anna has more than twenty years' experience working in the existing crematorium and could be considered the project's chief client since she has specialized knowledge of what is required in the new building. As she was the chief client, part of Anna's role in the design process is to consult with people who will use the future building and then communicate the thoughts of these people back to the architect.

The DTRS7 data support the recognition that designers do not work alone, with the DTRS7 project contributing to the trend in design research that focuses on "the way that designing occurs between people . . . rather than on individual design problem solving" (McDonnell and Lloyd, 2009:1). This interest in the social nature of design echoes the work of others, such as architecture historian Adrian Forty, who, in his influential book *Objects of Desire,* argued that "only by shifting our attention away from the person of the designer can we properly comprehend what design is" (1986:245). Forty sought to have less attention directed to "the creative acts of individuals" (ibid.) and more concentration on design as a process that "embodies ideas that are held in common by the people for whom the object is intended" (ibid.). Forty draws attention to how the creativity of production is distributed socially, with many agents involved in a final outcome. His interest in the "social relations" (ibid.) of design implicitly suggests that design may be considered through its emergence within social interaction, because it is in conversation that many of the social relations of practice are performed. Such practice-based interactions are the contexts for the small stories of design.

SMALL STORIES

Until recently, small stories have not received much attention in narrative research when contrasted with the scholarship on big stories (Georgakopoulou, 2006, 2007). However, if we think of a narrative as the telling of a sequence of events that are relevant to speakers and listeners, then small stories can be significant actions that: shape situations, interpretations, and meanings; help to make social activities orderly; and, reveal characteristics of participant identities (Bamberg and Georgakopoulou, 2008). In the DTRS7 data, where the social activity is a design meeting concerning a new crematorium, the small stories within the meeting help the participants to perform design in ways that are mutually meaningful and also productive materially, in that these small stories (together with other talk) had an impact on decisions made concerning the form and function of the proposed building (Oak, 2009, 2011).

The following extract is a small story told during a design meeting held between Adam, Anna, and Charles, with Anna producing the story. Her brief account indicates that interpretations of the new building are distributed beyond the meeting at hand, because she refers to the circulation of images and understandings of the crematorium among people who are not present at this meeting. That is, as chief client, Anna solicits opinions from people, such as funeral directors and ministers of religion, who will use the new building. To encourage discussion with such parties, Anna has put up some photographs of an existing building that gives "the idea" of what the future crematorium will look like. In the following extract, Anna has just walked into the room, where Adam and Charles are present. On her entrance, Anna uses talk and gestures to point out the photographs. After Adam's supportive response to her opening words ("I'm impressed"), Anna launches into a small story that tells why she put up the images. Her narrative, occurring in conjunction with Adam's comments, demonstrates aspects of local meaning and interpretive context, given that her story emerges as a joint production in relation to the architect's talk.

Extract 1: Small Stories

Anna: Registrar; Adam: Architect

Anna: We've put these [photographs] up.
Adam: I'm impressed.
Anna: Are you oh well I got those from the website for the -
Adam: Kimbell.
Anna: From the Kimbell Museum so that people could see what we were trying to do—I copied them to show them what the idea was and where it came from—I put them up so that people could see and everyone could sort of comment and have some sort of feedback from that—just to start with even just at this stage really.
Adam: Good—I'll look forward to hearing the feedback because that's the purpose of the meeting after all—yeah that's great

Beyond its interpretation as a sequence of jointly produced talk, Anna's small story concerning a past, reportable event (putting up the photographs) points to several issues regarding the identities and relationships of the participants in design. For instance, the story indicates aspects of Anna's identity as a client, as her words draw attention to her initiative of supplying images that will elicit comment from people. Although her account recollects why she put up the photos (so that "people could see what we were trying to do" and so "everyone could sort of comment"), the brevity of her words belies her complex role as a translator and negotiator of the new building. That is, as chief client, Anna attends meetings with the architect, remembers what occurred in those meetings, and then talks to people who have an interest in the future building (but who have not attended the meetings with the architect). In effect, Anna translates for others the building in progress and represents to them the architectural process in which she participates with Adam. Then, Anna listens to the comments that others make during her meetings with them, selects from these recollected comments, and translates them back to the architect as feedback. Thus, through Anna's small story she draws attention to actions (such as finding photographs) that are part of her identity as a proactive client; she locates herself as a mediator positioned in relationship to the architect and other users; and she indicates the polyphonic nature of design (Bakhtin, 1984), wherein the voices of many contribute to practice and so, ultimately, to the nature of the final object.

Anna's small story is part of a sequence of talk wherein the explanation of her efforts is followed by Adam's appreciation ("I'm impressed," "Good," and "yeah, that's great"). He also says he is "looking forward" to hearing comments about the building and draws attention to his interest in hearing from others by stating that the purpose of the meeting is for him to receive feedback. Such talk indicates that Adam's role as an architect is consciously performed with concern to engage with others. This is reinforced at several points in the transcripts (other than extract 1) wherein Adam states his desire to hear what other's think of the building and where he seeks the opinions of the clients in ways that indicate his appreciation for their expertise. Such a collaborative approach to practice is favored by many design professionals who seek to shift the image of the designer/architect away from being dictatorial and towards being cooperative (Lee, 2008). When considering the collaboration of Adam and Anna through this small story and responses to it, we can see that their talk, although brief, is a "site of engagement where identities are continuously practiced and tested out"

(Bamberg and Georgakopoulou, 2008:379). Clearly, small stories are valuable when seeking to understand design because it is partly through them that the situated expressions, contingent memories, and participant identities of collaborative practice are performed.

BIG STORIES

Referring again to extract 1, Anna mentions photographs of a building referred to as "the Kimbell," that is, the Kimbell Art Museum in Texas (Plate 24), designed by Louis Kahn and opened in 1972 (Loud, 1989). In reviewing the 130 pages of transcripts for the DTRS7 architecture project, the word *Kimbell* was uttered in passing on only two occasions other than those in extract 1 (once regarding the crematorium's roof and once regarding its exterior). Based only on the transcripts of the meetings, it would have been relatively easy to overlook the influence that a gallery in Texas had on the design of a crematorium in England. But DTRS7 also included a background information video of an interview held between Adam and Paul (a researcher and DTRS7 organizer). This interview was not part of the main DTRS7 data but, when considered alongside the talk of the real meetings, it helps to illuminate how design practice happens as a relationship between social interaction and those more personal "acts of individuals" (Forty, 1986:245).

During the interview, Adam performs big-story narratives in which he speaks of events concerning the crematorium's design. Big stories are usually performed in response to researcher-generated questions and involve a speaker selecting, and reflecting on, their memories in relation to motives, connected events, and emotional states (Bamberg, 2006:7). Further, big stories are normally recounted at a time that is distant from the circumstances described (Freeman, 2006; in this case, circumstances occurred between one and fourteen years before the interview). Big stories are the traditional purview of an oral history approach that seeks "new knowledge about and insights into the past through an individual biography" (Shopes, 2011:451), with this particular interview following the lines of a "topical interview" in which one or more episodes or elements from a subject's life is recalled and reviewed (Shopes, 2011:452). Here, the episodes that are recounted include how Adam was offered the role of crematorium designer and his response to that offer, how his ideas for the building developed in relation to the input of others, and how his experience of the Kimbell Museum has had an impact on the design of the crematorium. The latter two issues are discussed in the following.

Extract 2: Big Stories

(repeated words and some other talk has been excised for brevity).
Paul: DTRS organizer; Adam: Architect

Paul: And why do you think you were given the job?
Adam: The way it happened was I just knocked on the door of my boss one day . . . and she said oh Adam how would you like to design the new chapel and crematorium and . . . I thought *what?* because of course it's every architect's dream to do a . . . building like this—I mean I love spiritual architecture so for me it was a dream come true . . .
Paul: And what was the brief that you were given by the clients?

Adam: A very, very simple brief . . . we really want a lot more information however when you have got a very thin brief by attending meetings with the clients you can develop the brief with them and you can obtain a better understanding of what is needed . . . As the briefing continued we talked to many other people . . . and the more people we spoke to the clearer idea we could put together as to how the building should develop . . . at the same time . . . we started to think about what sort of form the building would take and for me I've always had this love of spiritual architecture . . . and so I started to look into the design of sacred spaces . . . I also looked at other building types that had a spiritual character—and very early on I thought about Louis Kahn's Kimbell Art Gallery in Texas which is a building that I visited back in 1993—it is an art gallery—but for me it has an *immensely* spiritual character . . . this is a concept that has remained throughout the entire project—the concept of the Kimbell is merely a sequence of arched vaults connected by narrow flat-roofed zones . . .

Paul: So it wasn't just the feeling of the spaces that you liked, it was actually all the underlying concepts of the architecture?

Adam: Yeah, it was the *feel* of the architecture more than anything—I was trying to find an architectural vocabulary that had an appropriate *feel* for a crematorium and this form appeared to deliver everything I was looking for . . . and so I started to look at the design of the crematorium based upon that concept.

Paul: And did you go back to the Kimbell and—reacquaint yourself with it or was it just a sort of feeling that you tried to bring into the crematorium?

Adam: I was very familiar with the Kimbell having visited it and having a collection of many books on Louis Kahn—the whole feeling had never left me since visiting the building in 1993.

When we consider this extract's big-story narratives, we can see that some of the talk supports issues previously noted when examining the small story earlier. That is, in extract 1, we saw Adam performing as an architect who is concerned to hear feedback from others and who supports his client's efforts to engage others. This collaborative approach to his profession is reiterated here, as Adam speaks of discussing the crematorium with many people in order to ascertain their needs. This big story thereby further indicates that a collaborative approach is a "continuous and repetitious" part of Adam's "identity work" as an architect (Bamberg and Georgakopoulou, 2008:379).

Another area in which the small and big stories overlap is with the participants' recognition of the Kimbell Museum as a concept that underpinned the crematorium's design. In extract 1 Anna refers to photographs of the Kimbell as indicating "what we were trying to do," whereas in extract 2, Adam speaks of the Kimbell as a central concept that "remained throughout the entire project." Yet, although both client and architect acknowledge the Kimbell as the crematorium's primary generator (i.e., "a starting point . . . a way in to the [design] problem"; Darke, 1979:38), it is Adam's big story that provides some understanding of the nature of the Kimbell's influence. That is, the Kimbell was a template for both the form and the function of the crematorium as Adam adopted Kahn's barrel-vaulted structures and his system of "servant and served" spaces (Ksiazek, 1993:423). However, these aesthetic and practical influences occurred in relation to Adam's personal experiences of the Kimbell and his recollection of what he emphasizes as its "*immensely* spiritual character."

Adam's felt memories of the Kimbell "had never left" him, and once he accepted the crematorium project, he thought of the Kimbell "very early on." Adam's professional role as designer offered the opportunity to translate his memories of the Kimbell into a new building that demonstrates his "love of spiritual architecture." Further, not only did Adam derive enormous satisfaction from the performance of his professional role ("a dream come true"); he also locates his work within a positive, if subjective interpretation of the wider field of architecture ("it's every architect's dream to do . . . a building like this").

Once we have considered Adam's big story account of his reaction to the Kimbell, then the couched references to Kahn's Museum in the transcripts gain resonance. For instance, at various points in the meeting, Adam refers to "my original concept," and he shows his clients "concept diagrams" to explain "where I'm coming from." Further, he states that he has "been trying my hardest" to design according to "what holds the architecture together." When we know that the Kimbell is the concept that "holds the architecture together," then such comments indicate that, while elements of Adam's practice are conducted in collaboration with his clients, he is also expressing a strong desire to create in relation to his own experiences. Although Anna's talk in the small story indicates some qualities of the Kimbell's impact on the crematorium, it is the memories that are recounted in Adam's big story that reveal the importance of his encounter with the Kimble, and thereby provide greater understanding of the subjective rationale for the form and function of the new building.

CONCLUSION

Clearly, both small and big stories are useful for understanding design practice, with both brief and extended narratives demonstrating that participants produce and collaboratively orient themselves towards relevant identities and activities. It has also been shown that the big story in extract 2 provides a different kind of information than extract 1, that is, information concerning subjectivities and personal experiences that had an impact on the crematorium. Adam's narrative helps us to comprehend the emotions that contributed to the "flow of decisions" (Wengraf in Bamberg, 2006:9) that led to the crematorium's design. Both extracts indicate that significant elements of design are not solely the "acts of individuals" (Forty, 1986:245) with extract 1 showing that even brief narratives concerning design are collaboratively constructed and performed (Bamberg, 2011). However, extract 2 demonstrates that the apparently collective practice of design may also be associated with and derived from idiosyncratic and deeply personal experiences.

This chapter is not in favor of only using big stories to understand design, because objects do not emerge from reflecting upon practice, but rather through its moments of live, jointly constructed meaning and action. However, by focusing exclusively on collaboration and avoiding the "acts of individuals" (Forty, 1986:245), we may learn about practice but yet not necessarily "properly comprehend what design is" (ibid.). The memories, meanings, and interpretations that are relevant to design are constructed and reflected on in both small and big stories, with each form of narrative constituting and expressing significant elements of practice. By attending in a "truly synthetic, dialectical" (Freeman, 2011:12) manner to how these stories interact, we may more fully comprehend what design is.

REFERENCES

Bakhtin, M. (1984), *Problems of Dostoevsky's Poetics*, Minneapolis: University of Minnesota Press.

Bamberg, M. (2006), "Biographic-Narrative Research, Quo Vadis? A Critical Review of 'Big Stories' From the Perspective of 'Small Stories,'" in K. Milnes, C. Horrocks, N. Kelly, B. Roberts, and D. Robinson (eds.), *Narrative, Memory and Knowledge: Representations, Aesthetics and Contexts*, Huddersfield: University of Huddersfield Press.

Bamberg, M. (2011), "Who am I? Big or Small—Shallow or Deep," *Theory & Psychology* 21/1: 122–9.

Bamberg, M. and Georgakopoulou, A. (2008), "Small Stories as a New Perspective in Narrative and Identity Analysis," *Text & Talk* 28/3: 377–96.

Darke, J. (1979), "The Primary Generator and the Design Process," *Design Studies* 1/1: 36–44.

Forty, A. (1986), *Objects of Desire: Design and Society from Wedgwood to IBM*, New York: Pantheon Books.

Freeman, M. (2006), "Life 'on Holiday'? In Defense of Big Stories," *Narrative Inquiry* 16/1: 131–8.

Freeman, M. (2011), "Stories, Big and Small: Towards a Synthesis," *Theory & Psychology* 21/1: 114–21.

Georgakopoulou, A. (2006), "Thinking Big with Small Stories," *Narrative Inquiry* 16/1: 122–30.

Georgakopoulou, A. (2007), *Small Stories, Interaction and Identities*, London: John Benjamins.

The Henry Ford Archive (2004–10), *Automotive Oral Histories*, University of Michigan-Dearborn, <http://www.autolife.umd.umich.edu/Oral_histories.htm>, accessed September 27, 2011.

Heritage, J. (2005), "Conversation Analysis and Institutional Talk," in K. Fitch and R. Sanders (eds.), *Handbook of Language and Social Interaction*, London: Lawrence Erlbaum.

Ksiazek, S. (1993), "Architectural Culture in the Fifties: Louis Kahn and the National Assembly Complex," *Journal of the Society of Architectural Historians* 52/4: 416–35.

Lee, Y. (2008), "Design Participation Tactics: The Challenges and New Roles for Designers in the Co-Design Process," *CoDesign* 4/1: 31–50.

Loud, P. (1989), *The Art Museums of Louis I. Kahn*, Durham, NC: Duke University Press.

McDonnell, J. and Lloyd, P. (eds.) (2009), *About Designing: Analysing Design Meetings*, London: Taylor & Francis.

Oak, A. (2006), "Particularizing the Past: Persuasion and Value in Oral History Interviews and Design Critiques," *Journal of Design History* 19/4: 345–56.

Oak, A. (2009), "Performing Architecture: Talking 'Architect' and 'Client' into Being," *CoDesign* 5/1: 51–63.

Oak, A. (2011), "What Can Talk Tell Us about Design?: Considering Practice Through Symbolic Interactionism and Conversation Analysis," *Design Studies* 32/3: 211–34.

Sandino, L. (2006), "Oral Histories and Design: Objects and Subjects," *Journal of Design History* 19/4: 275–82.

Shopes, L. (2011), "Oral History," in N. Denzin and Y. Lincoln (eds.), *Handbook of Qualitative Research*, London: Sage.

Wengraf, T. (2006), "Interviewing For Life Histories, Lived Situations and Experience: the Biographic-Narrative Interpretive Method (BNIM). A Short Guide to BNIM Interviewing and Practice," Version 6.1b, in M. Bamberg, "Biographic-Narrative Research, Quo Vadis? A Critical Review of 'Big Stories' from the Perspective of 'Small Stories,'" in K. Milnes, C. Horrocks, N. Kelly, B. Roberts, and D. Robinson (eds.), *Narrative, Memory and Knowledge: Representations, Aesthetics and Contexts*, Huddersfield: University of Huddersfield Press.

CONCLUSION
ORAL HISTORY AND RESEARCH ETHICS IN THE VISUAL ARTS: CURRENT AND FUTURE CHALLENGES

matthew partington

Reflecting on the potentially invasive nature of the life story interview, Ruthellen Josselson acknowledges the effect the undertaking can have: "that we explore other peoples' lives to make them into an example of some principle or concept or to support or refute a theory will always be intrusive and narcissistically unsettling for the person who contributes his or her life story to this enterprise" (1996:70). Josselson suggests that in recording life stories, we should be uncomfortable with what we do in order to ensure we always consider the well-being of the interviewee. Research ethics in the visual arts is a process concerned with this point of discomfort and attempts to ensure that those people involved in or affected by the research feel as secure as possible.

This essay investigates the ethical issues that arise out of research in the visual arts with particular reference to oral history interviewing (and in some cases to issues raised in the chapters in this book). Given both the widespread use of recorded interviews in visual arts research and their potential to touch on extremely sensitive issues, this chapter looks at ways in which higher education in the United Kingdom, through its procedures and protocols, engages with ethics. I draw on my experience as a crafts historian and as chair of my faculty's Research Ethics Committee. In using ethics in higher education as one particular approach, I outline the main areas of concern for anyone with a particular interest in the ethics of research interviewing in the visual arts. I then conclude with a consideration of the future challenges for oral history and ethics in a rapidly developing digital world.

The difference between ethics procedures in a university and in an oral history project elsewhere in the community is essentially one of scale and detail. Unless a project is very specific and continues for several years, each is treated differently, and a separate application for ethical approval has to be made to the relevant faculty or university ethics committee. The context of the researcher, the researched, the environment in which the interviews take place, and many other issues are questioned thoroughly each time. A researcher conducting interviews for a film project about cinematographers working under a repressive regime obviously faces very different ethical dilemmas regarding his or her interviewee's safety than if he or she were making a film about contemporary sculptors working in London. The key point is that every project is different and ethics procedures cannot be generic; they have to be tailored carefully to specific projects.

Although some of the interviewing in the visual arts is of a fact-finding, journalistic kind that is akin to a conversation, a significant majority would fit in to the oral history approach: essentially an attempt by the researcher to allow the respondent to speak (usually in response to questions or comments) with as little "contamination" or bias caused by the researcher as is possible. Most researchers are well aware of Louis Starr's proclamation that "a good interviewer is a good listener" (Morrissey, 1998:108). In addition to conducting interviews in an ethically sensitive manner the researcher must also care about the well-being of the interviewee—before, during, and after the interview takes place.

A RECENT HISTORY OF ETHICS

Research ethics in higher education in the United Kingdom deals with human participant research and is designed to protect the researcher and those being researched. Formal ethics procedures in the United Kingdom grew out of the Royal Liverpool Children's Inquiry following the Alder Hey Children's Hospital case in 1999 to investigate "the removal, retention and disposal of human organs and tissues following post mortem examination at the . . . Hospital" (Royal Liverpool Children's Inquiry, 2001). The inquiry in 2001 led to much more stringent ethics procedures that filtered down to university research in the sciences and eventually to all university departments. It is therefore important to stress that formalized ethics procedures in the visual arts in the United Kingdom are very recent, and as a result, very little has been published on this issue beyond university web pages (see University of Central England, Lancaster University, and University of the Arts London).

In the United States, there is a slightly longer history of institutional oversight of research ethics and this is largely undertaken by college Institutional Review Boards (Ritchie, 2003). Following the public outcry at the Tuskegee Syphilis Study in Alabama (1932–72), in which researchers "allowed a curable disease to go untreated" (Ritchie, 2003:215), a 1979 federal government report recommended "rules to govern federally funded research involving human subjects" (ibid.). Although originally brought about to protect those being researched as part of medical experiments, the regulations were altered in 1991 to cover all human participant research, and therefore, at a stroke, the legislation encompassed social sciences and the humanities (Papademas, 2004:122). Although this essay concentrates on the approach to research ethics adopted in the U.K. higher education sector, the issues are applicable wherever in the world the research may take place and in whatever context.

DEFINING RESEARCH

The first issue is one of definition—what constitutes research? Most definitions state that research must entail some form of original investigation that "establish facts and reach new conclusions" (*Concise Oxford English Dictionary*, 2002). The way my institution has currently chosen to deal with this issue is to assume that work related activity undertaken by any student or staff member that involves human participants and might be considered under the umbrella of research deserves some degree of ethical oversight. This is often in the form of advice, but sometimes, formal ethical approval is needed.

Research in my own faculty's Department of Creative Industries covers everything from fine and applied arts to animation, fashion, journalism, and photography. Even within this department, it could be argued that all artwork produced is just that—a piece of art and therefore not research (in other words, it did not involve formal research such as interviewing, observation, or experimentation). However, if in the production of the artwork there are human participants beyond the artist or designer who might be implicated in the artwork, or who might be affected by it in some way, then the fact that it was not in the form of formal interviews or questionnaires does not mean an element of ethical oversight is unnecessary.

If an artist chooses to scratch cars with a key as an artwork, as Mark McGowan did in Glasgow in 2005, then the criminal and personal responsibility lies with the individual artist, regardless of whether they were creating an artwork or not (BBC News, 2005). When asked to justify his actions McGowan argued, "I do feel guilty about keying people's cars but if I don't do it, someone else will. They should feel glad that they've been involved in the creative process. I pick the cars randomly" (BBC News, 2005). Although this kind of criminal behavior is not unheard of in the fine art world, the usual sort of project for which approval is sought from an ethics committee in higher education is usually the conventional oral history interview whereby a recording is made of questions and answers about a particular topic (such as the interviews discussed in earlier chapters of this book and conducted by Natalya Buckel, Eleanor Flegg, and Jo Turney). These sorts of interviews might then be quoted from in the normal academic way via a dissertation or a journal article, or the interview itself might be incorporated into an artwork or some other form of public broadcast. A particularly pertinent example of this is the Negotiations section of New York–based artist Marysia Lewandowska's website, the Women's Audio Archive. Negotiations charts the process of gaining consent for the archive's contents to be made freely available online, so it is both an oral history archive and artwork, as well as both an account and a record of an ethics methodology (Lewandowska, 2009). Whatever format the interview is finally published in it, is important that basic ethical issues such as consent, confidentiality, security, and copyright are carefully considered.

CONSENT

The issue of consent was set out in the 1947 Nuremberg Code, which "laid down 10 standards to which physicians must conform when carrying out experiments on human subjects" (British Medical Association, 1996:1448). Although aimed at ensuring medical experiments involving human subjects were conducted ethically, the main points regarding informed consent are widely applicable. The 1964 Helsinki Declaration was adopted by the 18th World Medical Assembly, stipulating

"that valid consent is properly informed and also freely given—without pressures such as coercion, threats or persuasion" (Economic and Social Research Council [ESRC], 2010). These codes remain at the heart of our principles of consent today—whether in the fields of medical sciences or arts and humanities. Consent is a process and ongoing, not a simple yes or no. Essentially, it is "the process by which potential participants can decide if it is worth taking part in a study despite any risks and costs" (ESRC, 2010).

Consent is crucial if the material is to be used in the outcome of the research, but it is vital that the consent is *informed*. In other words, participants have to understand clearly what they are consenting to, how the interview is going to be used, who will have access to it, and where it will be stored. Two types of documentation are usually required: the first is a participant information sheet explaining all aspects of the research; the second is a signed consent form with the participant's contact details, whereby the interviewee consents to taking part in the research as described in the information sheet. The participant information sheet asks a number of basic questions:

1. Study Title
2. Invitation Paragraph
3. What is the purpose of the study?
4. Why have you been chosen?
5. Do you have to take part?
6. What will happen to me if I take part? What will I have to do?
7. What are the possible disadvantages of taking part?
8. What if you have a concern about anything after the interview has been conducted?
9. Will taking part in this study be kept confidential?
10. What will happen to the results of the research study?
11. Who is organizing and funding the research?

The researcher should disclose every aspect of the research to the participant so that they fully understand the project. The participant must volunteer, not be coerced, and be competent to grant consent. It is accepted practice that consent can be withdrawn at any time. Nevertheless, in my own research, I have argued that this can only be allowed to happen in extreme cases as the cost of filming interviews (which is my usual practice) means withdrawal incurs considerable financial losses. This demonstrates the degree to which each project has its particular consent requirements. The points listed earlier are guidelines only, and it is up to researchers to justify their methodology if they choose to take a different approach.

I have written in the past about the crucial aspect of the visual in oral history when recording interviews with visual artists (Partington, 2008). My own research tends to concentrate on video recording and increasing numbers of practitioners in the creative arts are using video recording, regardless of whether it is a traditional "talking heads" interview or a more creative form of documenting as part of an artwork. However, it is important to state that in oral history, video is very much a minority recording methodology (as I discuss later). The importance of informed consent in video recording is even more crucial—not least because the participant is identifiable both aurally and visually. Whereas people are identifiable by the sound of their voice, they are made doubly identifiable if their face is also visible. As an example, several years ago a student interviewed a local person as part of their research and then decided later to include the video recording in an artwork

that was assessed as part of a course. It transpired that the student did not obtain the consent of the interviewee for the recording to be used in this way. When the student's tutor insisted consent be sought, the interviewee refused, and the artwork could not be displayed. The interviewee declined to give consent because of being clearly recognizable and was uncomfortable with being so publicly visible. It is therefore crucial to be clear in the consent procedures that the participant understands the ways in which the recorded material will, or may be, made available in the public arena.

Another issue that sometimes arises is the ethics of taking up an interviewee's time. Is it ethically sound to interview a self-employed artist and not pay them? It may be flattering to some to receive an invitation to be recorded for a public institution, but that does not necessarily make it ethically acceptable not to pay him or her for the time. In some applied science research, it is perfectly acceptable to pay volunteers whereas in other areas it is not; it is seen as coercion. In oral history work, I prefer to think of it as normal procedure; nonpayment should be justified, or at least acknowledged in funded academic research projects. In my own work, if I have secured funding for a project, I build in a daily payment rate to the interviewee because, otherwise, I would be taking away at least a day of his or her working life. For most student research, it is not financially possible to pay interviewees, and most oral history projects do not pay their interviewees, principally because such projects are poorly funded and are often only made possible by the volunteer workers donating their time. However, it is an issue that needs to be more carefully considered, particularly when making a funding application in which payment could be built in to the project from the beginning.

CONFIDENTIALITY AND ANONYMITY

Most U.K. arts faculties' ethical terms of reference grew out of an applied science model and are therefore sensitive to ethical issues around confidentiality that are not always applicable to visual arts research. One of the norms in U.K. higher education research projects is that participants are guaranteed confidentiality; their details are not apparent in the outcomes of the research. This is because their identification is irrelevant to the study and might be harmful, invasive of their security, or essentially unnecessary. A stricter standard is one whereby the participant is anonymous, but if details are given in the published research, such as where research took place and the profession of the interviewees, then it is sometimes possible to guess their identities. Anonymity, therefore, can be difficult to guarantee.

In the creative arts, however, it is almost always the case that the identity of the person involved is relevant to the research. In my experience, more than 80 percent of the formal applications for ethical approval are for projects involving interviews with artists, designers, or others associated with the visual arts in which their identities are important to the understanding of the data. Of the interviews mentioned by the authors in this book, the overwhelming majority use participants' actual names. Those who did not included David Gates, who used pseudonyms for his participants. This was partly because his research was not about individuals but about a type of artist: the discursively constructed craftsperson and he felt that to name participants was counterproductive. He was also compelled to make participants anonymous because his PhD was based at a university renowned for its medical research and which, therefore, operates an ethics procedure that assumes the anonymity of participants in research studies. He did not question this assumption as he himself preferred to use pseudonyms. Alexandra Handal used anonymity with some of her interviews in line

with the individual interviewee's requests. However, in Claire Wilcox's chapter, the interviewer and her sister both proudly waived anonymity (despite the sometimes very personal and private nature of the testimony) as they were keen to have the story told. In order to satisfy ethical requirements it is a matter of justifying one's approach and provided the rationale for waiving confidentiality is clear to the participant then that is perfectly acceptable. I would repeat, however, that there should be no assumption that approval will be granted; a clear justification has to be given for each project.

SECURITY AND SAFETY

A common query in relation to student research proposals is to ensure they are conducted safely. Tutors have a duty of care to students whether they are eighteen or eighty. A colleague reported a story about a student who, some years ago, went to interview a male designer who proceeded to make sexual advances. Although this was repelled, and the student was physically unharmed, the student had failed to inform anyone about where she was going or how she could be contacted. Safety both for the researcher and the researched is a key consideration. The vast majority of interviews are conducted along fairly conventional lines for the purposes of building a picture about a particular period, social group, or artistic endeavor. This does not mean, however, that fundamental safety rules should not be considered: ensuring meetings are held in a public place, taking an assistant along, telling somebody where one is, and not giving out personal contact details such as mobile phone numbers or addresses to research participants. The purpose of ethical oversight is so ensure the safety of the researcher and the researched.

COPYRIGHT AND RETAINING DATA

Copyright is about establishing what right the researcher has to copy and publish, broadcast, or otherwise disseminate the recording and/or its transcript. In most cases, a consent form is used, which states clearly to what uses the recordings can be put, most frequently indicating that it is for educational and research purposes. Nowadays, this will also cover noncommercial Internet use. For any commercial uses of the material, a separate agreement would have to be reached with the interviewee. Ethics procedures in U.K. higher education encompass copyright, but it is rarely a central element of an ethics application and is not focused on to the same extent as in, for instance, the Oral History Society's web guidance on ethics (Oral History Society, 2011). This is because in higher education, the focus is on securing consent and copyright usage for the material for the duration of the research project rather than in perpetuity, as is often the case for oral history projects in which the recordings might be kept in a museum or an archive. However, given the increasing number of university research repositories, the need to engage with copyright will become a more central concern. Although this chapter deals with human participant research, a large area of visual studies research looks at the ethics associated with imagery in the visual arts, including copyright issues (see Papademas, 2004).

It used to be the case that researchers were encouraged under ethical protocols to destroy the data after the research was published. Research councils now encourage researchers to keep data because it is impossible to be sure that the raw material will not be crucial to future understanding of the subject area. Researchers are therefore more and more aware when recording interviews that

the material may be made available for use beyond the immediate project at hand, many years in the future. The Oral History Society (2011) argues that "[i]t is essential . . . that recordings should be available for research and other use within a legal and ethical framework which protects the interests of informants." However, in academia, it had been the case that interviews were recorded for research purposes, but once the publication appeared (whether it be PhD dissertation, a journal article, or a book), the recordings were often destroyed.

As noted previously, universities are starting to engage with the idea of research repositories and archives. Material can then be properly catalogued and stored for future use. My own university has a dedicated website for its research repository with the explanatory tagline that "the UWE Research Repository provides immediate world-wide open access to all of UWE's research output" (University of West England [UWE], 2011). Examples of academic repositories can be found across the globe; for instance, the Massachusetts Institute of Technology in the United States has its DSpace institutional repository (http://dspace.mit.edu/), and Hong Kong University Scholar's Hub, which can be found at http://hub.hku.hk. The existence of these archives increases the need for researchers to be fully aware of the ethical implications of retaining material "in perpetuity," as well as their responsibilities in passing on their work on other people's lives to future generations of researchers.

The U.K. ESRC (2010) Research Ethics Guidebook states that "archiving data and longitudinal work are potentially difficult in terms of the principle of fully informed consent, because you may, effectively, be asking participants to agree to something that is uncertain." Essentially this is a warning that consent in perpetuity is problematic. Another option for interviewees is to consent to take part, but to insist the data are destroyed. In oral history projects, the accepted procedure in such cases is to embargo the material for an agreed number of years. Although this is inconvenient for the researcher, it is clearly ethical. Although much time is taken in considering ethics in relation to the planning and implementation of research, it is also vital that we consider ethics as taking place before, during, and *after* the interview. What happens to the recording many years later may turn out to be the most ethically sensitive aspect of the whole project.

FUTURE CHALLENGES FOR ORAL HISTORY AND ETHICS

One of the most significant opportunities for oral history in the visual arts is the bewilderingly rapid developments in digital modes of recording and dissemination of the last twenty years. These opportunities also present ethical challenges that must be faced if we are to fully embrace the digital age. Oral historians have on the whole been adept (if a little cautious) at taking up new technologies for audio recording but the digital explosion of the last ten to fifteen years has changed the environment of both recording and delivery beyond all recognition. The technological landscape is bewilderingly fecund, but in so being, it offers its own difficulties. As Jonathan Sterne has pointed out, "we have made recordings more portable and easier to store than ever before, but in so doing we have also made them more ephemeral" (2009:56).

RECORDING

Alongside the Internet, digital technologies have transformed our lives with items as varied as mobile phones, mp3 music players, laptops, personal computers, tablets, and video game consoles.

In the world of the oral historian, when at one time the recording was on an audio cassette, now the recording may only exist on a hard disc within the recording device or upon a memory card that can easily be digitally duplicated. The cautious approach of some oral historians in adopting new technology is completely understandable: few formats stand the test of time (as the relatively quick death of MiniDisc technology demonstrated so clearly). Although an article in 2002 about new technology and oral history did not foresee the explosion in the use of mp3 music players ("I think we will go on seeing CD [*sic*] being used as that common currency of music for a very long time"; Copeland, 2002:106), it did conclude that the move to digital was inevitable and that digital was "all or nothing" (Copeland, 2002:109).

Oral history's current default state of aural recording is an accident of history. The first recordings were made because the technology became available to record sound. On the American Oral History Association's website (as of December 2011), the technology page has a long section on audio and then under the heading "Oral history and digital video" are the words "coming soon." Video has been an inexpensive and accessible recording medium since the 1980s (Ishino, 2006:320), yet it is still not used by more than a handful of oral historians. This book is testament to the degree to which the textual reproduction of the transcript is still the norm when oral history in presented in print. In a book on oral history in the visual arts, none of the essays expound on the opportunities offered by video or photography in making truly visual oral history interviews, (Alexandra Handal's interviews for her *Dream Homes* project used video as a recording medium, but the chapter itself does not reflect upon the visual in oral history). Whereas Donald Ritchie's seminal *Doing Oral History: A Practical Guide* (2003:134–54) has a clear and concise account of the pros and cons of video as an oral history tool, the reality in the field is that few oral historians are truly engaging with video as a methodology.

Alexander Freund and Alistair Thomson's recent book, *Oral History and Photography* (2011), essentially deals with the ways in which photographic images are used in oral history recordings as an aide mémoire. There is no discussion of the ways in which photography as a process might be used to enhance oral history recordings when they are made or to visually record the process of interviewing or the environment of the interview, the interviewer, or the interviewee. This is not a criticism of the premise of their book, in which oral historians reflect on their use of photographs, but more an observation that when the term *oral history* is used it almost always refers to the aural. It is assumed that an oral history recording is an audio artifact.

DELIVERY

If we accept that audio is still the norm, the most apparent challenge and opportunity for oral history is not just in terms of the mode of recording but also in the delivery of the published outcome of the recording. If you are reading this text on an e-book reader or some other digital format that isn't the printed paper page, then there is no reason why a quote from a transcript cannot be linked to the actual recording. There are any numbers of apps where one can read a text on a tablet device (such as an iPad) and the words can be heard as well as read. An oft-cited example is the app of the T. S. Eliot poem "The Wasteland," which has the text linked to the audio file of Eliot (among others) reading it as well as a video performance of the poem (Eliot, 2011). E-books have been described as the harbingers of death for the traditionally printed page (Barnsley, 2011), but they are simply another form of delivery of the written word. Although the majority of e-books currently

available are simply electronic texts, many are making genuinely innovative use of the capabilities of the e-book devices with interactive texts linked to video, audio, and even games and puzzles.

With all of these possibilities, the future for oral history is potentially transformed. If we truly value the spoken word, then the e-book offers a paradigm-shifting opportunity for oral history to be delivered aurally at the point of publication rather than as the transcript, which is at best a shadowy rendering of the interview. Raphael Samuel's 1972 article "The Perils of the Transcript" begins unequivocally: "The spoken word can very easily be mutilated when it is taken down in writing and transferred to the printed page" (p. 19). He concludes, stating, "Unless recordings can be preserved in their original integrity, and made freely available for other researchers to consult, they will remain locked forever in the preoccupations of the collector, immune to criticism, and incapable of serving as a base for a continuing enquiry" (p. 22). New technologies such as the e-book (and others we cannot yet imagine) offer the opportunity to make our oral history recordings widely available and avoid the potential "mutilation" of offering the transcript alone.

However, this raises the ethical implications inherent in making oral history recordings more accessible. Within a transcript, participants are easily made anonymous, whereas an actual voice recording or a video recording offering vision and sound both make anonymity impossible and confidentiality difficult to ensure. Consent forms for the use of the recording will need to take account of the known and currently unknown future uses of the recordings we make. We must assume the material we record will become available in the future to everyone and in every format and in contexts we cannot foresee.

CONCLUSION

In essence, the ethics issues at stake in higher education are the same as those in most oral history projects, but the mechanisms in place to deal with them are now closely scrutinized and are dealt with on a case-by-case basis. The purpose of having a clear ethics procedure is to nurture a mature, thoughtful research culture among all art college staff and students as well as ensuring the safety of the researcher and his or her subject. Researchers are in a position of power, and it is vital that as approaches to ethics evolve, that we all acknowledge them to ensure our approaches to interviewing take in to account our ethical conduct in our particular subjects of study. Although artists working outside of higher education are not subject to the same ethical procedures and safeguards, nonetheless, they have an ethical responsibility when they use human subjects and their narratives as a resource in the production of their art works.

REFERENCES

Barnsley, V. (2010), "Is it the end for publishing—or a new beginning?" *Futurebook*, October 5, <http://futurebook.net/content/it-end-publishing-or-new-beginning>, accessed December 2, 2011.

BBC News (2005), "Artist vandalises cars with key" (April 17), <http://news.bbc.co.uk/1/hi/england/london/4454485.stm>, accessed August 20, 2011.

Birmingham Institute of Art & Design (2006), "Research ethics in art, design and media," Birmingham City University, <http://www.biad.bcu.ac.uk/research/rti/ethics/>, accessed August 20, 2012.

British Medical Association (1996), "The Nuremberg Code (1947)," *British Medical Journal* 313/7070: 1448.

Cashell, K. (2009), *Aftershock: the Ethics of Contemporary Transgressive Art*, London: I.B. Tauris.

Concise Oxford English Dictionary (2002), Oxford: Oxford University Press.

Economic and Social Research Council (2010), "The Research Ethics Guidebook," <http://www.ethicsguide book.ac.uk/Consent-72>, accessed August 20, 2012.

Freud, A. and Thomson, A. (eds.) (2011), *Oral History and Photography*, New York: Palgrave Macmillan.

Gregory, I. (2003), *Ethics in Research*, London: Continuum.

Higher Education Funding Council for England (2008), Research Assessment Exercise, <http://www.rae.ac.uk/>, accessed August 20, 2012.

Ishino, C. (2006), "Seeing Is Believing: Reflections on Video Oral Histories with Chinese Graphic Designers," *Journal of Design History* 19/4: 319–31.

Josselson, R. (1996), "On writing other people's lives, self-analytic reflections of a narrative researcher," in R. Josselson (ed.), *Ethics and Process in The Narrative Study of Lives*, vol. 4, Thousand Oaks, CA: Sage Publications.

King-Roth, S. and Roth, R. (eds.) (1998), *Beauty is Nowhere: Ethical Issues in Art and Design*, London: G+B Arts International.

Lancaster University (n.d.), "Ethics and Ethical Practice in Social Science Research," <http://www.lancs.ac.uk/fass/events/ethicalresearch/index.htm>, accessed August 20, 2011.

Lawendowska, M. (n.d.) "Negotiations," Women's Audio Archive [website], <http://www.marysialewan dowska.com/waa/negotiations.php>, accessed August 20, 2011.

Mauthner, M., Birch, M., Jessop, J., and Miller, T. (eds.) (2008), *Ethics in Qualitative Research*, London: Sage.

Morrissey, C. T. (1998), "On oral history interviewing," in R. Perks and A. Thomson (eds.), *The Oral History Reader*, London: Routledge.

Oliver, P. (2010), *The student's guide to research ethics*, Maidenhead, England: Open University Press.

Oral History Society (2011), Ethics pages, <http://www.oralhistory.org.uk/ethics/index.php>, accessed 20 August 2011.

Papademas, D. (ed.) (2004), "Editor's Introduction: Ethics in Visual Research," *Visual Studies* 19/2:122–5.

Partington, M. (2008), "A Blurred Photograph of Jesus Is Better than No Photograph at All—The Practicalities of Using Video as an Oral History Tool," unpublished conference paper, International Oral History Conference, University of Guadalajara, Mexico, September.

Perks, R. and Thomson, A. (eds.) (1998), *The Oral History Reader*, London: Routledge.

Ritchie, D. A. (2003), *Doing Oral History: A Practical Guide*, Oxford: Oxford University Press.

The Royal Liverpool Children's Inquiry (2001), The Report of the Royal Liverpool Children's Inquiry, <http://www.rlcinquiry.org.uk/>, accessed August 20, 2011.

Samuel, R. (1972), "Perils of the Transcript," *Oral History* 1/2: 19–22.

Shopes, L. (2007), "Oral History, Human Subjects, and Institutional Review Boards," Oral History Association (USA) [website], <http://www.oralhistory.org/do-oral-history/oral-history-and-irb-review/>, accessed December 15, 2011.

Sterne, J. (2003), *The Audible Past: Cultural Origins of Sound Reproduction*, Durham, NC: Duke University Press.

Sterne, J. (2009), "The Preservation Paradox in Digital Audio," in K. Bijsterveld and J. van Dijck (eds.), *Sound Souvenirs: Audio Technologies, Memory and Cultural Practices*, Amsterdam: Amsterdam University Press.

University of the Arts, London (n.d.), "UAL Research Online," <http://ualresearchonline.arts.ac.uk/>, accessed August 2, 2011.

University of Central England (Birmingham) (n.d.), "Research Ethics in Art, Design and Media," <http://www.biad.bcu.ac.uk/research/rti/ethics/>, accessed August 20, 2011.

University of West England (2011) "Welcome to the UWE Research Repository," <http://eprints.uwe.ac.uk/> accessed August 20, 2011.

CONTRIBUTORS

Liz Bruchet is a London-based oral historian and curator. Her work explores narratives in exhibitions and institutional archives. She holds an MA in Curatorial Studies from the University of British Columbia and has undertaken a wide range of projects, most recently the Association of Art Historians' Oral Histories.

Natalya R. Buckel gained a BSc in Textile and Apparel Products, Design and Marketing from University of North Carolina–Greensboro in 2006. She was awarded an MA in Public History at Appalachian State University in 2010. She currently resides in the United Kingdom and works for the National Trust.

Richard Cándida Smith is Professor of History at the University of California, Berkeley, where he teaches intellectual and cultural history of the United States and directs the oral history research center. Currently writing a book on U.S.–Latin American cultural exchange, he is the author of five books related to the arts in modern society.

Dr. John Clarke is Curator of the Himalayan collections at the Victoria and Albert Museum. He received his doctoral degree at the School of Oriental and African Studies (University of London) in 1995 and has published *Tibet, Caught in Time* (1997/99) and *Tibetan Jewellery* (2004). He was Lead Curator for the Robert H. N. Ho Family Foundation Gallery of Buddhist Sculpture, which opened at the Victoria and Albert Museum in 2009.

Ann Cvetkovich is Ellen C. Garwood Centennial Professor of English and Professor of Women's and Gender Studies at the University of Texas at Austin. She is the author of *Mixed Feelings: Feminism, Mass Culture, and Victorian Sensationalism* (1992), *An Archive of Feelings: Trauma, Sexuality, and Lesbian Public Cultures* (2003), and *Depression: A Public Feelings Project* (forthcoming).

Eleanor Flegg is a freelance writer with a particular interest in craft and design. She has taught design history at the Dublin Institute of Technology and the National College of Art and Design and

is a PhD candidate in craft history at the University of Ulster. She has written a craft and design column for the Irish *Arts Review* since 2002.

Bettina Furnée trained as a lettercutter, public artist, and art historian. She has been involved in many public art schemes producing environmental and text-based works. She initiated the projects *If Ever You're in the Area* (www.ifever.org.uk) and *Powerhouse* (www.powerhouse.me.uk). She lives in Cambridge and is studio artist representative on the board of Wysing Arts Centre.

David Gates designs and makes furniture. His work as an artist and craftsperson informs his PhD research at King's College London on narratives and discourses of workshop practice. He was awarded the 2010 Jerwood Prize for Contemporary Makers and the Wesley Barrell prize in 2011. He jointly founded the artist's collective Intelligent Trouble.

Dr. Alexandra Handal is a London-based Palestinian visual artist, filmmaker, and essayist. She holds a practice/theory PhD from the University of the Arts London (2010) and was the recipient of the University of the Arts London Research Studentship Award, U.K. (2004). Handal's short film *From the Bed & Breakfast Notebooks* (2008) was selected for New Contemporaries 2009. She has exhibited her work internationally.

Dr. Ian Horton teaches at the London College of Communication, University of the Arts London. His current research examines experimental typography, public art, and curatorial practices in historical and contemporary contexts. In 2009 he co-organized the "Beyond the Margins" International Experimental Typography Symposium.

Dr. Liza Kirwin is the Acting Director of the Smithsonian's Archives of American Art. She is the author of numerous publications about the Archives' holdings, most recently *Lists: To-dos, Illustrated Inventories, Collected Thoughts, and Other Artists' Enumerations from the Smithsonian's Archives of American Art* (2010).

Dr. Michael McMillan is an interdisciplinary arts practitioner whose recent work includes *The Waiting Room*—an arts in health audio-visual installation (Bangor, 2011), a new translation of Bertolt Brecht's *The Good Person of Sezuan* set in Jamaica in 1980 (2010), and *The Front Room: Migrant Aesthetics in the Home* (2009); see www.thefrontroom.org.uk.

Dr. Arlene Oak is an Associate Professor in Material Culture Studies at the University of Alberta, Canada. Her background includes design practice, design history, and the social psychology of design. Her research explores how conversation has an impact on the creation, interpretation, and consumption of the material world.

Dr. Matthew Partington is Senior Research Fellow (Applied Arts) at University of the West of England, Bristol, where he is Chair of the Faculty of Arts, Creative Industries and Education Research Ethics Committee. He is also the university's Visiting Research Fellow at the Victoria and Albert Museum in Contemporary Crafts, and Director of Recording the Crafts (see www.uwe.ac.uk/sca/research/rtc/).

Anne G. Ritchie is the senior archivist and oral historian at the National Gallery of Art, Washington. She received a master's degrees in History and Information Science from the University of Kentucky. She has served as president of the Oral History Association and vice-president of the International Oral History Association.

Dr. Linda Sandino is the Camberwell/Chelsea/Wimbledon [CCW] Graduate School, University of the Arts London Senior Research Fellow in Oral History at the Victoria and Albert Museum where she is researching curators' working lives and their narratives of expertise. She also developed VIVA (Voices in the Visual Arts, www.vivavoices.org/website.asp?page=Viva) and manages the Design History Society oral history project.

Shehnaz Suterwalla is completing her PhD in History of Design at the Royal College of Art/V&A. Shehnaz has worked as a journalist and an editor for *Newsweek* and *The Economist*. She is a contributor to *Global Design History* (2011). She lectures and has presented at various conferences and symposia including "The Postmodern Legacy" (Victoria & Albert Museum, 2011).

Maria Tamboukou is Professor of Feminist Studies and Co-director of the Centre of Narrative Research, University of East London, United Kingdom. Her recent publications are *In the Fold between Power and Desire: Women Artists' Narratives* (2010), *Nomadic Narratives: Visual Forces* (2010) on Gwen John's letters and paintings, and *Visual Lives* (2010) on Dora Carrington's letters, drawings, and paintings.

David Toop is a composer and sound artist whose works have been shown in Beijing, Tokyo and London. He was the curator of "Sonic Boom: the Art of Sound" (2000). Author of several books, his most recent publication is *Sinister Resonance: the Mediumship of the Listener* (2010). He is a Visiting Professor at University of the Arts London at the London College of Communication.

Dr. Jo Turney is the course leader for the MA Investigating Fashion Design at Bath Spa University. She is the author of *The Culture of Knitting* (2009) and has written extensively about amateur crafts practice using oral history. She is the editor of *Fashion and Crime: Dressing for Deviance* (forthcoming, 2013) and is currently writing a cultural history of fashion in the 1970s.

Dr. Gali Weiss is a visual artist living and working in Melbourne, Australia. Her practice predominantly takes the form of works on paper and artist's books. Her work is represented in private and public collections, including the National Gallery of Australia and the Israel Museum.

Claire Wilcox is Senior Curator of Fashion at the Victoria and Albert Museum. She was curator of "Radical Fashion" (2001), "Versace at the V&A" (2002), "Vivienne Westwood" (2004), and "The Golden Age of Couture: Paris and London 1947–1957" (2007). She has published widely, most recently co-editing *The Ambassador Magazine: Promoting Post-war British Textiles and Fashion* (2012).

INDEX